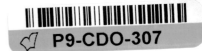

WOMEN IN ATLANTA

ABOVE: Pictured is an African American curb market. See page 47 for more information.

ON THE COVER: In the days before air conditioning, Atlanta's warm climate caused many residents to seek the cool comfort of area watering holes. Most likely considered risqué in its day, this image of friends frolicking at Ponce de Leon Springs reflects the lighter side of women's lives. Good manners could occasionally be relaxed among close friends. *Jeanette Jones, Viola Logan, Mrs. John Whipple, and Mary C. Logan; unattributed; Atlanta, c. 1900.* (Courtesy of the Atlanta History Center.)

WOMEN IN ATLANTA

STACI CATRON-SULLIVAN AND SUSAN NEILL
ATLANTA HISTORY CENTER

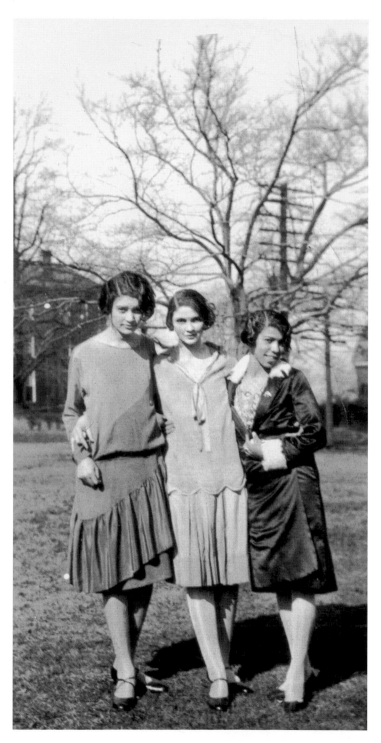

Published by Arcadia Publishing
Charleston, South Carolina

Printed in the United States of America

Library of Congress Catalog Card Number: 2004112677

For all general information contact Arcadia Publishing at:
Telephone 843-853-2070
Fax 843-853-0044
E-mail sales@arcadiapublishing.com
For customer service and orders:
Toll-Free 1-888-313-2665

Visit us on the Internet at www.arcadiapublishing.com

CONTENTS

ACKNOWLEDGMENTS

Cornelia Adelaide Banner posed for this striking portrait in a perfectly fitted dress with false buttons and elaborate sleeves, most likely made of wool challis. From the costly lace collar and embroidered ribbon tie to her gold watch, every detail indicates the young woman's wealth. Nineteenth-century women had few avenues to foster artistic talent, although elite women were expected to be accomplished needleworkers. Exceptional for the time, Banner pursued her interests in drawing and painting as well. *Cornelia Adelaide Banner (Mrs. George M. Everhart); sixth-plate daguerreotype, unattributed; c. 1850.*

Women in Atlanta grew out of the Atlanta History Center's award-winning exhibition "Gone with the Girdle: Freedom, Restraint, and Power in Women's Dress" (November 1, 2003–September 12, 2004). The exhibition featured 65 mannequins, along with a host of accessories, images, and accounts from women in their own words. From hoop skirts to miniskirts, from pantaloons to barely-there underwear, the Center sought to tell the stories of women and their roles from the home to the workplace and beyond.

We want to thank all of our colleagues at the Atlanta History Center for lending their enthusiasm and expertise to *Women in Atlanta*. We are particularly grateful to Karen Leathem and Stacy Braukman, managing editors for *Atlanta History: A Journal of Georgia and the South*, for their knowledge of women's history, their astute editing, and their willingness to juggle this project during a staffing transition. We thank Michael Rose, vice president of Archives and Research Services, for generously sharing his intimate knowledge of photography and the collections of the James G. Kenan Research Center. We are also indebted to Andy Ambrose, senior vice president and chief operating officer, for his keen insights into the complexities of Atlanta history.

In addition, we want to thank staff members at area institutions who enabled us to include their images in the book: Agnes Scott College; the Special Collections and Archives Division, Robert W. Woodruff Library, Emory University; the Georgia Historical Society; the Special Collections Department, Georgia State University Library; the Ida Pearle and Joseph Cuba Archives of the William Breman Jewish Heritage Museum; and the Spelman College Archives. We also extend our gratitude to Marge McDonald, who graciously allowed us to include an image from her private collection, and to Rosemary Doyle for lending her expertise in dressing mannequins.

A companion exhibition featuring images selected from this book was presented in the Kenan Research Center gallery from November 11, 2005, to February 26, 2006.

INTRODUCTION

Despite the enduring mythology of the Southern belle, the photographic record suggests the true diversity, complexity, and richness of Southern women's lives. In their roles as wives, mothers, teachers, businesswomen, and reformers, to name only a few, women contributed to the growth and development of the region. In Atlanta, they helped remake a small railroad hub into the thriving capital of the New South. Images of well-to-do whites on Peachtree Street, elite African Americans of "Sweet" Auburn Avenue, and working women across the city come together in this book to illuminate the realities of urban life.

Atlanta and photography both appeared in the late 1830s, and the photographic record provides glimpses of the city's history and residents from its earliest days. The emergence and refinement of photography—both as an art form and as a documentary device—shape the ways we view history. Nevertheless, the photographic record is incomplete, particularly in its nascent years when mostly elite and middle-class Atlantans sat for their portraits, and even then only rarely. Working, African-American, and immigrant women from this time period are represented in more limited numbers, while other marginalized women do not appear at all. Early images in *Women in Atlanta* are listed by format, such as daguerreotype, ambrotype, tintype, carte-de-visite, cabinet card, etc. For later images (those made in the decades following the evolution and dissemination of the modern gelatin silver print in the 1890s), formats are not noted.

Drawn from the collections of the James G. Kenan Research Center at the Atlanta History Center, these photographs illustrate some of the recurring themes in Southern women's history, including the importance of family, changing roles in the workforce, the significance of education, the pursuit of civil and equal rights, and increasing participation in athletics. Together, the images show how the experiences of Atlanta's women were both similar to and distinct from women in other cities.

Whether women define themselves as wives and mothers, question traditional roles, or reject them entirely, family is often central in their lives. When Atlanta was a young city in the mid-19th century, most of its women were educated in the domestic arts, aspired to marry and have children, and toiled to feed, clothe, and nurture their families. Although women's lives changed tremendously over the next century, their struggle to balance family, career, and personal needs continued.

Most women's work in the Victorian era related to home and family. Whether free or enslaved, black or white, women's days were consumed by cooking, sewing, cleaning, laundry, and childcare. Over the decades, growing numbers of women entered the workforce, and with the harnessing of electricity, a host of appliances were invented to make domestic work easier and more efficient.

Formal education for young women became a significant aspect of Southern life in the decades following the Civil War. Atlanta opened public schools for both white and black students and founded the first institutions of higher learning. Since then, the numbers of women graduating from high school and college and earning graduate degrees have grown steadily. Along the way, the curriculum has evolved from emphasizing the domestic arts and trades to a broad range of specialties in the arts and sciences.

From enslaved women's struggle for emancipation to the call for woman suffrage in the early 20th century, some Atlanta women fought for an equal place in society. In the post–World War II era, with more freedoms than their mothers and grandmothers, African-American and white women joined the local battles for civil and equal rights and continued to make Atlanta—and America—live up to the promise of democracy.

Women's involvement in athletic and recreational activities also changed dramatically over the years. In the Victorian era, women's active pursuits were limited to "proper" ones, like walking, horseback riding, bicycling, tennis, and croquet. By the early 20th century, the first women participated in the Olympic Games and thousands played team sports through school and extracurricular programs. Their growing passion for sports led them to lobby for equality, which was guaranteed in 1972 under Title IX.

The photographs in this book depict Atlanta women at work and at play from the mid-19th century to the 1970s. In addition to illustrating women's dramatically changing roles during this period, the volume situates these women within both a regional and national context. *Women in Atlanta* uncovers the realities of women's lives as educational, economic, and social opportunities emerged beyond hearth and home. From images of society mavens to seamstresses, from nurses to activists, these photographs bring to light the challenges, successes, struggles, and joys of Atlanta's women.

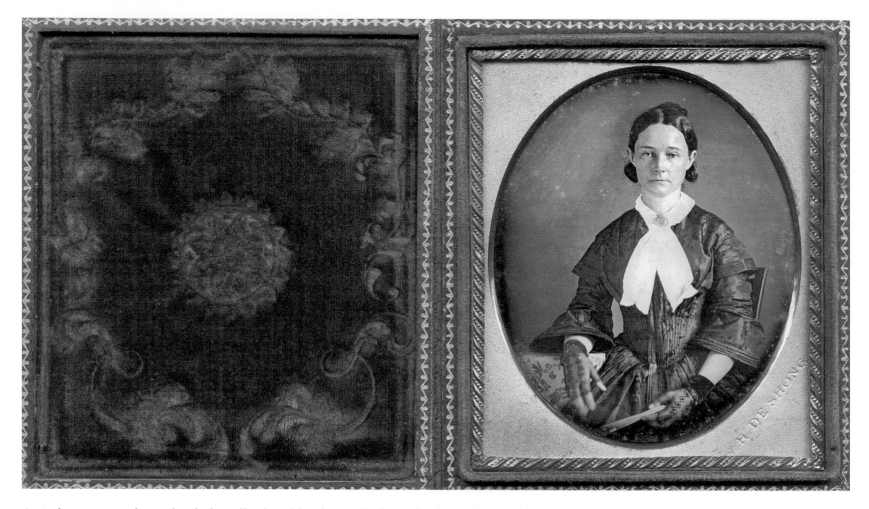

A good portrait may be rendered of no effect by a false choice of color in the dress of the model. The colors which are most luminous to the eye do not always produce the most energetic effects. For instance, red, orange, and yellow are almost without action; green acts but feebly; blue and violet are reproduced very promptly. —*Peterson's Ladies Magazine*, June 1864. *Unidentified subject; sixth-plate daguerreotype; William H. DeShong, photographer; Atlanta, c. 1850.*

ONE

FORGING
PIONEER WOMEN AND LADIES
1837–1865

Atlanta was founded as a small southeastern railroad hub in 1837. Significant numbers of whites began settling in north Georgia only after the passage of the Indian Removal Act of 1830. Settlers were primarily of Irish descent, along with ethnic Germans and Jews, many of whom relocated from other Southern states. An 1840 census reported 10,466 residents in Dekalb County (where Atlanta was located) including 1,052 enslaved women of color and 4,142 free white women. Originally called Terminus, the town was named Marthasville in 1845 and incorporated as Atlanta two years later.

In the mid-19th century, the Southern feminine ideal was the white, upper-class lady, whose manners and refinement white women of all classes were supposed to emulate. Free black women often subscribed to these standards of demeanor and appearance as well. Southern society's expectations for women guided their behavior, influenced their appearance, and shaped their dreams. White women were associated with home and private life, while white men were linked with business and public life. According to this idealized separation of spheres, wives, sisters, and daughters were believed to be above the vulgarities of the masculine realm. Girls were expected to be modest, restrained, polite,

and otherwise "ladylike." Typically, they learned to stitch, cook, manage a household, and perhaps read and play music. When a suitable match was made, a Southern lady joined her mate already trained to do her household duties.

Although white women of all social levels and free black women often strived for the Southern ideal of womanhood, the majority of Atlanta women enjoyed few of the privileges and little of the protection offered to the elite. Most early Atlanta women, whether enslaved or free, white or black, worked under brutal pioneering conditions. Enslaved women generally endured the harshest circumstances and abuses. Because photography was in its infancy in the 1840s through the 1860s, limited documentation is available to study the fullness and scope of these women's lives. The images that survive are typically portraits for which women dressed with care. As a result, they do not usually depict women at work or leisure but instead serve as studied examples of femininity.

Despite their great distance from urban centers, many women on the frontier were familiar with the latest fashions and followed them to the extent their means allowed. Whether or not one could afford new fabrics and trimmings, it was common

to remake a dress to stay up-to-date. The event and time of day guided a woman in her selection of clothing and accessories, while age and status also affected her choices. For instance, a white dress was considered appropriate for "maidens," while older women and those in mourning often preferred black. Married women typically wore caps at home, hats for active pursuits, and bonnets on social occasions. Wide, shallow necklines and short sleeves could be worn by girls and, for evening, by women.

During the Civil War, life became increasingly difficult for Southern women, many of whom adopted new roles to support their families. In Atlanta, elite white women gained a voice in the public sphere by rallying for the Confederacy and even filling roles previously held by men. For poor white women, feeding their families was a daily challenge. In April 1863, *Harper's Weekly* reported five bread riots, including one in Atlanta, where "all entreaties could not deter the women from their riotous intentions until their demands were satisfied." The report stated that all of the riots were instigated by famished women, tormented by their children's cries for food and left with no male providers. Already accustomed to hard living, the

national crisis gave slave women opportunities to wage their own war. With their children, many slave women fled plantations and bondage, attempted to reunite their families, or followed Union troops in search of food and protection.

Despite the hardships that accompanied the Civil War, Confederate women took great care with their appearance to help boost men's morale and retain a sense of normalcy. As resources continued to dwindle, women revived the crafts of previous generations, learning to spin and weave, which had been the province of the rural and poor. Dresses of homespun cotton became marks of patriotism.

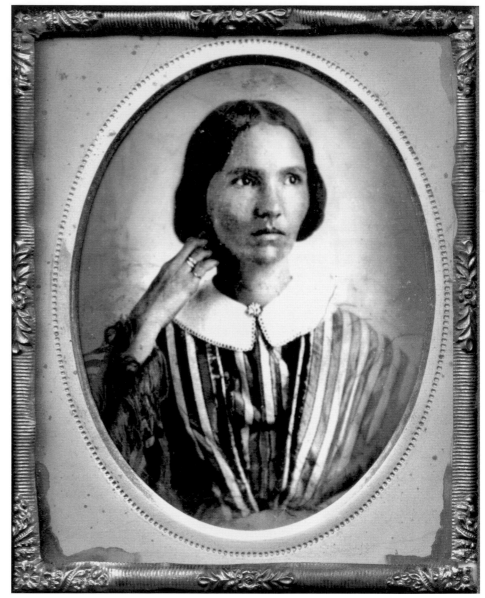

Sarah Elizabeth Lumpkin Haynes married Dr. Benjamin F. Bomar in 1840. The couple moved to Atlanta in 1847, and Dr. Bomar was elected Atlanta's second mayor in 1849. Sarah's role as the wife of a prominent Atlanta citizen required her to behave and dress like a true Southern lady. By 1850 at the age of 24, Sarah Bomar had four children: Thomas (age 7), Amaryllis (5), William (2), and Benjamin (5 months). Her husband was eight years her senior. *Sarah Elizabeth Lumpkin Haynes (Mrs. Benjamin F. Bomar); ninth-plate tintype; unattributed; Atlanta, c. 1855.*

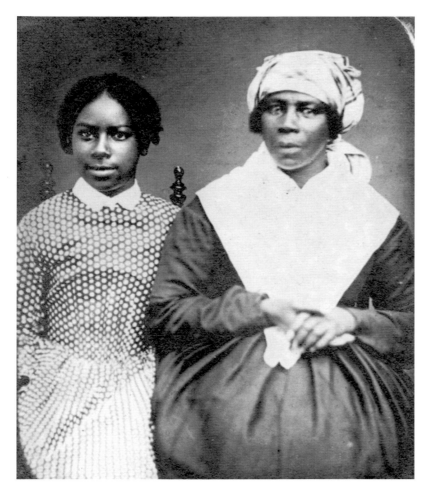

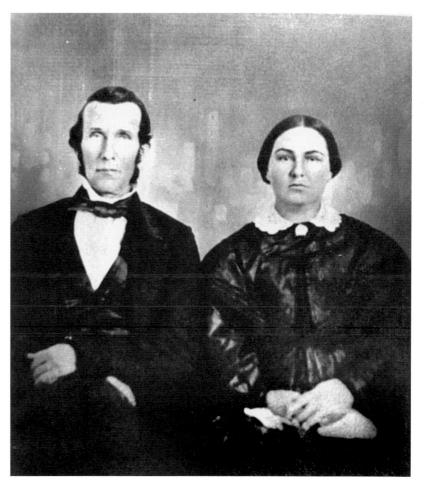

These women worked for the Telfairs, a prominent Savannah family. Judy Telfair Jackson was a cook, and her granddaughter Lavinia was Mary Telfair's maid. Both are well dressed, as was typical for slaves working in the main house. The teenager is lightly corseted, while her grandmother wears the large kerchief and turban headwrap often associated with older enslaved women. *Lavinia and Judy Telfair Jackson; tintype (from an original daguerreotype, c. 1849); unattributed; Savannah, Georgia. (Courtesy of the Georgia Historical Society.)*

Atlanta pioneers Thomas W. and Temperance Peacock Connally had 16 children. Childbearing and -rearing responsibilities often consumed the lives of antebellum women. *Thomas W. and Temperance Peacock Connally; sixth-plate tintype; unattributed; c. 1855.*

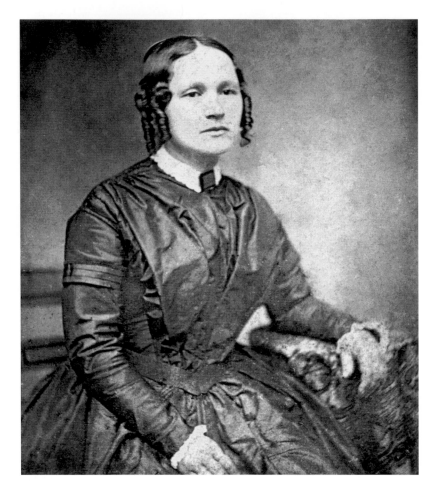

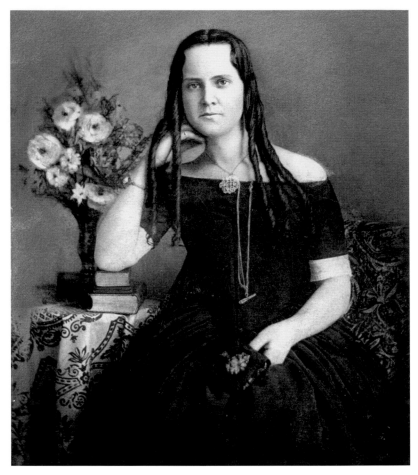

Sarah Moses Alexander of Charleston, South Carolina, moved with her husband, Aaron, to Atlanta in 1848. He established a drug business in the city, and she founded its first Jewish sabbath school. Sarah Alexander was likely admired for her restraint in trimming her dress simply, with only covered buttons and bands of satin fabric or ribbon. Readers of the July 1866 *Godey's Lady's Book* were counseled to be discreet in finishing their garments: "A dress loaded with trimmings makes a dowdy of its wearer. The real lady subordinates her attire to her own style, character, and condition." *Sarah Moses Alexander; cabinet card (from an original daguerreotype, c. 1846); Edwards and Sons, photographer; Atlanta.*

In the 1840s, women sometimes wore as many as six starched petticoats under their dresses to create the famous bell-shaped silhouette. When cage crinolines were introduced in the 1850s, women eagerly adopted them because they provided the desirable shape without the bulk, weight, and warmth of numerous petticoats. Delia Henry Nichols was the vice president of the Ladies' Hospital Aid Society in Atlanta during the Civil War. Her husband, then Capt. G.J. Foreacre, was wounded at the Battle of Bull Run. In records from the Pioneer Woman's Society in Atlanta, she recalled visiting the "only fashionable ice cream and cake parlor of the day, where the belles and beaux of the past found the most delightful recreation partaking of these dainties." Other activities for elite women were visits to mineral springs, cemeteries, and annual revivals—all with escorts. *Delia Henry Nichols (Mrs. G.J. Foreacre); print (from an original daguerreotype, c. 1849); unattributed.*

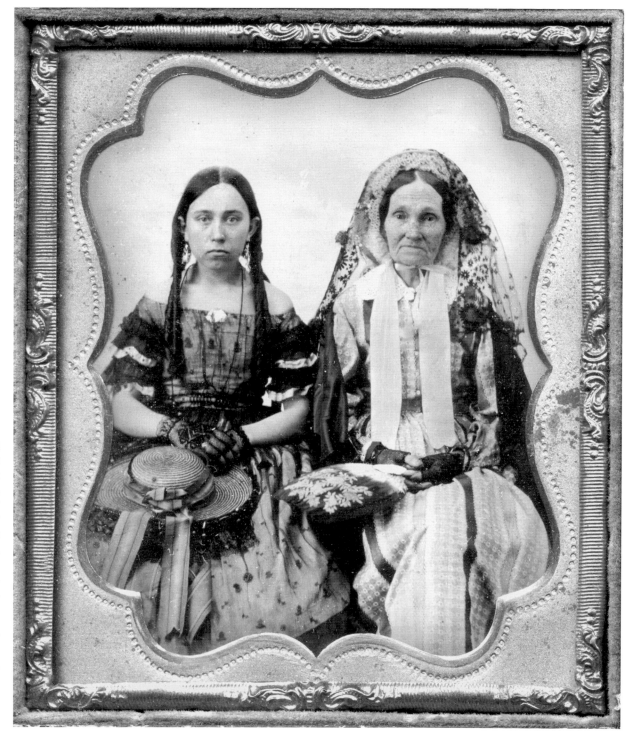

When adolescent Eveline King Reynolds posed for this image, she was outgrowing the girlish styles that featured shallow, wide necklines and slightly raised waistlines and was ready to adopt floor-length, adult fashions. Her mother's dress was similarly appropriate and up-to-date yet conservative, in keeping with her age and marital status. Both posed with headwear trimmed with striped silk ribbons and black lace mitts. Fingerless gloves, or mitts, were not intended for everyday wear, but were reserved for dinner and party dress. In summer, undersleeves were sometimes omitted and long mitts were worn to dress the lower arms. *Eveline King Reynolds with Elizabeth Reynolds (Mrs. John A. Reynolds); quarter-plate ambrotype; unattributed; c. 1855.*

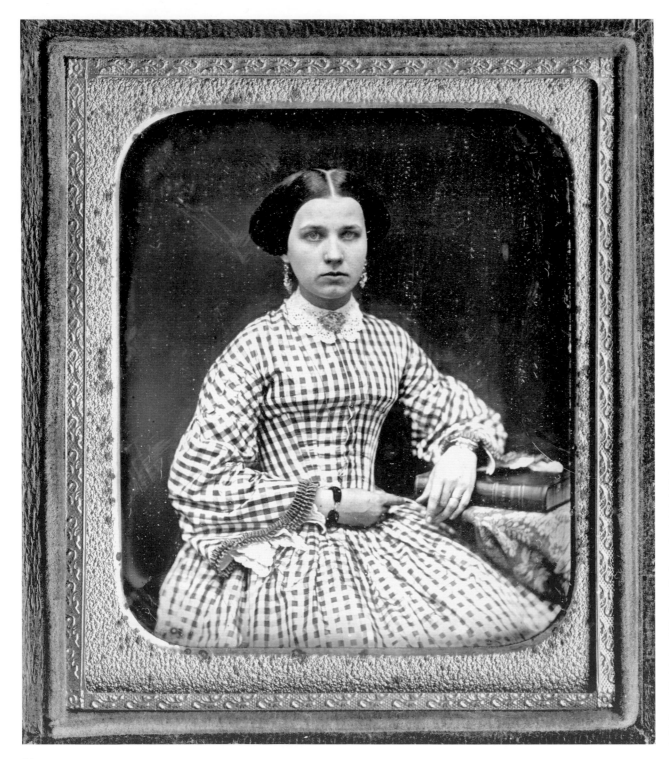

From the glovelike fit of her dress to her stylish coiffure and accessories, it seems likely that Sarah Winifred Peck Lawshé was a trendsetter in Atlanta's early years. In the mid-1800s, people exchanged locks of hair as keepsakes, and women saved and collected hair for use in jewelry and decorative wreaths that were hung on the wall. Sarah's decision to wear hairwork bracelets for her portrait reveals the popularity of hair jewelry. Her husband opened a jewelry store on Whitehall Street in the late 1850s. *Sarah Winifred Peck Lawshé (Mrs. Er Lawshé); sixth-plate daguerreotype; unattributed; c. 1854.*

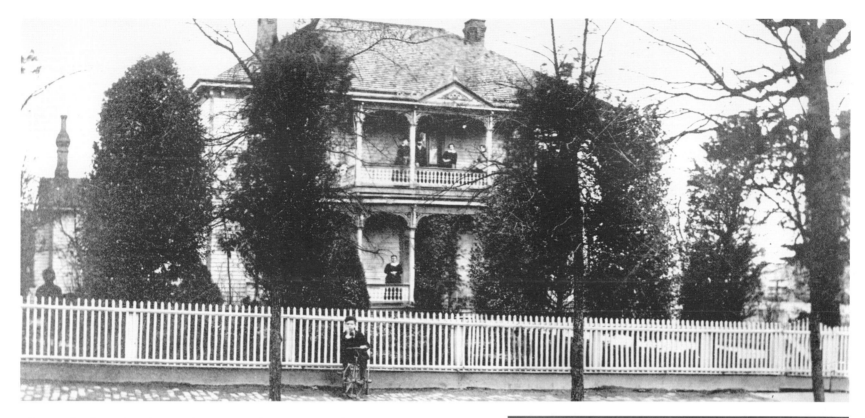

The Lawshés built their fine Peachtree Street home in 1859. The ornamental trees and fencing in this later image demonstrate the family's wealth, as does the servant at left. *The Lawshé home; print (from an original albumen print, c. 1885); unattributed; Atlanta.*

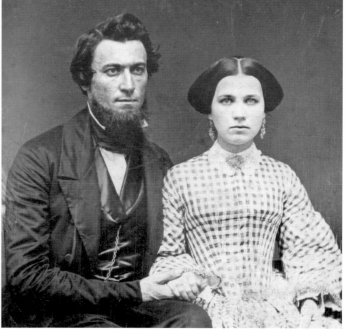

Married on August 8, 1854, Er and Sarah Lawshé took refuge in Augusta, Georgia, during the Civil War. *The Atlanta Constitution* later published his wartime reminiscences. *Er and Sarah Lawshé; print (from an original daguerreotype, c. 1854); unattributed.*

Gov. Wilson Lumpkin's daughter Martha inspired Atlanta's previous name of Marthasville. Here, a choppy haircut suggests a recent illness. In her journal, Lumpkin recorded a thought that applied both to fashion and gender roles in her day: "Women should be early accustomed to submit themselves to a certain restraint for on their power willingly to accommodate themselves to the wishes of others depends their happiness in life." *Martha Lumpkin; ninth-plate tintype; unattributed; c. 1855.*

Dressed in simple clothing, this young couple illustrates typical antebellum dress. Most Atlantans had neither power nor wealth prior to the war. *Unidentified subjects; sixth-plate ambrotypes; unattributed; c. 1860.*

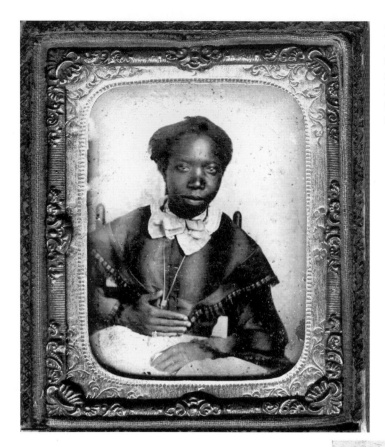

People sitting for portraits usually showed off personal objects, including symbols of wealth or learning. This sitter, however, appears to shield an object and may be concealing a slave hire badge. These badges were worn by slaves when they were hired out by their masters to work for someone else—for which the owner received most of the pay. If hired-out slaves were found without the proper badge, they were arrested, and their masters were forced to pay fines for their return. *Unidentified subject; ninth-plate tintype; unattributed; c. 1860.*

This runaway-slave advertisement offers a glimpse into the world of an enslaved African-American woman. Martha, age 17, is described as quick-spoken, intelligent, and well-dressed. She outsmarted her master, J.L. Hamilton of Stone Mountain, and made her way by train to Atlanta. *Runaway advertisement*, Daily Intelligencer; *Atlanta, November 5, 1863.*

$100 Reward.

RANAWAY from my house at Stone Mountain, on the 10th day of October, my Negro Girl, MARTHA, a mulatto, with straight black hair, and black eyes; good countenance, quick spoken, about 17 years of age, intelligent, and well dressed. I believe she was decoyed away through the influence of a White Man, by negroes who visited her that evening. She left on the Georgia Railroad train to Atlanta. I will give the above reward for her apprehension so that I can get her, or $200 for the proof to convict the thief and secure her in any safe jail.

Address, J. L. HAMILTON, Atlanta.
nov4-110t or Stone Mountain, Ga.

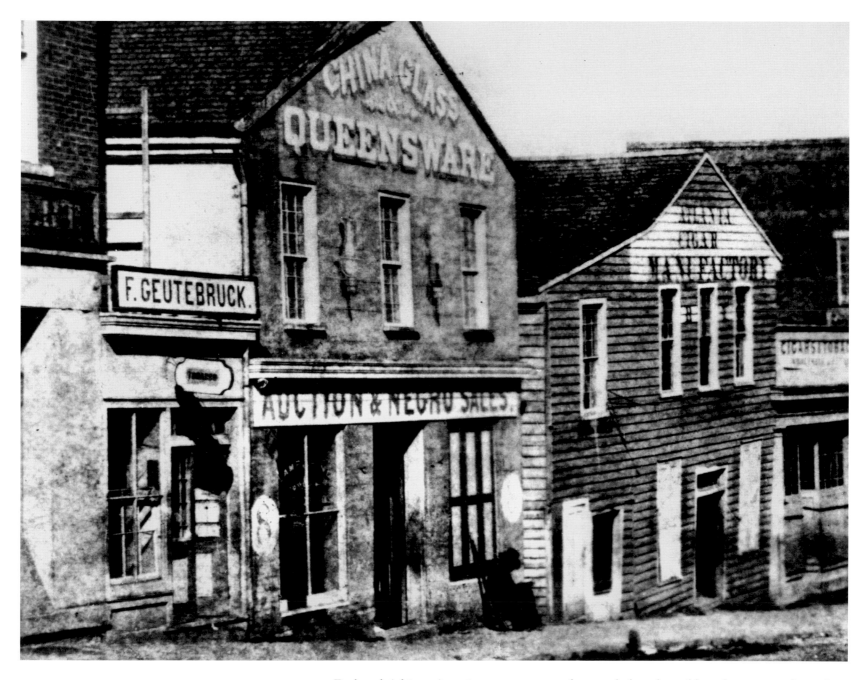

Enslaved African-American women were frequently bought, sold, and torn away from their partners and children. The Crawford, Frazer, and Company slave market was located at No. 8 Whitehall Street between Alabama and Hunter Streets. *Crawford, Frazer, and Company; print (from an original albumen print, 1864); George N. Barnard, photographer; Atlanta.*

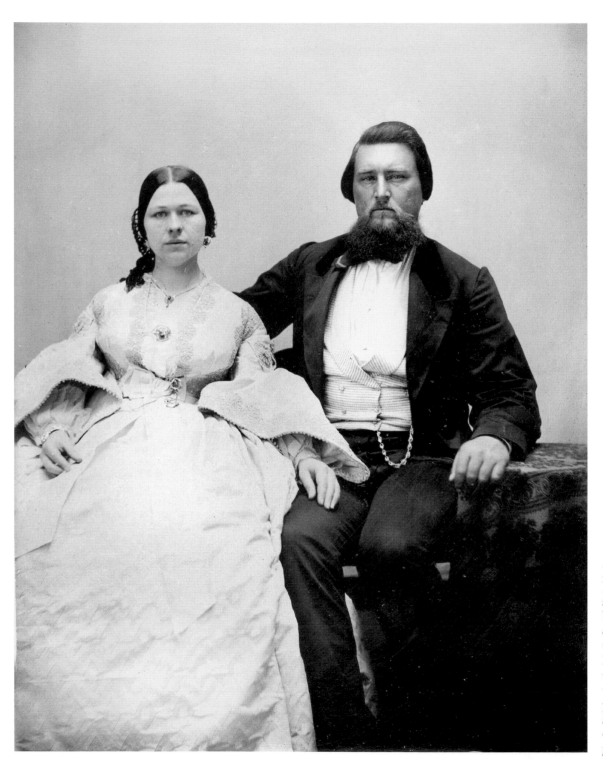

In popular books and movies, the hoop-skirted ladies of the mid-1800s stroll demurely in snug bodices, shrouded head-to-toe by their bonnets, wraps, and tight shoes. Even the size of their stylish, bell-shaped skirts seems to keep them at arm's length from the rest of the world. In effect, Southern white women were placed upon pedestals, to safeguard their virtue and to distance them from the vulgarities of the public sphere. *Nancy Reynolds Maddox with her husband, Col. Robert Flournoy Maddox; whole-plate ambrotype; William H. DeShong, photographer; Atlanta, May 17, 1861.*

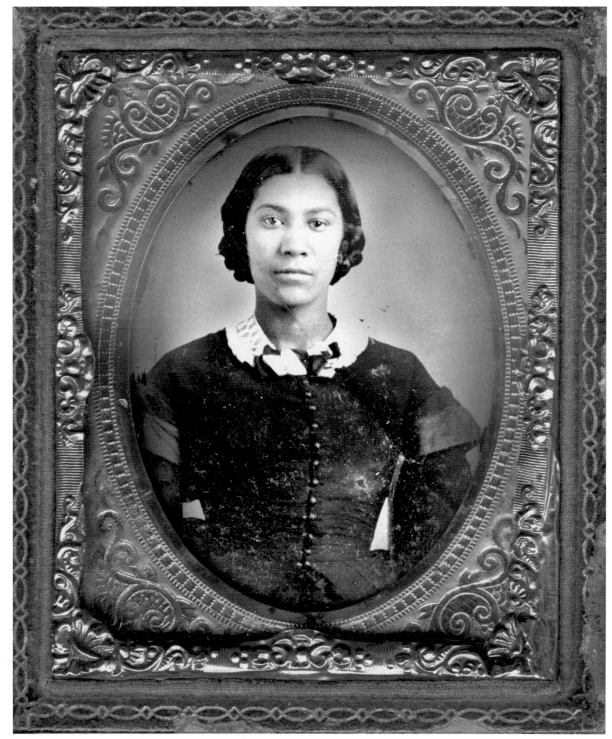

The impeccable dress of Nancy Cunningham Luckie, a free black woman, shows no discernable difference from ensembles typically worn by her white counterparts. The sheen of her stylish dress suggests it is wool or a wool and silk blend; the snug fit indicates the hand of a skilled seamstress; and the silhouette reveals a new corset shape that tapered the rib cage to a small waist. The round collar, necktie, sleeves, pleated skirt, and hairstyle were all stylish in the early 1860s. Her husband, Solomon Luckie, ran a barbershop and bathing salon at the Atlanta Hotel. He died in August 1864 soon after being hit by a shell fragment on a city street during the siege of Atlanta. *Nancy Cunningham Luckie (Mrs. Solomon Luckie); ninth-plate ambrotype; unattributed; c. 1862.*

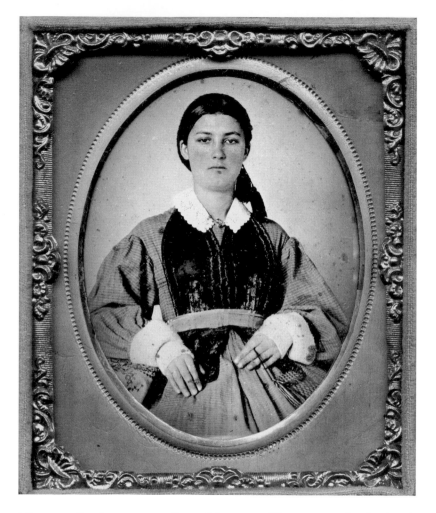

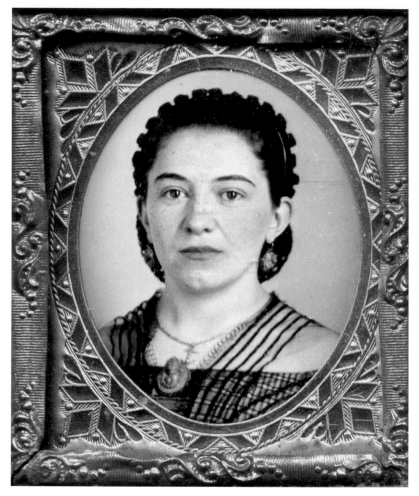

Like many Southern women, Laura Thompson Chapman sent her husband, George, off to war with a keepsake. Laura made a Bible marker inscribed with "I Love Thee," which he carried with him. He was severely wounded in May 1864 at the Battle of the Wilderness. *Laura Thompson Chapman (Mrs. George Reed Chapman); ninth-plate ambrotype; unattributed; c. 1860.*

Columbus W. Motes of Athens, Georgia, carried this cased image of his future wife while serving in the Civil War. His love, Emily White, tied a piece of her chestnut hair with a blue ribbon and tucked it inside the case. Motes, one of Atlanta's premier postbellum photographers, married Emily White in Clarke County, Georgia, on June 14, 1866. *Emily White (Mrs. Columbus W. Motes); ninth-plate ambrotype; unattributed; c. 1862.*

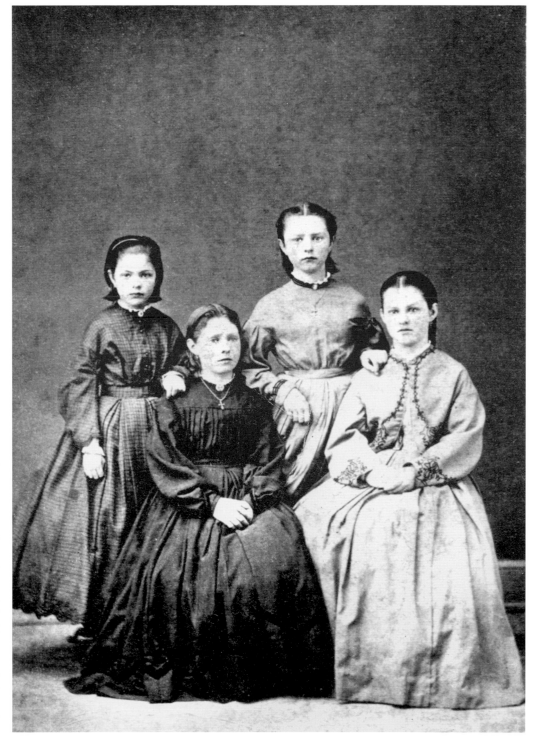

Of the four Rawson girls, the eldest, Mary, kept a diary for much of September 1864 documenting the evacuation of Atlanta: "This day witnesses the downfall of the hopes of the citizens of Atlanta. Today Gen. Hood commenced his evacuation of our city." The garibaldi-style suit with braid trim worn by Mary Rawson was fashionable for young ladies during the war years. Her sister Laura was also grown-up enough to wear a floor-length dress, while Carrie and Emma both had short, girlish hairstyles. The sisters all wore the indispensable hoop skirt.

In 1862, war refugees Lizzie Hardin, her mother, and her sister gave up their fashionable clothing to pass unnoticed from Chattanooga to Atlanta. Once safely in Atlanta, they sought to reestablish their routines and their wardrobes: "The time was very dull but we met some friends and between reading and sleeping and a desperate hunt for hoops in which we were engaged we managed to exist very comfortably. The hoops we had finally to send to Augusta for, that being the nearest point where such articles of luxury could be obtained. I hailed mine with joy and determined that no pursuit, however hot, should ever make me drop them." *Pictured from left to right: Carrie, Laura, Emma, and Mary Rawson; print (from an original carte-de-visite, c. 1864); unattributed.*

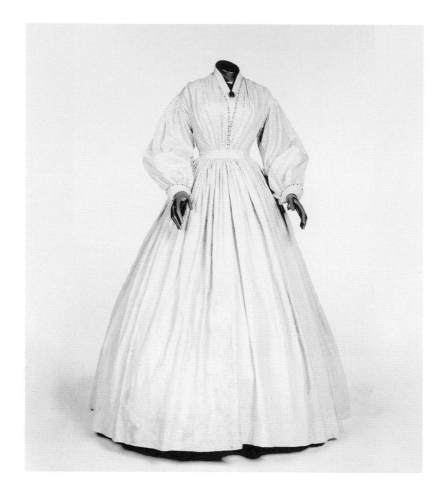

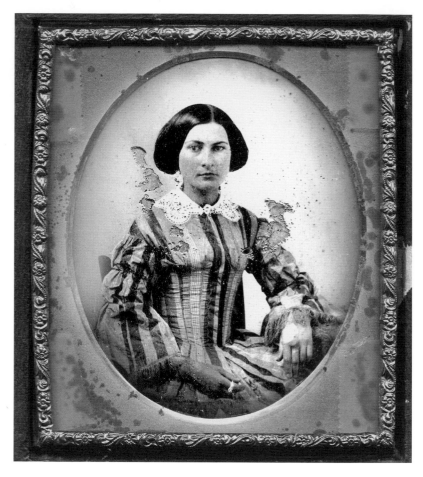

Most women in the 1800s gradually dressed more conservatively as they aged. This open neckline was fashionable in the 1850s, but the chemisettes worn beneath it were depicted in women's magazines well into the following decade. Ann Margaret Magill Smith and her daughters, Elizabeth and Helen, did a good deal of knitting and sewing to outfit William and Archibald Smith Jr., who served in the Confederate Army.

Upon receiving a request from Archie for an overcoat, Mrs. Smith wrote to Willie with questions about a similar coat she had apparently made for him. The letter included specific tailoring questions "about the pockets of your overcoat. I cannot remember where & how they were cut," Mrs. Smith wrote. "Do let me know as soon as convenient whether they are cut as sack pockets usually are or whether more long ways of the coat & how far from the arm hole, also length of strap behind & how far below the arm hole measuring along the seam where it is put in. If it has only breast pockets measure the distance from the collar." *Printed cotton day dress, presumably made and worn by Ann Margaret Magill Smith (Mrs. Archibald Smith); Roswell, Georgia, c. 1860. (Atlanta History Center collection; Jonathan Hollada, photographer.)*

A pair of images of Martha Ann Jincie Powell reflects the hardships endured by Atlanta women during the Civil War. She was the daughter of Dr. Chapmon Powell, a pioneer of the Atlanta region, who served in the Georgia legislature in 1836. Powell conducted his medical practice from the family's log cabin located near the present-day intersection of Clairmont and North Decatur Roads. In 1850, the Powells moved to Atlanta and built a house at the corner of Peachtree and Ellis Streets. *Martha Ann Jincie Powell (Mrs. Fielding Powell); sixth-plate ambrotype; unattributed; c. 1855.*

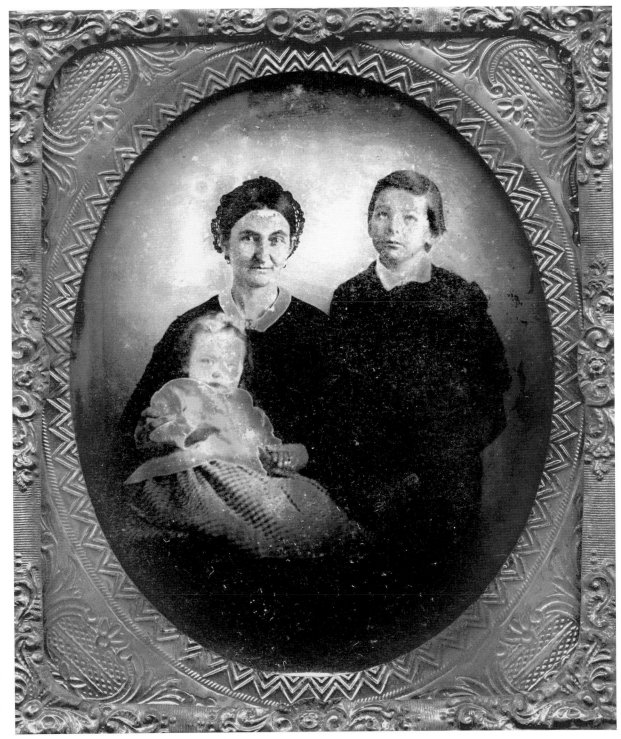

Martha Ann Jincie Powell married her distant cousin, Dr. Fielding Travis Powell, and they had several children. Martha and her family remained in Atlanta until July 1864, when they fled to Newton County. "My husband and I took our children in our arms," she recalled, "and left the house as General Sherman's army began shelling the town. I shall never forget that night of terror as we were escaping." *Martha Ann Jincie Powell (Mrs. Fielding Powell) with Ella May and Frank Powell; sixth-plate ambrotype; unattributed; c. 1864.*

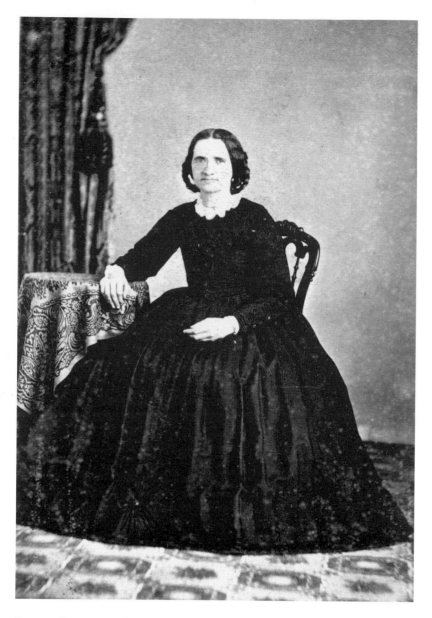

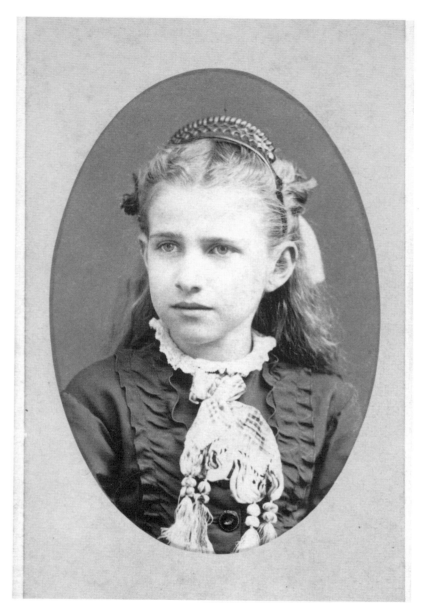

Born in Germany on May 14, 1827, Sophia Wilhelmina Steinbeck immigrated to the United States in 1849, traveling on the same ship as her future husband, August Wilhelm Kuhns. They married on July 31, 1851, in Mobile, Alabama, and later moved to Atlanta, where August became a pioneer photographer in the region using an Americanized version of his name. Sons William Theodore and Julius Henry followed suit; the family photography business thrived for decades. *Sophia Steinbeck Kuhns (Mrs. William A. Kuhns); carte-de-visite; William A. Kuhns, photographer; Atlanta, c. 1870.*

Born in 1865, Isabella Elizabeth Kuhns was one of eight children of Sophia and William A. Kuhns. Her girlish face and grown-up dress suggest that she was about 14 when she sat for this portrait. Her father and brothers photographed her regularly; she worked as a photograph retoucher and salesperson in the family's studio showroom. Kuhns sang in the choir and was very active in women's groups at Inman Park Methodist Church. She never married. *Isabella Elizabeth Kuhns; carte-de-visite; William A. Kuhns, photographer; Atlanta, c. 1879.*

REBUILDING
RESILIENT AND "FREE" WOMEN
1866–1879

In 1866, Atlanta's population surpassed 20,000, slightly more than half of whom were white; by the end of the 1870s, the city's population nearly doubled to 37,000. No longer a frontier town, it was now a thriving city. Emerging from the Civil War as a commercial hub, Atlanta drew opportunity-seeking whites and blacks from throughout the rural South and became the state capital in 1868.

Beyond the rebuilding of homes and businesses, the postwar years witnessed the tumultuous and wrenching shift from slavery to freedom for African Americans and the subsequent renegotiation of racial norms. Beginning in March 1867, the United States Congress passed a series of Reconstruction Acts calling for the enfranchisement of African-American men. In 1875, the Civil Rights Act was approved by Congress, guaranteeing equal rights to African Americans in public accommodations and allowing black men to serve on juries. This act was ruled unconstitutional by the United States Supreme Court in 1883 on the grounds that the Reconstruction Amendments did not extend into the area of public accommodations. In 1896, the Supreme Court upheld separate but equal public facilities for blacks in *Plessy v. Ferguson*.

Despite racial violence against black voters,

Georgia passed a postbellum constitution in 1868. However, Reconstruction efforts in Atlanta were short-lived. By 1877, a new state constitution effectively stymied African Americans' attempts to gain legal equality. Frustrated with discrimination, poverty, racism, and violence, large numbers of African-American Southerners emigrated to the West in 1879.

During this era, the lady or Southern belle remained the feminine ideal, yet white women's wartime experiences—working in hospitals, sewing uniforms, and reading to soldiers—had whetted their appetites for life beyond the domestic sphere. Women in the city organized their first philanthropies, closely aligned with churches. The Women's Missionary and Benevolent Society of the Second Baptist Church, formed in 1873, was an early group, but gradually all congregations—Protestant and Jewish, black and white—found women involved in philanthropic work. The city's first Jewish congregation, the Hebrew Benevolent Congregation, was established in 1867. One of the oldest women's organizations in Atlanta, the Atlanta Ladies Memorial Association, was founded in 1866 to honor Confederate veterans. Atlanta University, the first all-black graduate school in the country,

received its charter in 1867, and the Freedmen's Aid Society of the Methodist Episcopal Church established Atlanta's Clark College in 1869.

Although they began moving tentatively away from the domestic sphere, the women of postwar Atlanta continued to be defined by their husbands and children. The tremendous losses suffered by Confederate forces meant that many white women were widowed and became heads of households, adding further burdens to motherhood. Census records from 1870 highlight the most common vocations for women in Atlanta, including laundress, milliner, domestic servant, cook, boardinghouse keeper, and seamstress. The records also show women caring for three to ten children as part of the traditional role of "keeping house." Nonetheless, women gained new levels of independence, often owning and selling property and working for wages.

Images from the late 1860s through the 1870s also show the democratization of photography. The carte-de-visite, a small albumen print mounted on a 2 1/2-by-4 inch card, could be printed in multiples. This popular new medium was relatively affordable and easily exchanged, allowing many people to assemble albums of family and friends' pictures.

The larger format cabinet card was also popular at this time and was used for both landscapes and portraitures. Even though new affordable forms of photography became available, the surviving record, composed primarily of posed studio portraits, fails to depict the realities of working-class life.

Another exciting new technology was the sewing machine, which was a fixture in many households by 1860. While men's ready-to-wear clothing was available in the mid-1800s, dressmaking remained entirely customized. Women did most of the family's sewing, although it was common to hire a professional seamstress to cut and fit a dress bodice, which had to lay smooth over a corseted figure. By the end of the decade, pattern drafting systems were available to help the home sewer. As in previous decades, women were aware of trends in fashion and followed them to the extent possible. Images from this era reflect the personal taste of the subjects as well as their class and stage in life.

In a girlhood diary, Carrie Berry described her daily activities, including the tasks that helped her acquire the skills necessary to run a household. Whether knitting her first pair of stockings, ironing, or sewing clothes for family members and her dolls, young Carrie was training for her future. She was 10 years old when Federal troops approached Atlanta in 1864. While many citizens fled, the Berry family remained in the city. A diary entry reveals the reason why: "Wed. Dec. 7 I had a little sister this morning at eight o'clock and Mama gave her to me. I think it's very pretty. I had to cook breakfast and dinner and supper." Carrie Berry studied with various teachers during the Civil War when schools closed and citizens left town. In time, schools reopened and city life gradually returned to normal. *Carrie Berry; print (from an original carte-de-visite, c. 1870); unattributed.*

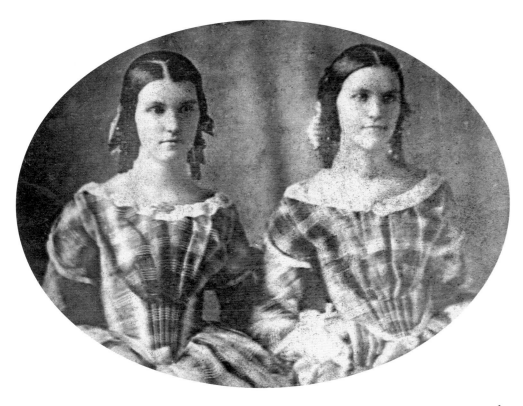

With their matching dresses and intertwined hands, the King sisters seem to project the special bond of twins. *Martha and Mary King (Mrs. Thomas S. Reynolds); print (from an original daguerreotype, c. 1843); unattributed.*

The family was a highly valued social institution in the 19th century, and most couples hoped to have numerous children. Given the high infant mortality rate, large families meant that couples commonly lost at least one child. Mary King married Thomas Stevens Reynolds, a book and newspaper printer in Atlanta. They had five children, including twins Charles and John. On May 10, 1864, Thomas wrote to his sister with sad news of John (not yet three) and its effect on Mary: "Dear Eveline, Tell mother that our dear little Johnny is no more with us. He died last night at 11 o'clock. . . . If you remember when Marcellus died you can imagine precisely how Johnny was affected. My sweet little Johnny I hope is now an angel. May we all so live that we shall meet him again. Mary is not well—nothing serious I hope. . . . Affectionately, Thomas." *Mary King Reynolds (Mrs. Thomas S. Reynolds); carte-de-visite; Columbus W. Motes, photographer; Atlanta, c. 1878.*

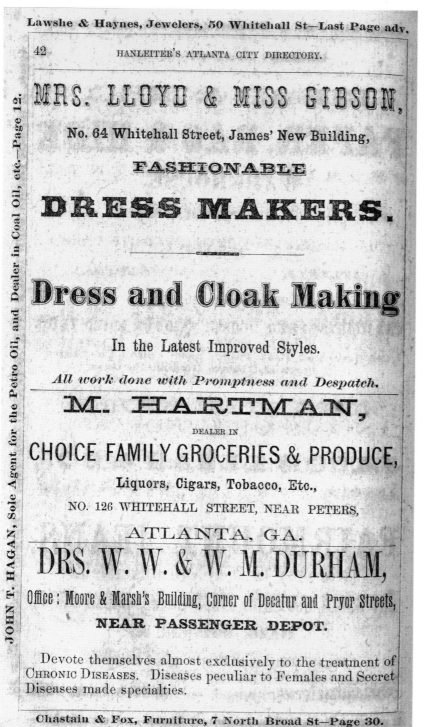

42 HANLEITER'S ATLANTA CITY DIRECTORY.

MRS. LLOYD & MISS GIBSON,

No. 64 Whitehall Street, James' New Building,

FASHIONABLE

DRESS MAKERS.

Dress and Cloak Making

In the Latest Improved Styles.

All work done with Promptness and Despatch.

M. HARTMAN,

DEALER IN

CHOICE FAMILY GROCERIES & PRODUCE,

Liquors, Cigars, Tobacco, Etc.,

NO. 126 WHITEHALL STREET, NEAR PETERS,

ATLANTA, GA.

DRS. W. W. & W. M. DURHAM,

Office: Moore & Marsh's Building, Corner of Decatur and Pryor Streets,

NEAR PASSENGER DEPOT.

Devote themselves almost exclusively to the treatment of CHRONIC DISEASES. Diseases peculiar to Females and Secret Diseases made specialties.

After the Civil War, many women found themselves without husbands, fathers, or brothers to support them. As in previous decades, Atlanta women—black and white—worked hard to make good lives for themselves and their families. Most women sewed the majority of their families' clothes, but they commonly hired dressmakers to cut and fit fashionable garments. In this 1879 advertisement, Mrs. Lloyd and Miss Gibson promoted their knowledge and professionalism along with their dressmaking skills. *Advertisement, Hanleiter's Atlanta City Directory, 1870.*

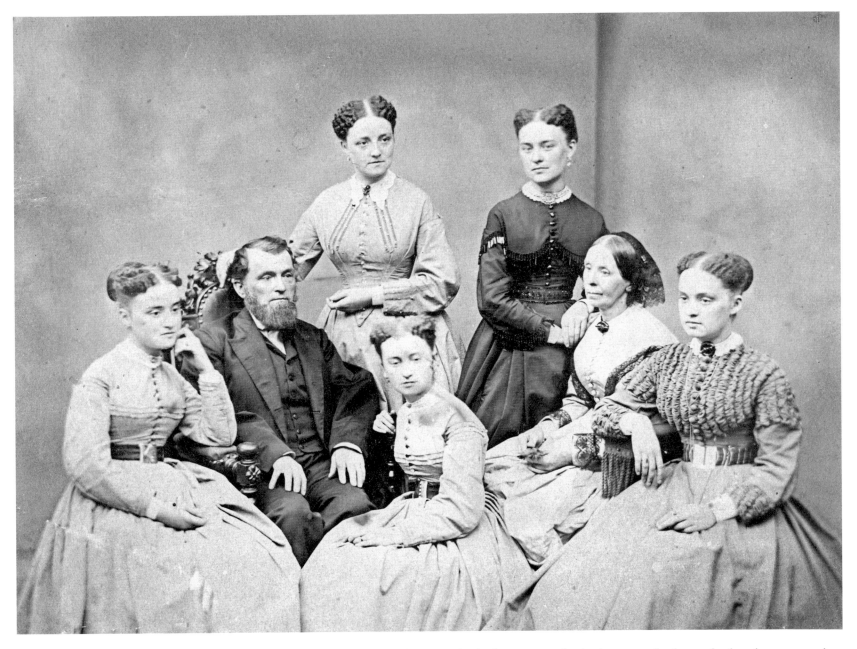

Whether working inside the home, outside the home, or both, motherhood was central to most women's identity in Victorian society. This image shows a couple with five well-dressed daughters of marriageable age. *Unidentified family; print (from an original albumen print, c. 1870); unattributed.*

Ellen Vail Woodward probably designed and applied the elaborate braid trim on the neat day dress she wore for this portrait. Ladies' magazines of the era offered ideas, instructions, and patterns to help women create personalized garments and accessories. Woodward met her future husband during the Civil War in Atlanta when she was a refugee from Hilton Head, South Carolina. *Ellen Vail Woodward (Mrs. Francis Hodgson Orme); carte-de-visite; F. Kuhn's, photographer; Atlanta, c. 1867.*

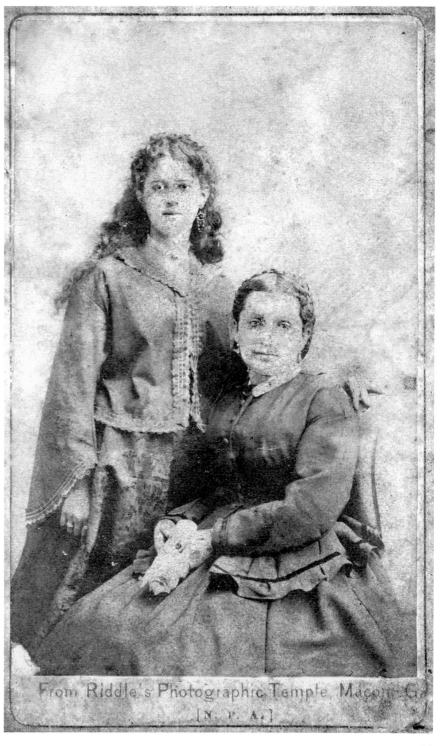

Pictured here with her mother, Lucinda Carhart Long, Annie Eunice Long was born in Macon in 1865. Her father, Jefferson F. Long, was born into slavery and later became a successful tailor. Despite overwhelming odds, Long was elected to fill a vacancy in Congress in 1870, making him Georgia's first African-American congressman. In 1889, Annie Long married prominent black Atlantan Henry A. Rucker. The Ruckers had eight children and purchased a fine home on Piedmont Avenue in the late 1880s. *Annie Eunice Long and her mother, Lucinda Carhart Long; carte-de-visite; Riddle's Photographic Temple; Macon, Georgia, c. 1877.*

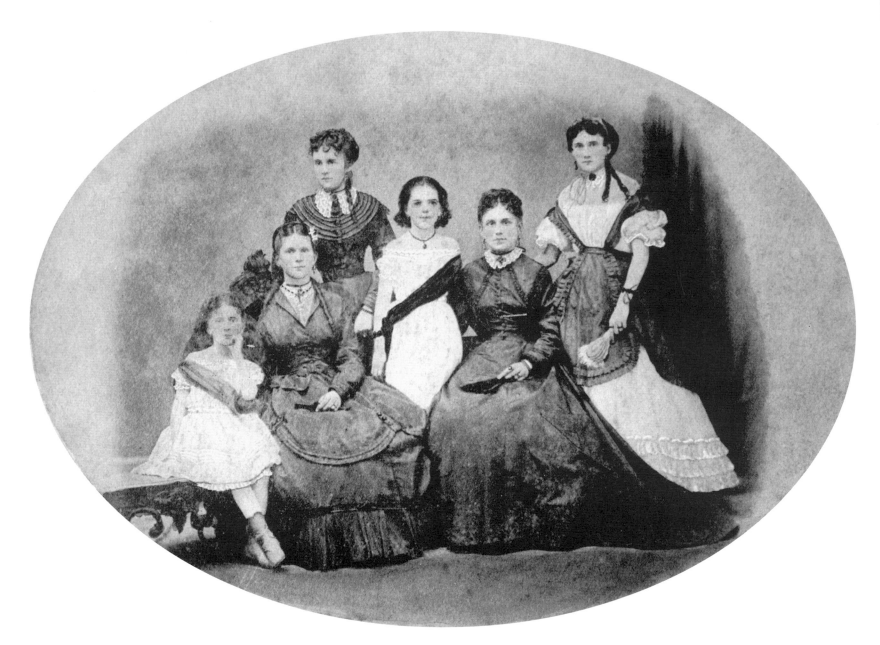

By 1870, only three of the six Lowry sisters were living at home with their parents. The dresses of Leila (about 10 years old), Alice May (about 14), and Julia (about 17) are white, which was considered appropriate for maidens. Their father, William Lowry, founder of the Lowry Bank in Atlanta, was the first president of the Atlanta Chamber of Commerce. His wealth and prominence afforded his wife and daughters a life of privilege. *Pictured from left to right: (standing) Mary, Alice May, and Julia; (sitting) Leila, Fanny, and Virginia Lowry; carte-de-visite, F. Kuhn, photographer; Atlanta, c. 1871.*

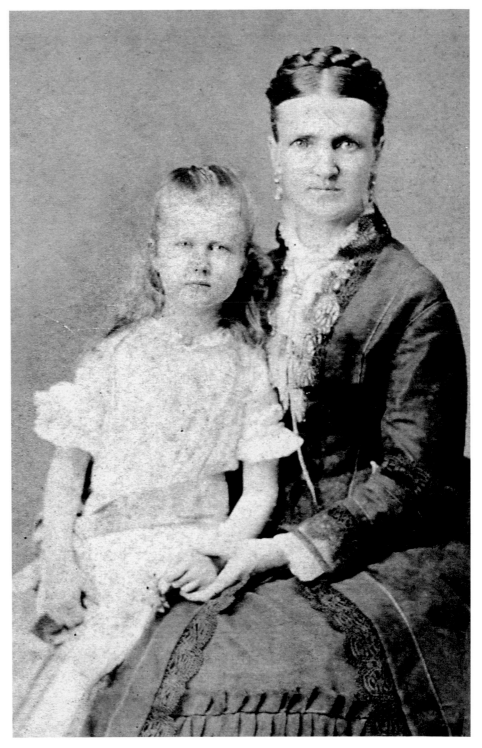

In a family of nine children, Anna May Peters was the youngest daughter. Her mother, Mary Thompson Peters, recalled her marriage in a newspaper interview: "In 1848 Mr. Peters and I were married by the Rev. John S. Wilson, of Decatur, and after a sojourn of six weeks in New York, Philadelphia and Boston we returned to Atlanta. Mr. Peters had purchased . . . the house corner [sic] Mitchell and Forsyth Streets. . . . We lived in that place for thirty-four years, and all my children were born there, but one, who was born and afterwards died on our farm in Gordon county." *Mary Jane Thompson Peters (Mrs. Richard Peters) and her daughter Anna May; carte-de-visite; Smith & Motes, photographer; Atlanta, c. 1874.*

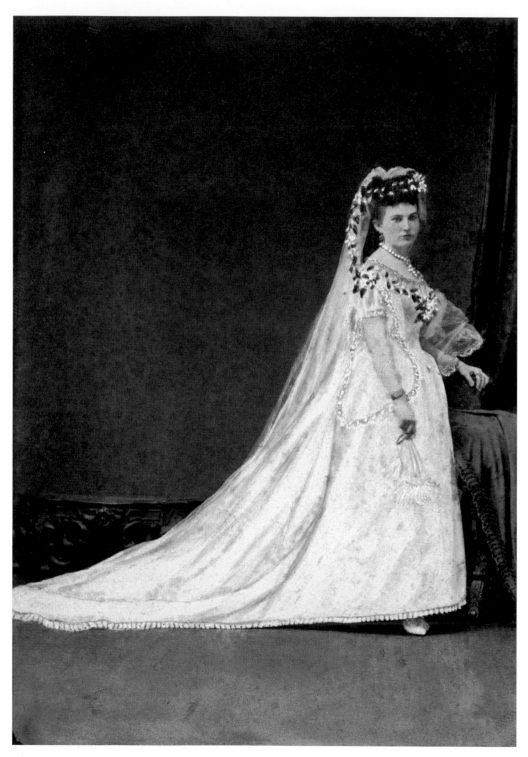

Annie Felder, who married Capt. Lavender R. Ray in Americus, Georgia, on June 20, 1871, had this image made on the couple's wedding trip to Atlanta. The bride's selection of a white gown followed the trend set by Queen Victoria, who chose white for her own wedding in 1840. Felder's bridal ensemble featured a satin, tulle, and lace gown with knife pleating at the hem, an elaborate headdress and veil, and a hand-painted fan. *Annie Felder Ray (Mrs. Lavender R. Ray); cabinet card; Kuhn & Smith, photographer; Atlanta, 1871.*

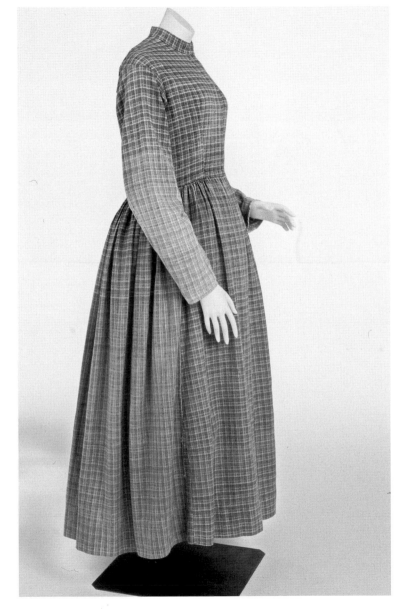

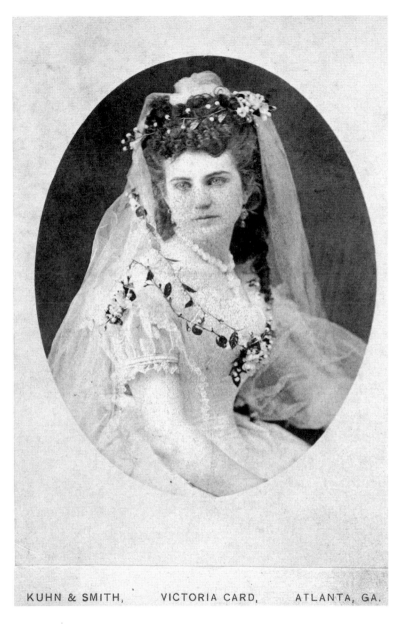

KUHN & SMITH, VICTORIA CARD, ATLANTA, GA.

Dressing during pregnancy has challenged generations of women, many of whom found simple solutions well suited to their needs. The rising waistline at the front of this cotton homespun dress allowed for dramatic change in its wearer's figure. Its shorter hem and wear indicate its use as an everyday or work dress. *Cotton maternity dress, likely made and worn by Mary Catherine Watson Jones; Union County, Georgia, c. 1870. (Atlanta History Center collection; Jonathan Hollada, photographer.)*

Annie Felder married Capt. Lavender R. Ray of Newnan, Georgia. Lavender and Annie Ray had one child, Ruby. *Annie Felder Ray (Mrs. Lavender R. Ray); Victoria card; Kuhn & Smith, photographer; Atlanta, 1871.*

Annie Foster inscribed this carte-de-visite, "To Sophie from her loving friend Annie Foster." *Annie Foster; carte-de-visite; unattributed; presented December 13, 1873.*

This image was "Given to my sweet friends Emma and Sophie." *Unidentified subject; carte-de-visite; Smith & Motes, photographer; Atlanta, presented 1873.*

Cartes-de-visite were relatively affordable and therefore easily exchanged among family and friends. These images show the importance of friendship in the 1870s and the sentimentality attached to such relationships. Lillie Russell presented her picture to Emma, which was inscribed, "Given to my dear friend Emma." *Lillie Russell; carte-de-visite; unattributed; presented May 21, 1872.*

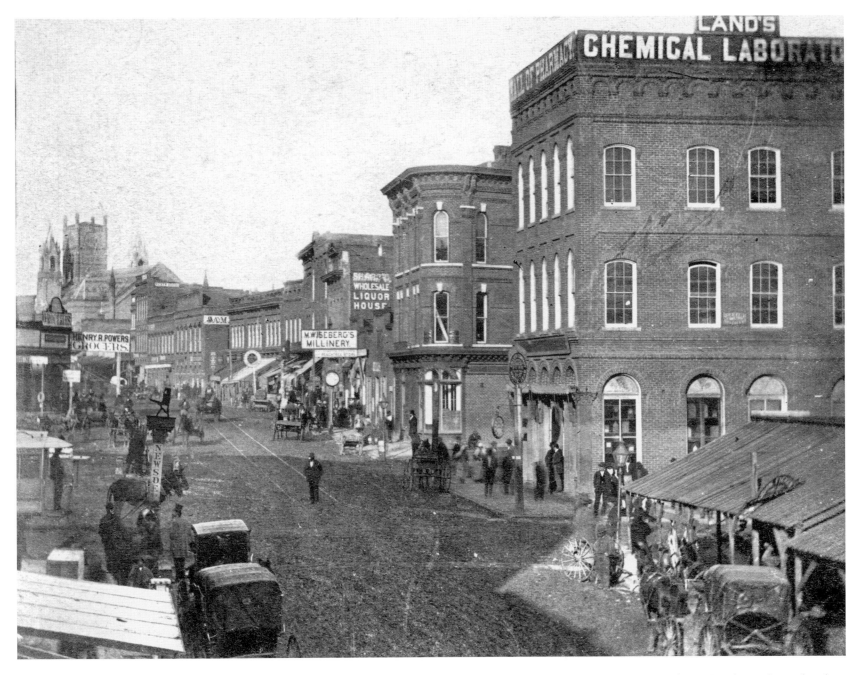

This view looking north from the present-day Five Points area shows Peachtree Street bustling with activity. The downtown shops promised to fulfill locals' and visitors' every desire, offering lodging, groceries, clothing, the latest news, and social opportunities in churches and saloons. *Peachtree Street; stereograph; unattributed; Atlanta, c. 1875.*

Born in 1863, Ada Julia Fraser McDowell was nine years old when she sat for this portrait. In her wide-necked, printed cotton dress, jewelry, and ringlets, she is a studied example of girlhood. *Ada Julia Fraser McDowell; carte-de-visite; Smith & Motes, photographer; Atlanta, July 30, 1872.*

In a similar pose, Nettie Hutchings wore the high-necked dress, earrings, and neat hairstyle of a young lady. The inscription on the back of this image reveals that her life was cut short: "My dear little Nettie died on the 13th of August and buried on the 15th 1881—my lost darling." *Nettie Hutchings; carte-de-visite; Blackshear, photographer; Macon, Georgia, c. 1875.*

This frame house with its picket fence was a typical dwelling for a middle-income family in 1870s Atlanta. The Kuhns family, including Sophia and Isabella, are pictured on the porch of their Luckie Street home. *William A. Kuhns residence, Luckie Street, Atlanta; cabinet card; William A. Kuhns, photographer; c. 1878.*

India Coker, the daughter of a bank president, graduated from Girls High School in 1879. Her fashionable graduation dress featured a bustled and trained skirt adorned with ribbons and lace in the manner of those seen in New York and Paris. Such elaborate fashions were due, in part, to technology, as the April 1870 issue of *The Ladies' Friend* revealed: "The sewing machine, like a magician out of fairyland, turns off yards upon yards of flouncing, and ruffling, and fluting, and furbelows generally, and the ladies put them all on, restrained only by their inches in height; so that at present it really seems that nothing was gained by this beneficial invention." *India Coker; print (from a cabinet card, 1879); unattributed; Atlanta.*

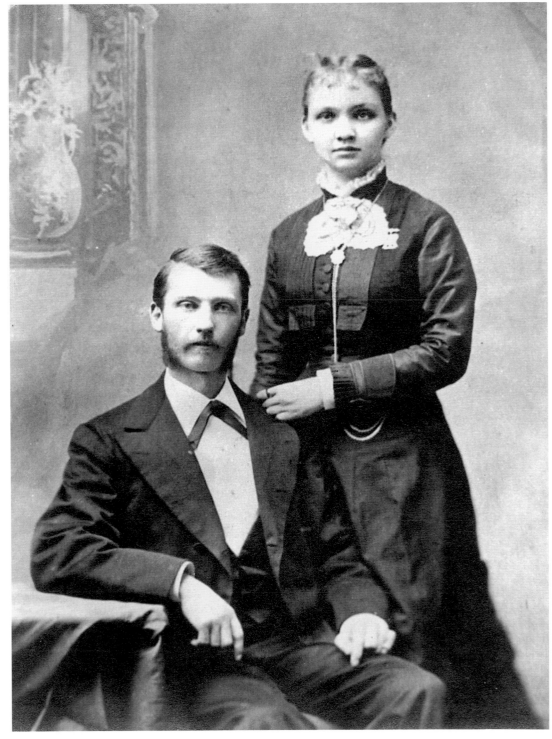

This photograph was probably taken to commemorate the marriage of Lizzie Luckie Jones to William Alanson Gregg, who soon joined partners Tommey and Beck in an Atlanta hardware business. Throughout the 19th century, young women like Lizzie often expected to marry for economic security. *William A. and Lizzie Luckie Jones Gregg; print (from a cabinet card, c. 1877); unattributed.*

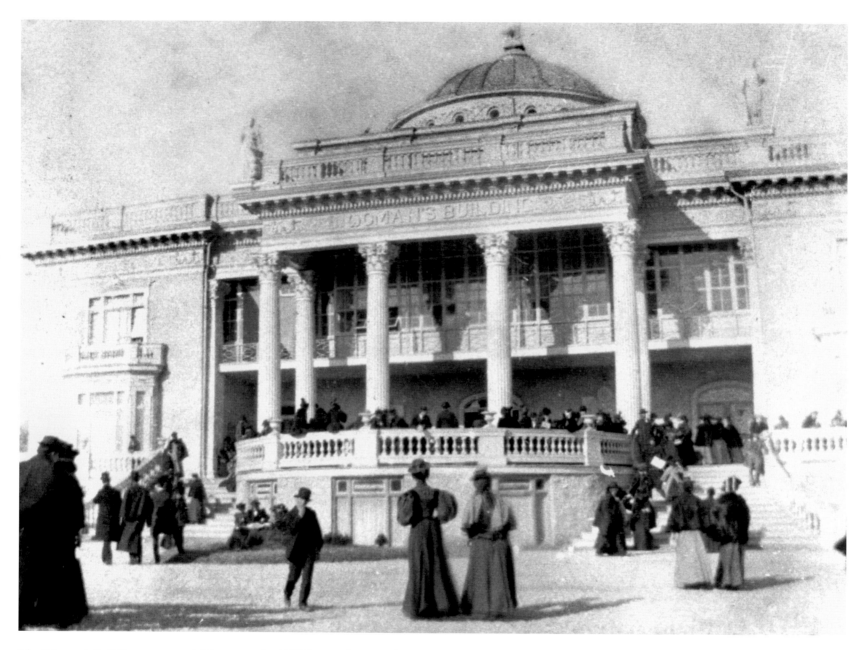

The Woman's Building was a special feature at the 1895 Cotton States and International Exposition, held in Piedmont Park to highlight Atlanta's success after the Civil War and its potential for the future. Envisioned, financed, and designed by women, the structure that celebrated the "New Woman" stood out among a host of plain gray buildings. Exhibits devoted to women's "industry and intelligence" were submitted in such great numbers that they required a second building called the Woman's Annex. *Woman's Building; unattributed; Atlanta, 1895.*

THREE

REVISIONING
VICTORIANS IN BLACK AND WHITE
1880–1899

Atlanta's population reached 65,000 in 1890, by which time any steps toward racial equality had halted. Southern states had reverted to white rule and wrote so-called "Jim Crow" laws into their criminal and civil codes as well as their constitutions, denying African Americans rights and privileges and creating separate facilities for blacks and whites. At the close of the 19th century, most Atlantans lived in either all-white or all-black neighborhoods. Nevertheless, with the growth of the city, a black upper class emerged, allowing some African-American women a prominent place in society. Both black and white Atlantans rallied around the 1895 Cotton States and International Exposition, hoping to gain positive exposure for the growing city.

Victorian norms continued to relegate many women to the domestic sphere, whether in their own homes or working for other women in theirs. Nationally, the 1890s saw the dawn of the Progressive Era, with women from all classes, races, and backgrounds entering into public life, expanding their roles in society, and becoming increasingly politicized. Options for Atlanta women—both black and white—grew, particularly in education, reform, and employment.

Although the practical domestic arts remained essential to preparing them for the roles of wife and mother, Atlanta girls had increased educational opportunities. Still, the curriculum of the many new schools springing up around the city remained rooted in Victorian ideologies about a woman's "place" in society. In 1872, the Atlanta public school system opened five grammar schools and two high schools, including Girls High School for whites only. No public high schools opened for blacks that year, but two grammar schools were established. In the decades to follow, numerous private schools opened, including in 1881 the Atlanta Baptist Female Seminary (later Spelman College), which provided education for African-American women in Atlanta, and in 1889 Decatur Female Seminary (later Agnes Scott College), which afforded educational opportunities for white women.

In the early 1880s, black and white women exerted their influence beyond the home by establishing comparable but separate organizations. From kindergartens, orphanages, and almshouses to study clubs, mission societies, and temperance groups, Atlanta women formed dozens of organizations to improve themselves and their communities. The first local Women's Christian Temperance Union was founded by white Atlanta women in 1880. African-American women established the West Atlanta Women's Christian Temperance Union in 1887.

By the 1890s, Atlanta women began working for voting rights. The Atlanta Equal Suffrage Association was formed in 1894. Like many other white Southern women's groups, this organization sought public support for its cause, in part, by emphasizing the power of their votes to offset the votes of African-American men. On the other hand, the city's black women leaders recognized that equal suffrage could enable them to reshape a segregated and racist society.

In the mid-1890s, the Atlanta Federation of Women's Clubs was founded as part of a national network of women's clubs. The Atlanta Federation served as a coordinating body for numerous white organizations, such as study clubs, nursing associations, patriotic groups, Red Cross auxiliaries, and charities. The General Federation of Women's Clubs and all its affiliates were racially segregated. A separate and parallel organization, affiliated with the National Federation of Colored Women's Clubs, developed for Atlanta's African-American women's groups.

Images from the late 19th century reflect women's increasingly active roles in public life. With more freedom than previous generations, the "New Woman" was less constrained by Victorian norms and domesticity. By the 1890s, there was more than a hint of masculinity creeping into women's wardrobes. Woolen bodices with full, feminine leg-o'-mutton sleeves and matching floor-length skirts were often topped with hats that were labeled "mannish." Women dressed to convey the gravity of their intentions as they campaigned for orphan care, workers' rights, woman suffrage, and other reforms. Conservatives objected to this New Woman, with her civic presence, outspoken manner, and altered dress. Though some women embraced opportunities for public participation with enthusiasm, many were more reserved in their call for change.

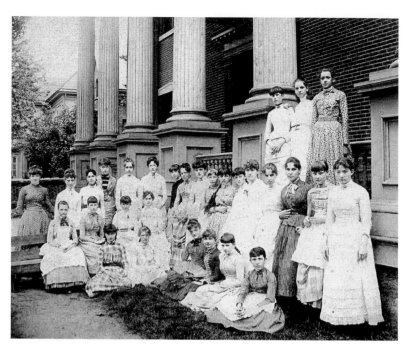

Established in 1872, Girls High School was the first public high school for Atlanta's young white women. Like other female schools, its curriculum reinforced Victorian ideals about a woman's role in society. An 1882 advertisement for the Atlanta Baptist Female Seminary (later Spelman College) indicated that prospective students must be "of good moral character." While most graduates hoped to marry and have a family, some pursued positions as teachers or in business. *Class of 1884, Girls High School; unattributed; Atlanta, 1884.*

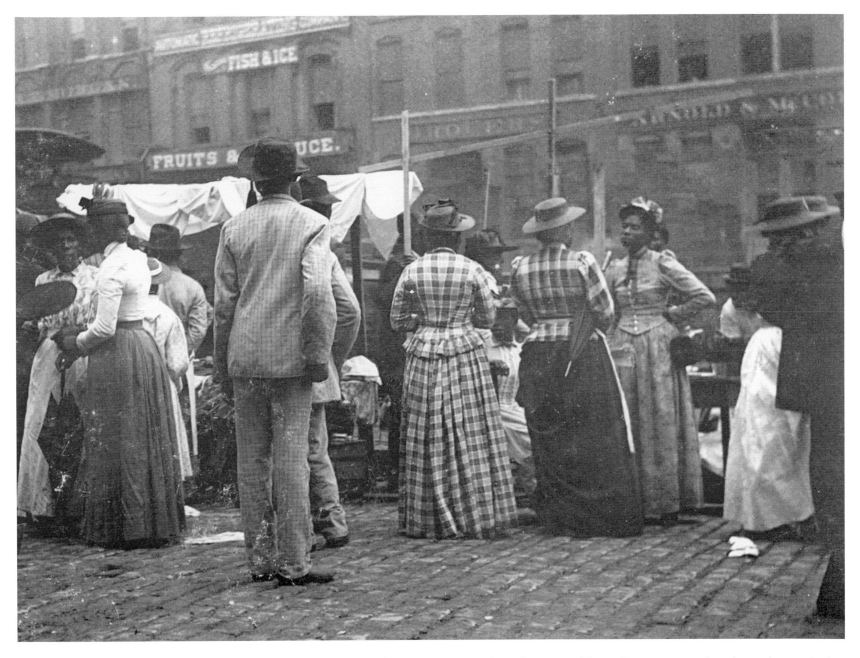

At the African-American curb market next to Union Station, women bought produce and other merchandise and socialized as well. Although segregated by law from white society, African Americans were far from powerless in late 19th-century Atlanta. Forming strong cultural, social, and political organizations, many of their businesses, churches, schools, and other institutions were vibrant and successful. *Curb market near Union Station; unattributed; Atlanta, c. 1889.*

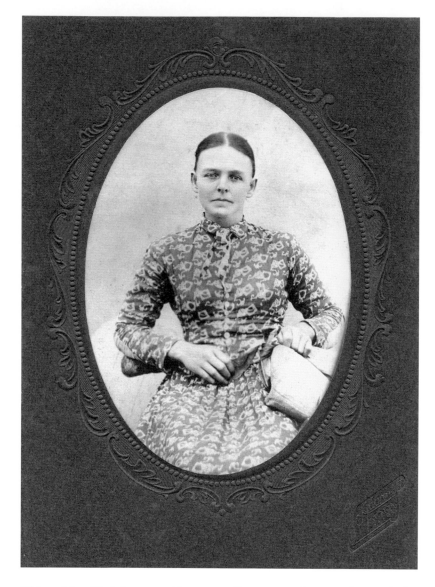

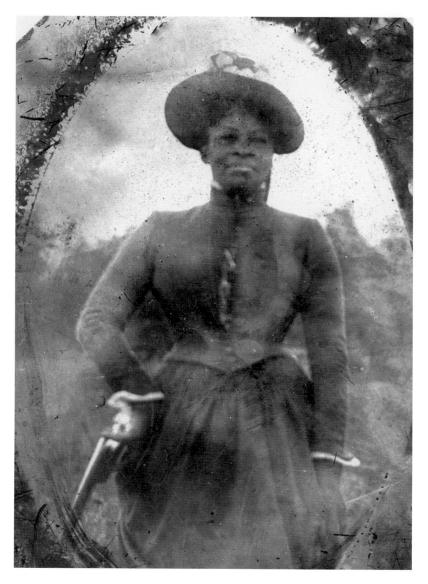

This unidentified sitter provides a rare glimpse into the everyday wardrobe of a working-class woman. Her simple, printed cotton dress buttons at the front and has a modest collar, patched sleeves, and gathered skirt. Mill workers, domestics, and other laborers favored dresses cut loose enough to provide for the necessary range of motion; protective aprons helped extend the lives of the dresses. In 1890, over 9,000 women were part of Atlanta's labor force, more than two-thirds of whom were black women in domestic service. *Unidentified subject; J.Q. Adams, photographer; Atlanta, c. 1890.*

In the late 19th century, middle- and upper-income women participated in a variety of recreational activities, including horseback riding, bicycling, tennis, croquet, shooting, and archery. Many women enjoyed the sense of freedom that accompanied these physical exertions. While some doctors advocated exercise and its health benefits for women, many others opposed it. *Unidentified subject; tintype; unattributed; c. 1887.*

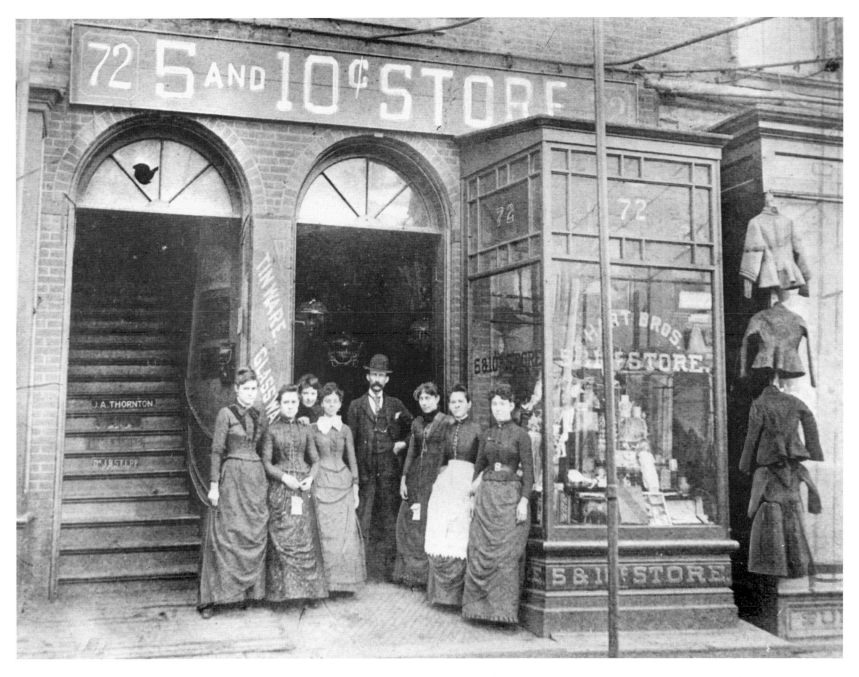

In the boom years following the Civil War, many young Atlanta women found work as shop clerks. For some, their wages allowed them a degree of autonomy, yet they often experienced long hours, strict rules, grueling physical work, and sexual harassment. *Hart Brothers' employees; unattributed; Atlanta, c. 1887.*

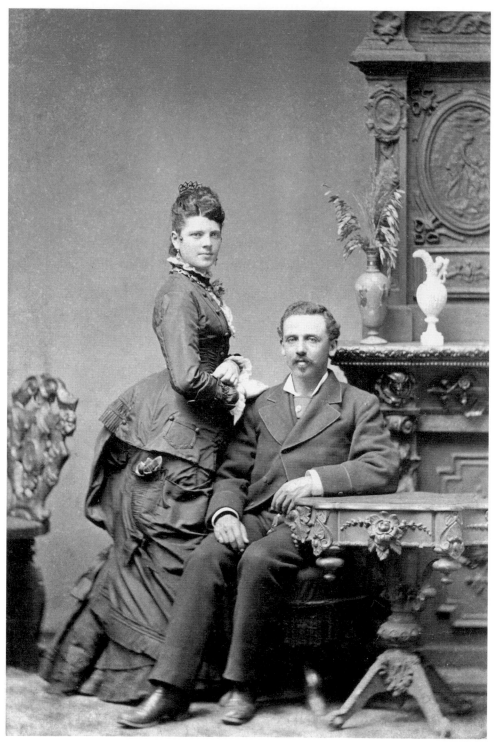

A lady in the traditional sense, Dora Cohen managed the family home and cared for her husband and two sons. As a traveling agent for J. Regenstein's, Henry Cohen understood the importance of being well-dressed. Dora's silhouette shows the exaggerated volume provided by elaborate bustles of the era. *Dora and Henry Cohen; cabinet card; Columbus W. Motes, photographer; Atlanta, c. 1885.*

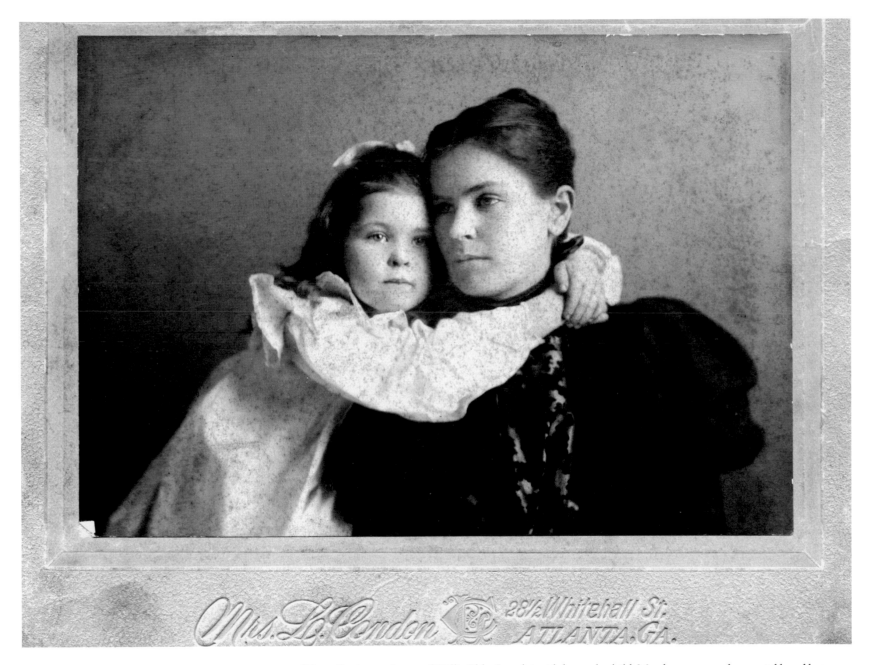

This affectionate image of Willie Elder Lawshé with her only child, Martha, conveys the special bond between a mother and her child. Mothers were considered instrumental in raising children to become good citizens. An 1892 issue of *The Parent's Review* highlighted the importance of "mother culture," which advocated self-care to ensure proper nurturing of her family: "If we would do our best for our children, grow we must; and on our power of growth surely depends, not only our future happiness, but our future usefulness." *Willie Elder Lawshé and her daughter, Martha; Mrs. Linnie Condon, photographer; Atlanta, c. 1897.*

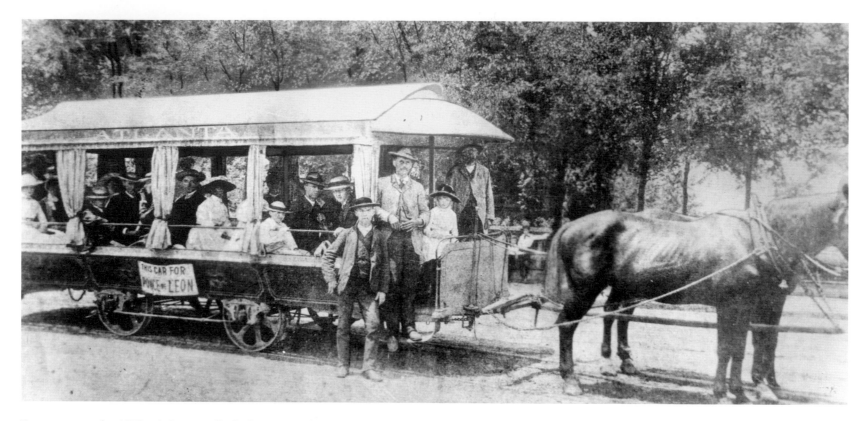

Beginning in the 1870s, Atlantans flocked to Ponce de Leon Springs for relaxation. Operating as a spa and park, Ponce de Leon Springs offered white Atlantans a wide range of amenities, including a lake, two springs, and a bathhouse with trails, bridges, and grounds for picnics and Sunday outings. *Ponce de Leon Springs streetcar; unattributed; Atlanta, c. 1884.*

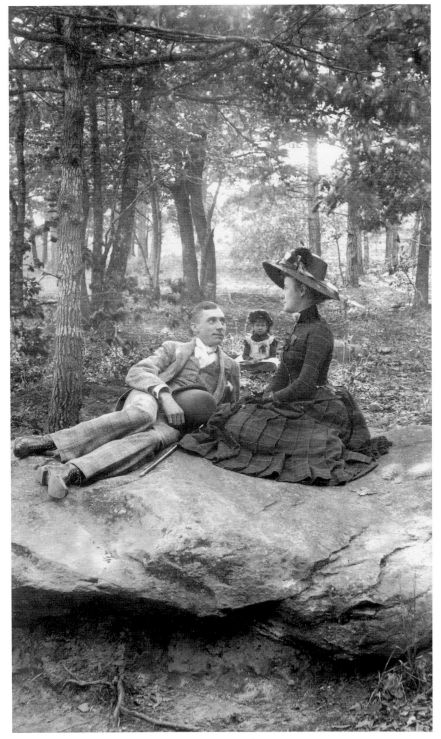

Those who could afford the fare boarded the Western and Atlantic Railroad at Union Station in the heart of Atlanta and rode the 11 miles to Vinings for a country retreat. Such picnics provided courting opportunities and were often elaborate affairs; this elegant couple dressed fashionably for their outing. *Unidentified Dixie Club members; Hugh B. Adams, photographer; Vinings, Georgia, May 4, 1889.*

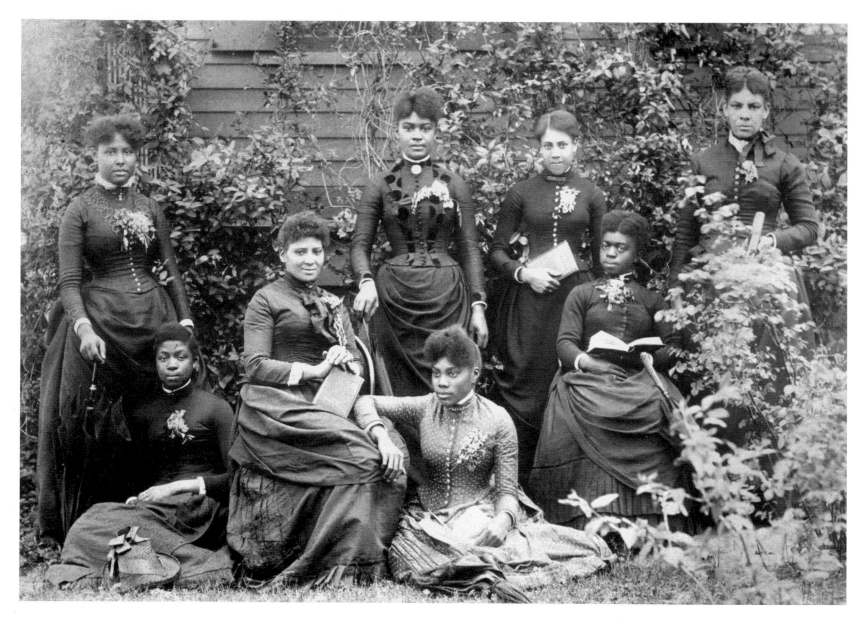

These eight young women comprised the third graduating class of Atlanta Baptist Female Seminary. Sophia B. Packard and Harriet E. Giles established the school in 1881 to educate African-American women. It operated from the basement of Friendship Baptist Church. Three years later, the school was renamed Spelman Seminary in honor of Laura Spelman Rockefeller and her parents, Harvey Buel and Lucy Henry Spelman, longtime activists in the antislavery movement. The institution granted its first baccalaureate in 1901 and became Spelman College in 1924. *Class of 1889, Spelman Seminary; unattributed; Atlanta, 1889. (Courtesy of Spelman College Archives, Atlanta, Georgia.)*

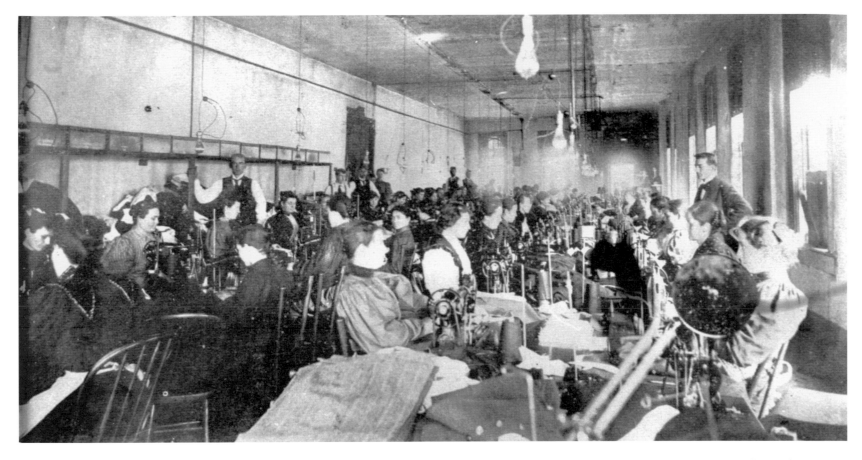

Factory workers, such as these seamstresses at the clothing manufacturer Nunnally Brothers, toiled at a demanding pace and under close supervision. The rise of industry in Atlanta during the 1880s and 1890s brought increasing numbers of women into the workforce. Women, both black and white, earned income as domestic workers, teachers, stenographers, seamstresses, milliners, and dressmakers, among other occupations. *Nunnally Brothers seamstresses; unattributed; Atlanta, c. 1897.*

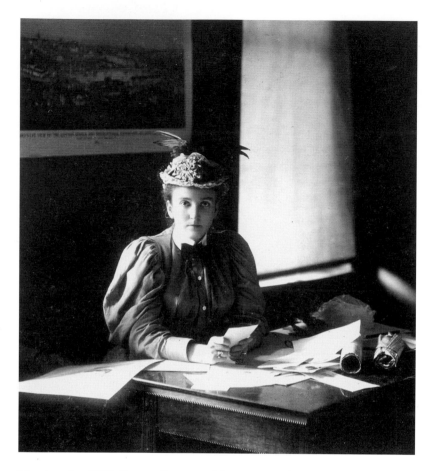

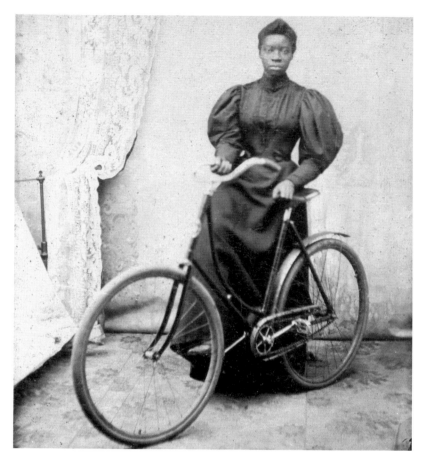

Hosting the 1895 Cotton States and International Exposition was a high point for Atlanta and its citizens. Supervised by a 40-member female board, the Woman's Building was the hub for women's activities. Recognizing that a Woman's Building was unconventional, leaders sought to reassure the public that their presence was not a threat. In the words of Emma Mims Thompson, president of the Board of Lady Managers, a woman was "neither the antagonist nor the rival of man, but his co-worker and helpmeet." Conferences held at the Woman's Building led to the establishment of numerous organizations, including the Atlanta Federation of Woman's Clubs and the local chapters of the National Council of Jewish Women and the National Association of Colored Women. *Emma Mims Thompson (Mrs. Joseph Thompson) in the Woman's Building; Frederick L. Howe, photographer; Atlanta, 1895.*

Like other physical activities, the bicycling craze of the 1880s and 1890s required special clothing. The boldest female cyclists adopted trousers, sometimes beneath skirts or with an extra front panel that, when buttoned to the full legs, gave the appearance of a skirt. More traditional women selected ankle-length skirts. Surviving photographs indicate that Atlanta women preferred to wear skirts for bicycling. *Unidentified subject; tintype; Kuhns Studio; Atlanta, 1895.*

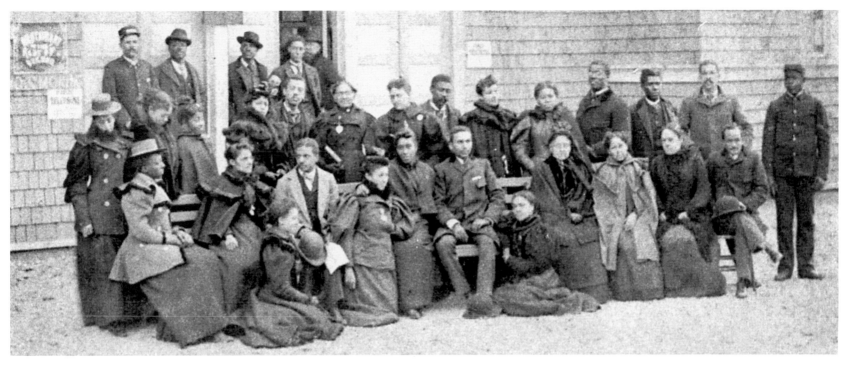

In 1895, Atlanta sought to trumpet its position as a prosperous New South city by hosting the Cotton States and International Exposition, which featured exhibitions and buildings devoted to transportation, electricity, manufacturing, agriculture, minerals, and forestry. The exposition not only featured the Woman's Building but also the Negro Building, which was designed, constructed, and managed by African Americans to showcase their accomplishments in the South. While the building represented the increasing separation of the races in Atlanta and the region, it also provided African Americans with a significant presence at a world's fair for the first time. Women from 25 states attended the Congress of Negro Women, whose organizing committee featured the most prominent black women of the day. *Unidentified group at the Negro Building; unattributed; Atlanta, 1895.*

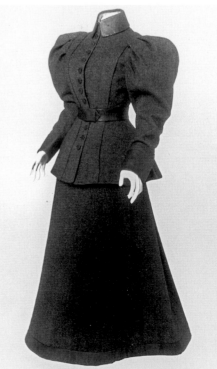

Propriety would have been second nature to the well-groomed Sarah Frances Grant, who became the First Lady of Georgia when her husband, John M. Slaton, became governor in 1913. The heavy leather trim at the skirt of this wool tweed ensemble helped ensure modesty, even on windy days. While some women donned bloomer costumes, an early type of trousers, for bicycling, many shied away from this controversial style because of its association with the suffrage movement. *Wool bicycling ensemble by J.A. Dunn & Co., Tailors & Costumiers of London, worn by Sarah Frances Grant Slaton; Atlanta, c. 1895. (Atlanta History Center collection; Jonathan Hollada, photographer.)*

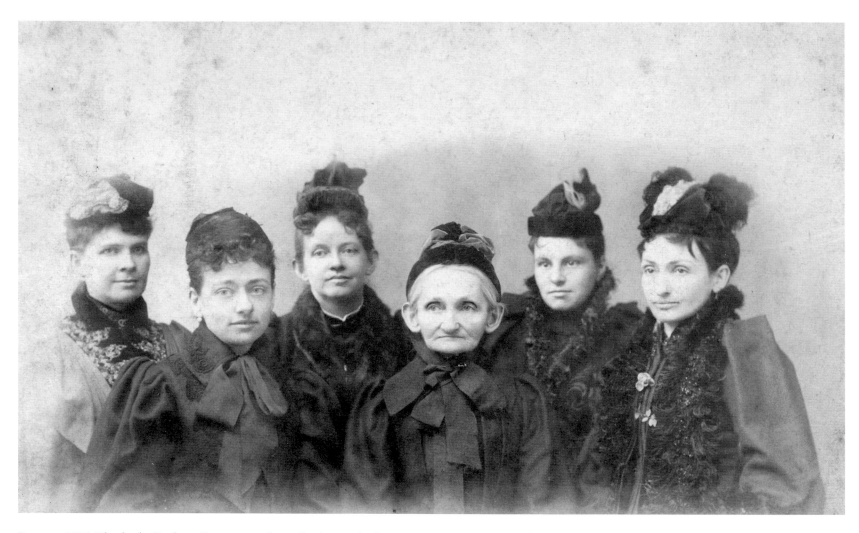

Born in 1826, Elizabeth Grisham Brown was the wife of an early Georgia governor. Women of privilege, such as Elizabeth and her daughters, enjoyed the broadest opportunities in society, including private education, travel, and political power in women's organizations. *Pictured center: Elizabeth Grisham Brown (Mrs. Joseph Emerson Brown) with her daughters and daughters-in-law; boudoir card; unattributed; c. 1893.*

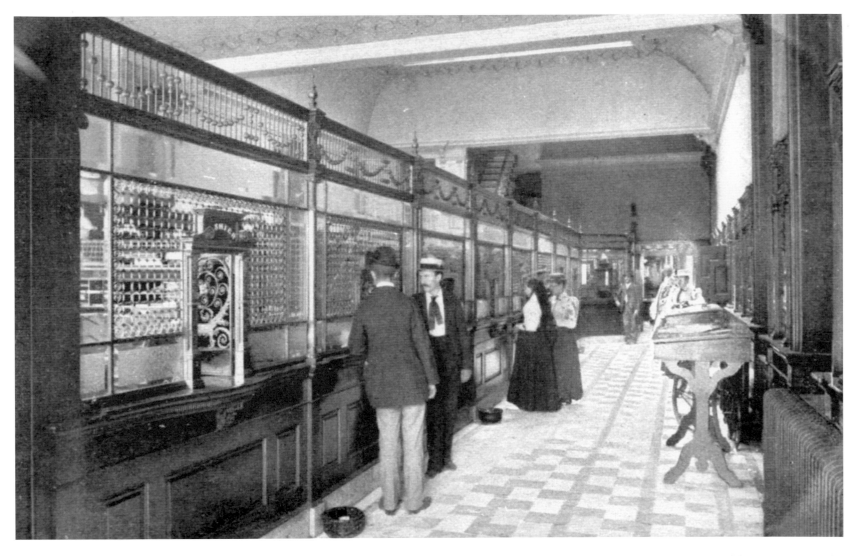

This image shows women patronizing the Atlanta National Bank on East Alabama Street. By the late 19th century, more women were active in public life than in previous decades. This autonomy allowed increasing numbers of women to operate their own businesses and manage their own accounts. *Atlanta National Bank lobby; unattributed; Atlanta, c. 1895.*

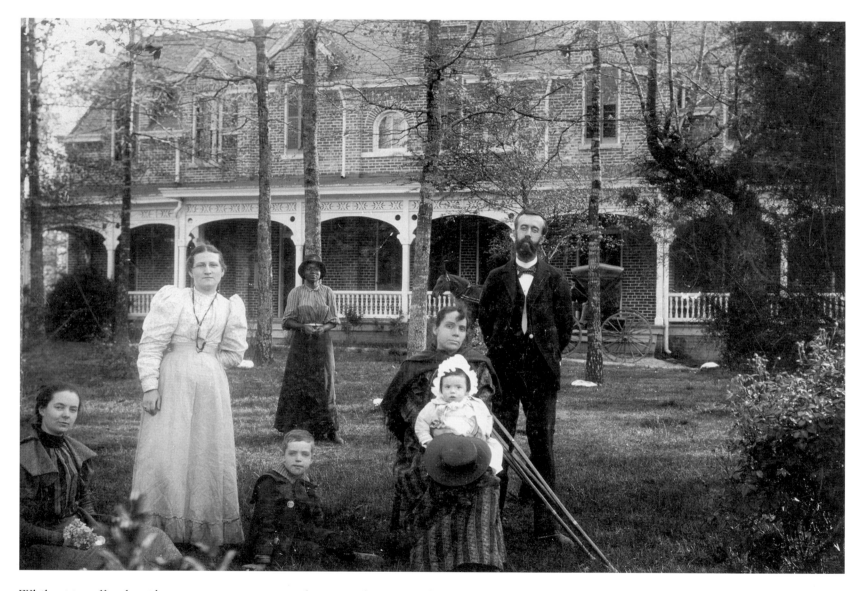

While cities offered residents many opportunities, they were also centers for crime, poverty, and disease. Late 19th-century reformers sought to alleviate these problems. In Atlanta, women established numerous charitable organizations, including orphanages in neighborhoods throughout the city. Some women provided financial support while many volunteered their time. *Unidentified group at the Fulton County Alms House; unattributed; Atlanta, April 15, 1898.*

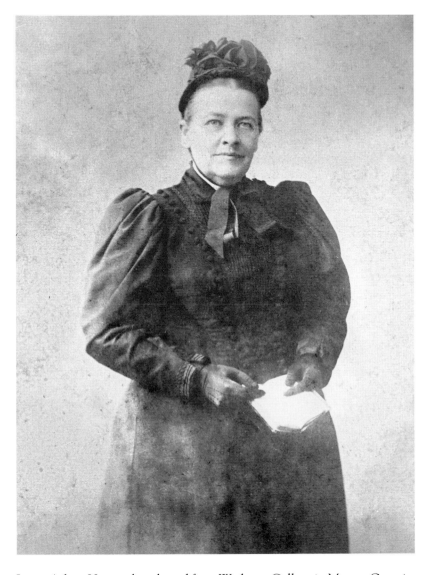

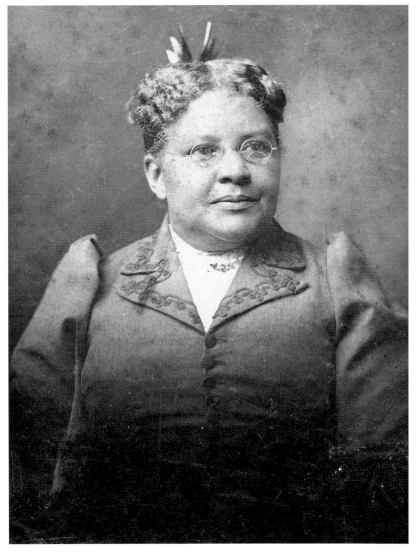

Laura Askew Haygood graduated from Wesleyan College in Macon, Georgia, in 1865 and immediately opened her own high school in Atlanta. This school later merged with Girls High School, where Haygood served as principal and teacher. In addition to educating women, she organized home mission societies to provide food and shelter to disadvantaged Atlantans. Haygood was devoted to her work and chose not to marry. Her ministry led her to China in 1884 where she established the McTyeire Home and School; she remained in China until her death in 1900. *Laura Askew Haygood; unattributed; c. 1893.*

This unidentified woman represents respectable women who did good works throughout the city; black and white women established separate philanthropic organizations. Known as the "Mother of Orphans," Carrie Steele Logan was born into slavery and orphaned as a young child. Her empathy for Atlanta's abandoned children compelled her to take orphans into her own home, write her autobiography, and sell her house to raise money for a larger orphanage—a three-story brick building was dedicated in 1892. *Unidentified subject; Moore and Stephenson, photographer; Atlanta, c. 1892.*

Mrs. M. L. Olson,

Fashionable Hair Dresser,

Orders for Hair Work of all kinds will receive prompt attention.
152 Decatur St., Atlanta, Ga.

In an era when ready-to-wear garments were just becoming available to women, the least expensive way to stay up-to-date was with a stylish hairdo. Not everyone was a natural at hairdressing, however, and women often turned to one another for help. Some, including Mrs. M.L. Olson, made hairstyling their profession. Curled, looped, and braided hairpieces were often required to create the elaborate styles seen in ladies' magazines. In addition to styling hairpieces and wigs, Olson probably created hair jewelry and wreaths as well. *Trade card; Atlanta, 1876.*

Harrie Fumade worked as a stenographer for the Insurance Company of North America and lived at a boardinghouse on Peachtree Street. Hundreds of women earned their livings as stenographers in Atlanta, where insurance companies and other businesses hired skilled single women for clerical positions. *Harrie Fumade; cabinet card; Columbus W. Motes, photographer; Atlanta, c. 1890.*

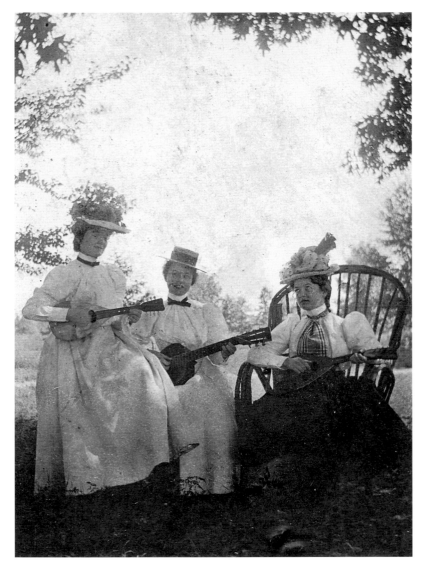

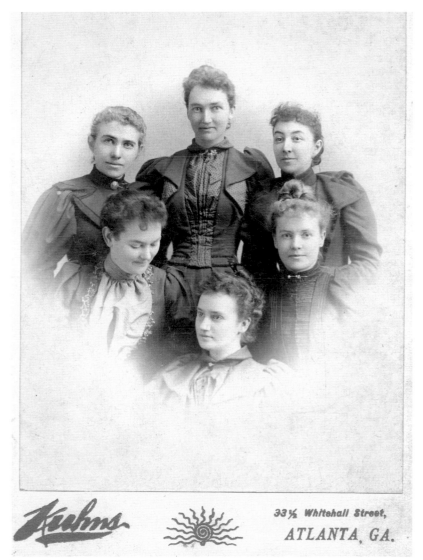

Deemed an appropriate activity for ladies in the 19th century, many young women pursued music as part of their formal education. These three young women played mandolins and a guitar to entertain themselves and others. Music, like needlework, writing, and painting, provided a creative outlet for self-expression. *Unidentified musicians; unattributed; c. 1895.*

Not all musicians play instruments; many use their own voices. Whether gathering around the piano in the parlor, humming a lullaby to a baby, or worshipping through hymns, singing was a part of Victorian life. Pictured here are six members of the Angel Choir of Edgewood Methodist Church. *Pictured clockwise from upper left: Isabella Kuhns, Lillie White, Ida McDonald, Lena Johnson, Nora Belle White, and Mary White; cabinet card; Kuhns Studio, photographer; Atlanta, c. 1898.*

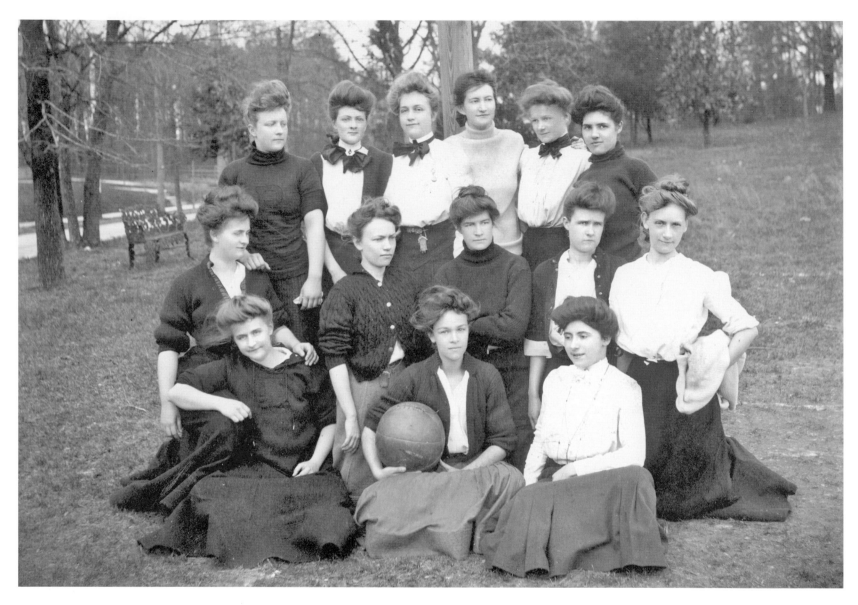

These young women enjoyed playing basketball on a lot at 14th and Peachtree Streets. Although wearing comfortable sweaters and tousled from their game, they still reflect the wholesome American ideal of the Gibson Girl. *Pictured from left to right: (front row) Julia Porter (Mrs. Bates Block), May DuBignon (Mrs. William Henry), and Josie Stockdell (Mrs. Hugh Foreman); (middle row) Florence Jackson (Mrs. Shepard Bryan), Nan DuBignon, Louise Black (Mrs. John F. MacDougald), Mary Ann Phelan (Mrs. Barry Wright), and Estelle Stewart (Mrs. George K. Selden); (back row) Sarah Calhoun (Mrs. Stephen Watts), Louise Gay (Mrs. Jack Somerville), Daisy Stewart (Mrs. Walter Farley Roberts), Anita Black (Mrs. Lamar Rucker), Ada Alexander (Mrs. James E. Hickey), and Cordelia Gray (Mrs. Thomas Brumby); unattributed; Atlanta, 1902.*

FOUR

PROGRESSING
ACTIVISTS AND WORKERS
1900–1919

Atlanta grew rapidly in the first decade of the 20th century, as its population increased from about 90,000 inhabitants (40 percent African American) in 1900 to 155,000 (one-third African American) in 1910. The commercial city remained the transportation and business hub of the South and became recognized as the birthplace of Coca-Cola and as a regional entertainment capital. At the same time, however, political, economic, and social divisions brought ongoing tensions and sporadic violence to Atlanta. The 1906 race riot made international headlines that tarnished the progressive image the city had promoted during the Cotton States and International Exposition. With the growth of the textile industry, increasing numbers of dissatisfied male and female workers organized labor strikes that rocked the city. Suffrage for women became a fiercely debated issue in Atlanta politics.

Building upon the public presence they had established in the previous decade, women from various classes and backgrounds advocated for orphan care, workers' rights, woman suffrage, and other reforms. Some women—for example, white suffragists and elite African-American women—responded to criticisms of the "New Woman" with the "politics of respectability," the belief that a refined appearance, combined with genteel manners, would help them achieve what were often radical political goals.

Organized efforts for woman suffrage in Georgia occurred several decades after the first women's rights convention was held in Seneca Falls, New York, in 1848. In 1891, a branch of the National American Woman Suffrage Association (NAWSA), the Georgia Woman Suffrage Association (GWSA), was formed in Columbus, Georgia. The following year, NAWSA established the Committee on Southern Work, and by 1893, GWSA had members in five counties. In 1894, the Atlanta Chapter of GWSA was founded. The following year, NAWSA held their annual meeting in Atlanta, where Susan B. Anthony, delegates, supporters, and press attended—lending further momentum for the woman suffrage movement in Georgia. African-American women were excluded from these meetings, though Anthony did give a speech at Atlanta University during her visit. In 1896, members of various African-American women's organizations joined forces to establish the National Association of Colored Women (NACW) in Washington, D.C. Some black Atlantans joined the suffrage movement through their involvement with NACW.

GWSA held its first convention in Atlanta in 1899 and passed several resolutions, including a statement that women should not pay taxes if they could not vote. In a show of support, the Georgia Federation of Labor endorsed women's right to vote in 1900. The Georgia Woman Equal Suffrage League was formed in 1913, expanding the movement beyond elite and upper-middle-class women with the support of businesswomen and teachers. Women who wanted to pursue more aggressively the right to vote established the Equal Suffrage Party of Georgia in 1914, gaining supporters in 13 counties by the following year. The first rally for woman suffrage was held in Atlanta in 1914; the nationally known settlement house leader Jane Addams addressed the rally. A major event in the movement occurred after Atlanta's Harvest Festival celebration in 1915, when Georgia's white suffrage organizations joined forces for the first time. More than 500 pro-suffrage advocates marched through the city wearing "votes for women" sashes and carrying banners. Members of the various suffrage groups continued to call for the vote—each with their own specific focus. Ultimately, the vote came later to Georgia women

than those in most states.

Atlanta's racial and class tensions shaped women's lives in complex ways. Beyond their status as second-class citizens, women often experienced poverty, physical and sexual violence, and racism. Visual documentation provides only glimpses of the working and living conditions of the city's working class. The lives of most Atlanta women—white and black factory workers and African-American domestic servants—were rarely captured by photographers. Despite the harshness of their circumstances, women forged friendships, raised families, and participated in community life.

For both African Americans and whites, class was the guiding factor in dress. The elite wore tasteful suits and day dresses, flowing afternoon gowns, and delicate evening gowns. For working women, including secretaries and schoolteachers, the white shirtwaist and dark skirt emerged as a proper and practical uniform for daily wear. Meanwhile, mill workers, domestics, and other laborers generally wore simpler dresses that allowed for a wide range of motion.

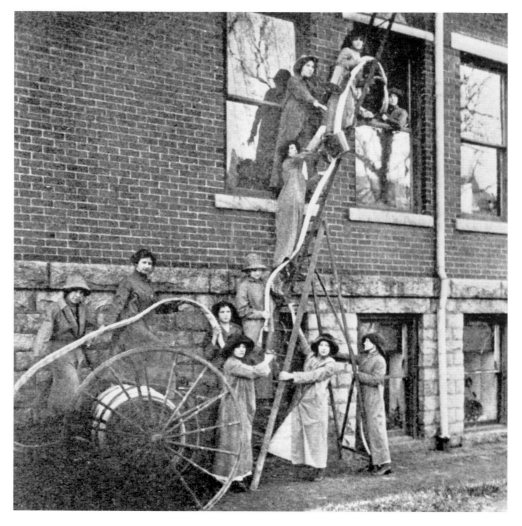

Each dormitory at Agnes Scott College designated student firefighters who trained to protect their homes away from home. Founded in 1889 as the Presbyterian-affiliated Decatur Female Seminary, the school strictly regulated the dress and behavior of students. An 1892 bulletin noted, "Pupils will not be allowed to go to Atlanta oftener than once a quarter for shopping purposes." In 1907, Agnes Scott College was the first school in Georgia accredited by the Southern Association of College and Schools, and in 1920, it was granted membership in the American University Association. *Student firefighters at Rebekah Scott Hall, Agnes Scott College; unattributed; Decatur, Georgia, 1913. (Courtesy of Agnes Scott College.)*

Atlantans paraded on Whitehall Street during the International Shriners' Convention in May 1914. In the 1910s, the fashionable silhouette became straighter and more natural than in previous decades. Ready-made women's clothing was becoming widely available in shops and department stores, although custom dressmaking and home sewing continued to flourish. The leading dressmaker in Atlanta during the decade of the 1900s was Margaret Kirkcaldie. *Street scene in front of the Atlanta National Bank building; unattributed; Atlanta, May 1914.*

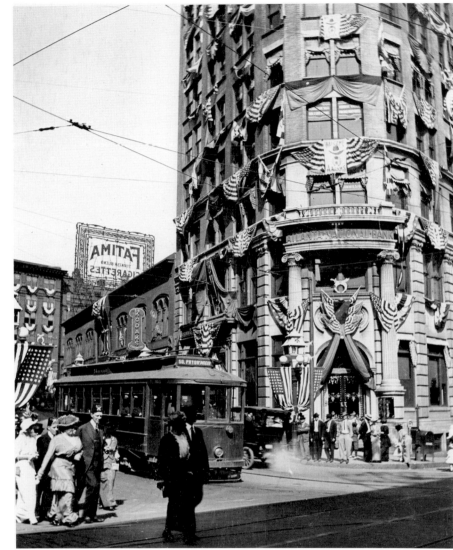

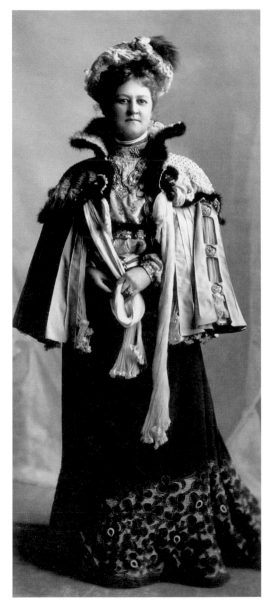

From her elaborate hat and fur-trimmed cape to her trained velvet skirt, the exuberant dress of Mary Josephine Van Dyke Inman reflects her husband's status as a businessman, a civic leader, and one of the wealthiest men in Georgia. Linnie Condon, who took this striking portrait, was one of Atlanta's first women photographers and created artistic pictures of many Atlantans. *Mary Josephine Van Dyke Inman (Mrs. Hugh T. Inman); Mrs. Linnie Condon, photographer; Atlanta, c. 1900.*

Selena Sloan Butler was a pioneer for African-American education in Atlanta. After graduating from Spelman Seminary, she became an English teacher, married Henry Rutherford Butler, and moved with him to Boston. There she studied oratory at the Emerson School while he studied medicine at Harvard University. After returning to Atlanta and starting a family, she established the first African-American parent-teacher association in the country at Yonge Street School and went on to found similar associations at the state and national levels. The national organization worked closely with the white parent-teacher association and shaped its policies and programs in coordination with theirs. When the two groups merged in 1970, Butler was one of the three women recognized as the founders of the National PTA. *Selena Sloan Butler (Mrs. Henry R. Butler); J.Q. Adams, photographer; Atlanta, c. 1905.*

Teaching was a respected occupation that even the most conservative women could enter with dignity. For over 20 years, India M. Pitts was a teacher and principal of the Mitchell Street School, a public school for black Atlantans. As her photograph shows, gloves were an important accessory and were worn very snugly. White kid gloves with lines of pointing on the back of the hand and snaps at the wrist were disposable and often purchased in multiples. *India M. Pitts; unattributed; c. 1910.*

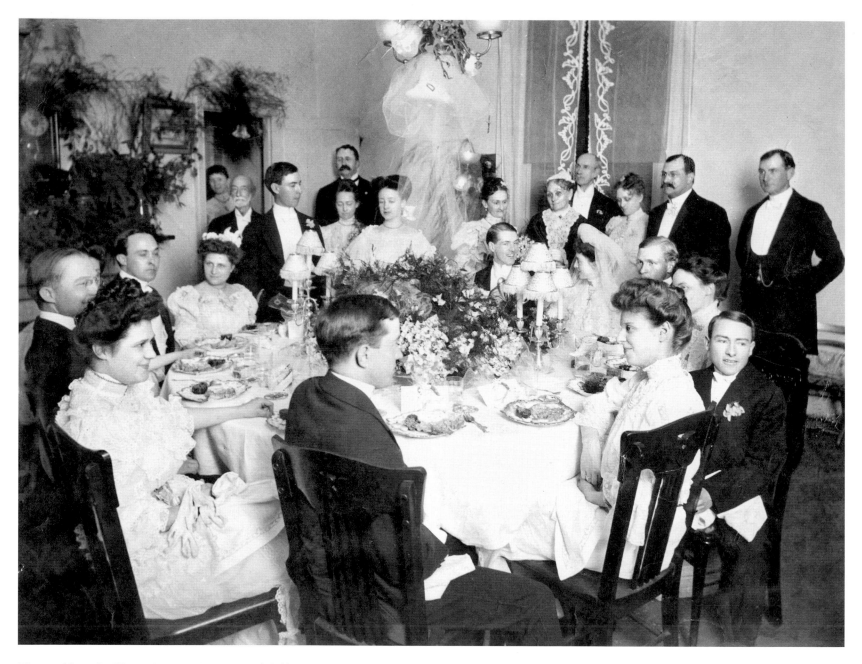

The wedding for Hiram Warner Martin and Sally Brown Connally was held at the home of the bride's parents. Relatives and out-of-town guests gathered in the family home to celebrate the occasion with food and drink. For the most part, weddings in this era remained intimate gatherings. *Sally Brown Connally and Hiram Warner Martin with family and friends; unattributed; Atlanta, June 1, 1905.*

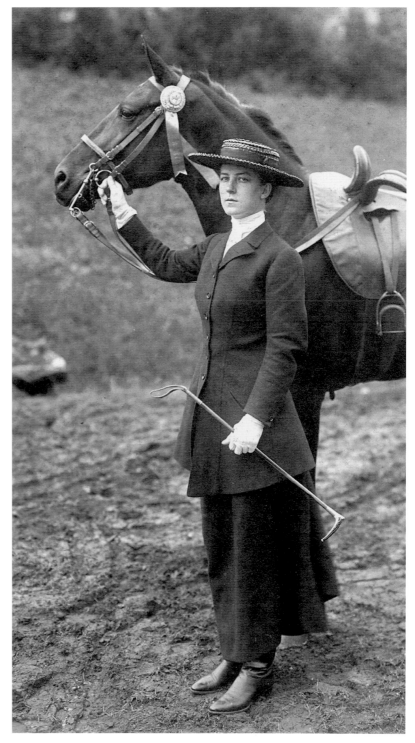

Sarah Peel posed for this portrait beside her award-winning mount. Riding sidesaddle enabled a woman to maintain decorum, yet the sweeping asymmetrical skirts that allowed for the position of her legs had to be looped up when she dismounted. To ride sidesaddle with grace required agility and strength, particularly when corsets reconfigured the body into the fashionable S-bend silhouette. *Sarah Peel; Will F. Nelson, photographer; Atlanta, c. 1907.*

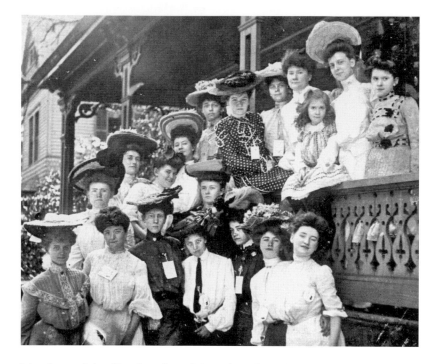

Members of the "Pigs" euchre club gathered on the porch of the Mitchell home on Ivy Street. The dress of these fashionable young women reflects the turn-of-the-century ideal—the Gibson Girl—popularized by the illustrator Charles Dana Gibson. The style featured a tiny, tightly corseted waist, tailored bell-shaped skirt, high-collared, long-sleeved blouse, and a mass of rolled hair under a huge hat. Key to this look was a corset that pushed the bosom forward and the hips back, resulting in an S-shaped curve. *Euchre club; unattributed; Atlanta, c. 1902.*

Mary V. Kernodle was working as a stenographer when she married electrician Thomas J. O'Keefe on August 8, 1910. At the time of their marriage, the median age for a first marriage in the United States was 25.1 for men and 21.6 for women. Although social convention precluded ladies from working outside the home, economic realities required large numbers of women to do so. *Thomas J. and Mary Kernodle O'Keefe; unattributed; Atlanta, January 1911.*

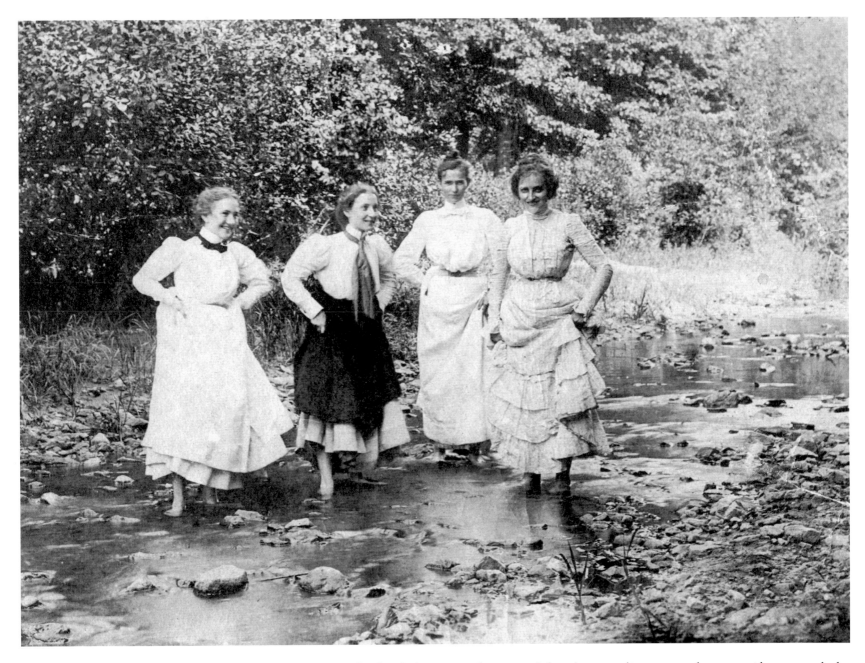

In the days before air conditioning, Atlanta's warm climate caused many residents to seek the cool comfort of area watering holes. Most likely considered risqué in its day, this image of friends frolicking at Ponce de Leon Springs reflects the lighter side of women's lives. Good manners could occasionally be relaxed among close friends. *Jeanette Jones, Viola Logan, Mrs. John Whipple, and Mary C. Logan; unattributed; Atlanta, c. 1900.*

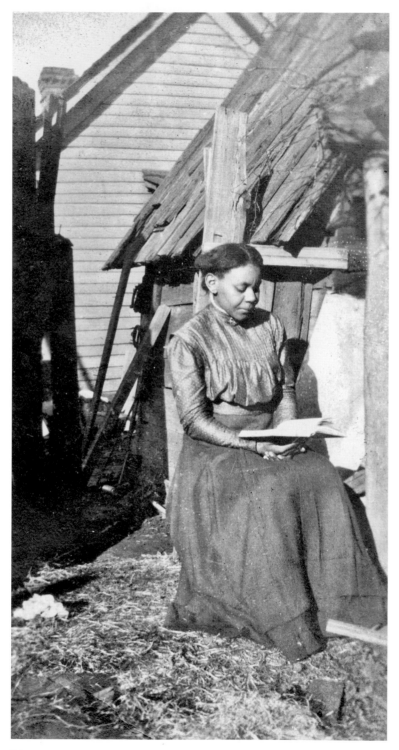

This reader was a student, relative, or close friend of Mitchell Street School principal India M. Pitts, whose photograph album contained dozens of snapshots, artistic images, and graduation portraits. Her commitment to educating students at the Mitchell Street School had a lasting effect on a generation of African Americans in Atlanta. *Unidentified subject; unattributed; c. 1905.*

This is to certify that

Mary Denney

has been a pupil of the.............Dress making.............Department of the

COLORED EVENING HIGH SCHOOL

during the Session ending March 25th, 1908 and that.........her.........Attendance and Scholarship

have been Satisfactory.

Date, March 25, '08. Lucille C. Wilson Teacher.

JKManin Principal.

As education became increasingly important for women in the late 1800s, evening schools were established for working women to further their education. While some students enrolled in vocational programs, others learned the basics of reading and writing. In 1897, attendance was growing at Girls Night School in Atlanta. Although the school was not yet fully equipped, a newspaper reported that all of the girls were well-dressed and enthusiastic: "Their conduct is excellent. The girls mean business, and do not lose time talking." *Colored Evening High School diploma; Atlanta, 1908.*

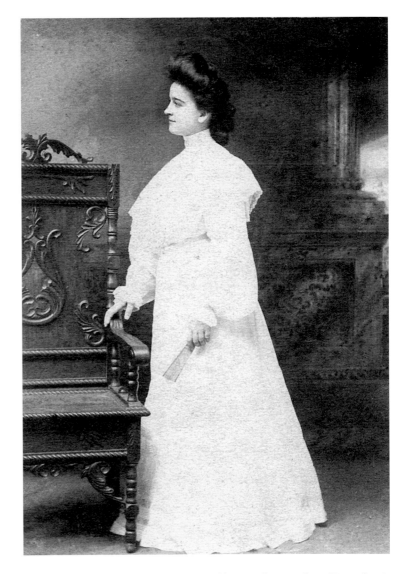

Agnes Tinsley Nelson commemorated her graduation from Draughon's Practical Business College in Atlanta with this formal portrait. White dresses are the traditional choice for graduates, debutantes, and brides, and in the early 20th century, white became an important color in many women's summer wardrobes. Upon receiving her diploma, Nelson became an assistant bookkeeper for V.E. Perryman, an area hospital supply company. The business school curriculum of the day could be quite demanding. As one student, Elizabeth Hanleiter McCallie, noted, "I found Mr. Gregg's system of shorthand far more difficult to learn than Latin or any subject I had taken in the regular course." *Agnes Tinsley Nelson; Mead, photographer; Atlanta, 1903.*

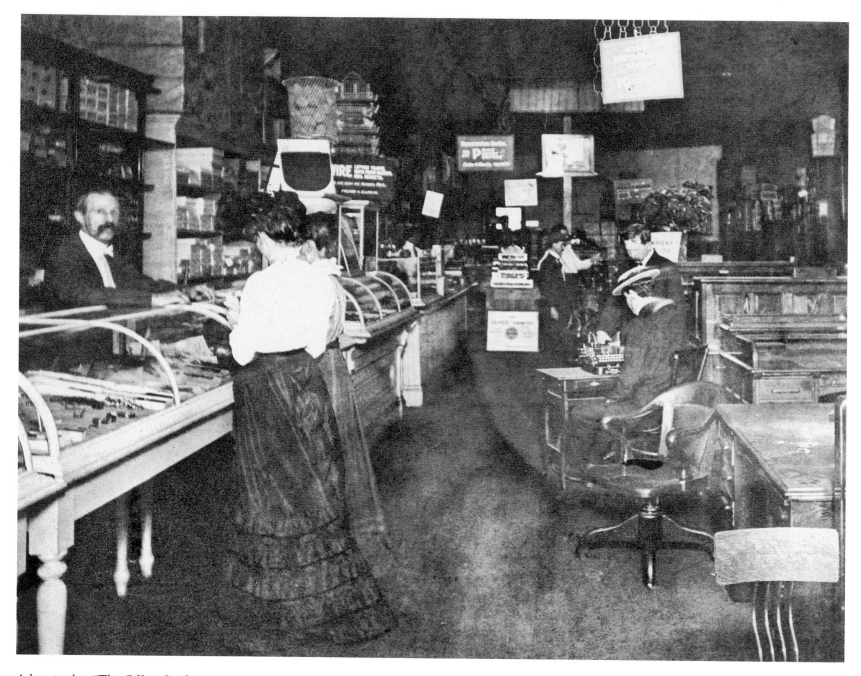

Advertised as "The Office Outfitters" to the city, Fielder and Allen, the predecessor of the Ivan Allen Company, sold pencils, carbon paper, typewriters, desks, and other office supplies. The business was located in the heart of Atlanta's shopping district on Peachtree Street and was frequented by businesswomen and -men. *Fielder & Allen Co.; K.M. Turner, photographer; Atlanta, 1900.*

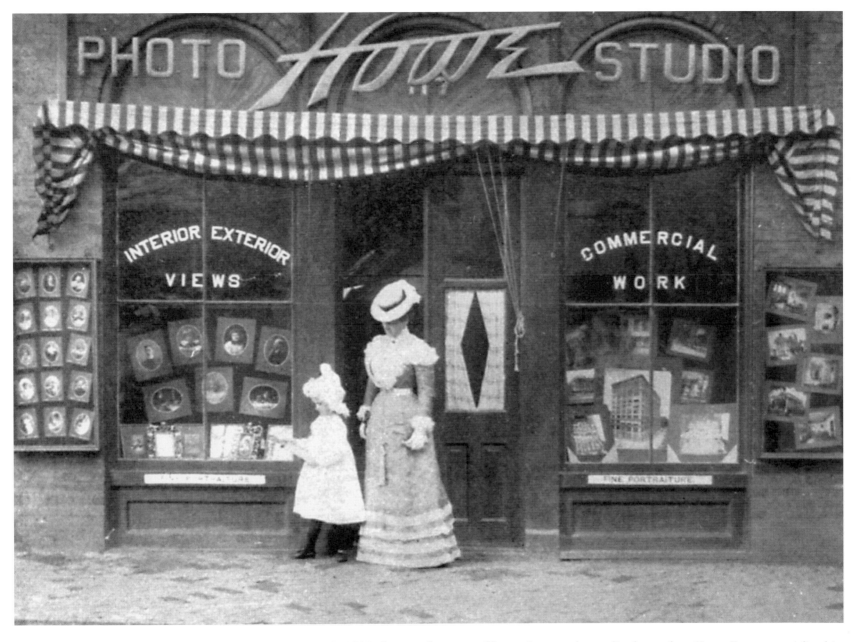

In 1901, the award-winning Howe photography studio, located on Pryor Street, specialized in both commercial work and fine portraiture. The composition of this advertisement features a popular photographic subject—the mother and child. *Advertisement from* Atlanta Illustrated: A Story of Success; *Frederick L. Howe, photographer; Atlanta, 1901.*

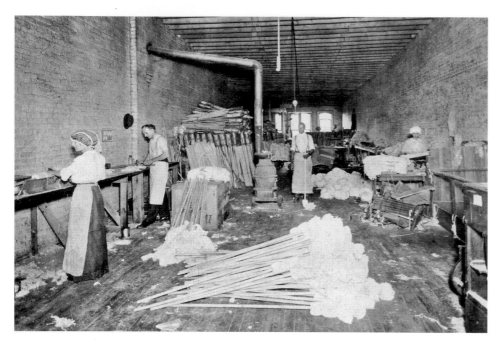

Atlanta was home to four broom manufacturers in 1900—the Atlanta Wooden Ware Company, the Fulton Manufacturing Company, Hodges' Broom Works, and the National Broom Works. Although records do not document a broom makers' union, these laborers may have belonged to one of the more than 30 unions and federations in the city at the time. *Unidentified laborers; unattributed; c. 1900.*

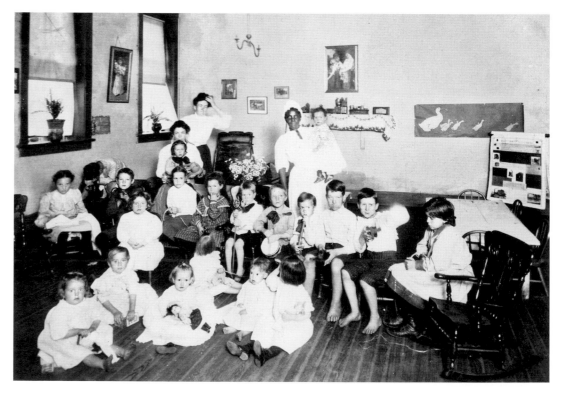

A host of kindergartens and day nurseries were established in Atlanta around 1900, many of them operating out of private homes and local charities. A few middle- and upper-class women moved into poor areas to foster education and to assist working women with childcare. The nursery school room for children of Atlanta Woolen Mills employees was well equipped. Mary Lee Echols, Florre Crim, and Victoria (last name unknown) seem to have their hands full during a music lesson. *Atlanta Woolen Mills day nursery; unattributed; Atlanta, c. 1904.*

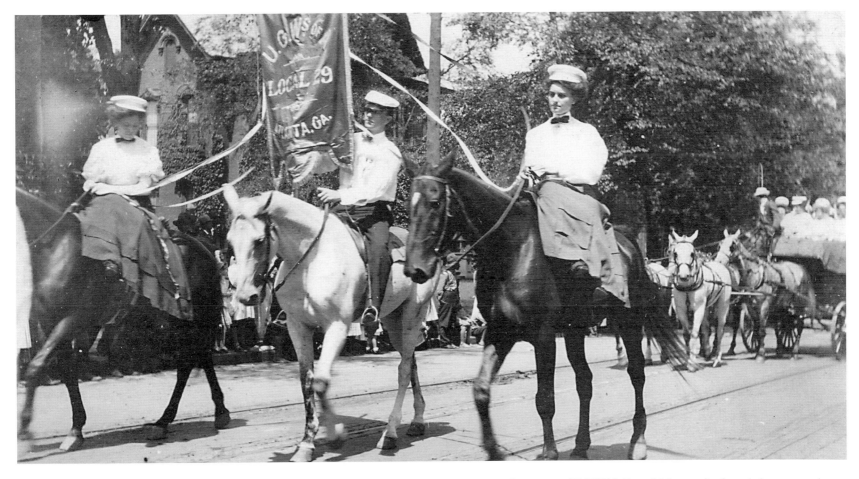

The United Garment Workers of America (UGWA), Local 29, marched in Atlanta parades in the 1910s. Affiliated with the American Federation of Labor, the national organization of UGWA was founded in New York City in 1891. Atlanta women joined the ranks of the Local 29 to gain fair wages and improved working conditions. *Parade; unattributed; Atlanta, c. 1910.*

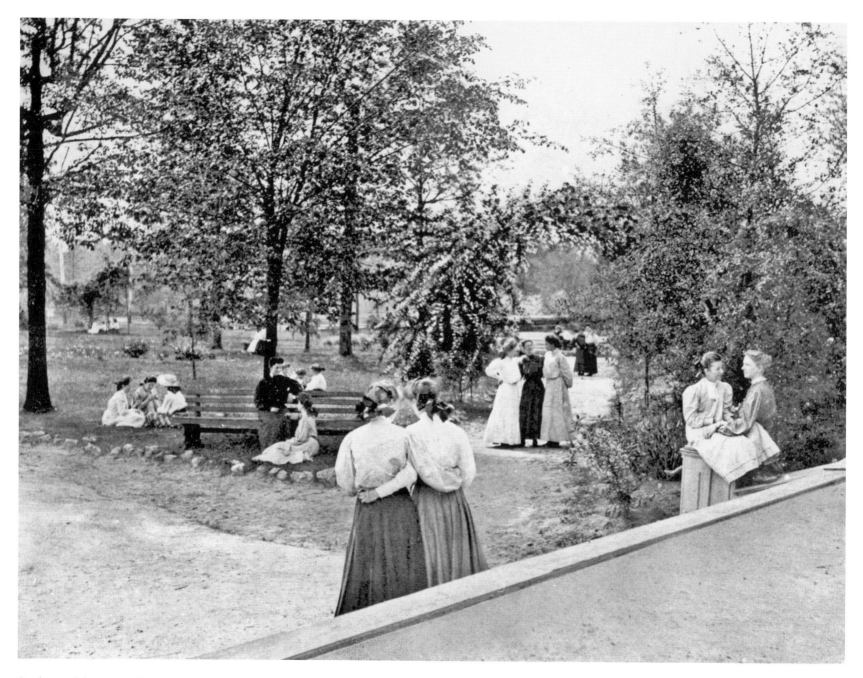

Students of the Cox College and Conservatory learned about horticulture during campus arboretum walks. Affectionate relationships, intimate letters, and hand holding, like the nurturing associated with the traditional roles of teacher and mother, were generally accepted as appropriate between female friends. *Cox College arboretum; unattributed; College Park, Georgia, c. 1905.*

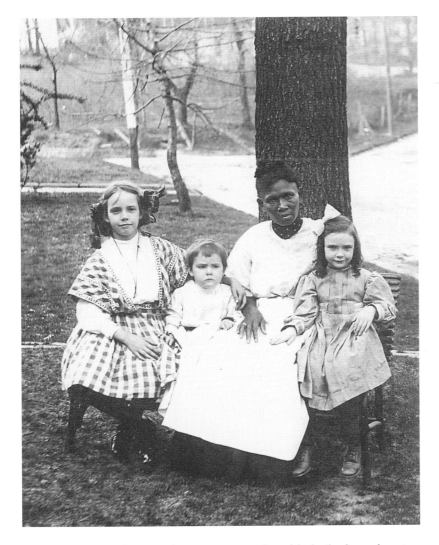

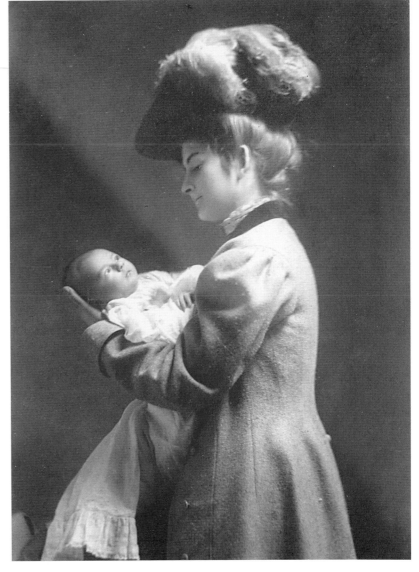

Many middle- and upper-class women employed help for housekeeping and childcare. The Barnett children were photographed with an unnamed cook who, like untold numbers of domestic workers, simultaneously kept two houses and raised two families—their own and that of their employer. Dorothy Bolden, the daughter of another Atlanta cook, recalled her mother's long hours and hard work: "And when she wasn't in her cooking job she did laundry at home. That was a tradition of black women to pick up laundry during the week and do it at home and deliver it back to the employer. . . . And back in those days we didn't have a washing machine. We only had the tubs and the rub boards and the big black pot to boil them in" (Kuhn, Joye, and West, 111). *Pictured from left to right: Mary MacDonald Barnett, Samuel Carter Barnett, unidentified cook, and Elizabeth Windfield Barnett; unattributed; Atlanta, 1907.*

Motherly instincts are suggested by this portrait of Julia Baxter Jones cradling her two-month-old nephew Sam, the grandson of Rev. Sam Jones, a famous evangelist from Cartersville, Georgia. The reverend favored Julia, his proper daughter, who married Rev. Walt Holcomb and bore two children. On the other hand, Jones disapproved of his daughter Laura, a "fallen" woman, who gambled, danced, smoked cigarettes, drank, used morphine, and divorced. In 1908, Laura lost custody of her only child, Sam, to her mother. *Julia Jones and Sam Jones Sloan; unattributed; c. 1904.*

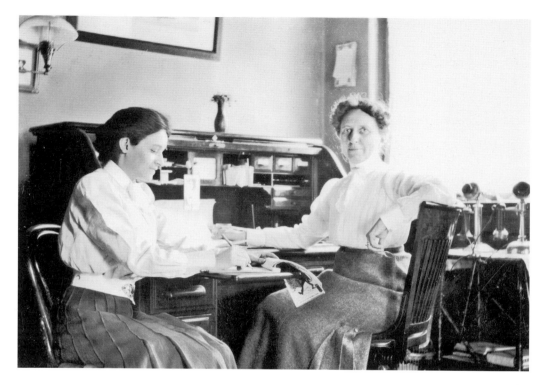

As a teacher at Girls High School and later as the secretary for the state school commissioner, Josephine Rainwater worked closely with Nettie Cole Sergeant. Before becoming the principal of Girls High, Sergeant graduated from Peabody Normal College in Nashville, Tennessee; studied at Columbia University, Harvard University, and other colleges; and earned a master's degree in education. One of her students, Elizabeth Hanleiter McCallie, worked in several jobs before she became secretary to Maj. John M. Slaton, the superintendent of Atlanta's public schools. According to McCallie, "'Miss Nettie' was a human dynamo. She was tireless in her efforts to improve the school. She raised the money to pay for and supervised a model school at the Cotton States and International Exposition in 1895. She brought expert teachers from the East to show the latest methods of teaching" students with special needs. *Josephine Rainwater (left) and Nettie Cole Sergeant at Girls High School; unattributed; Atlanta, c. 1910.*

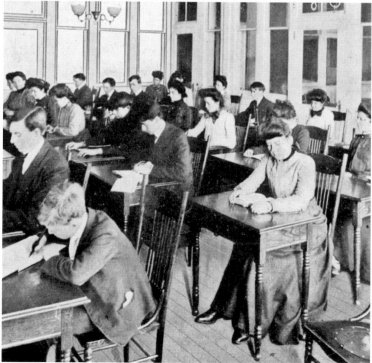

Reflecting upon her clerical career, Atlantan Elizabeth Hanleiter McCallie wrote: "In the 1890s, a woman's opportunity to make a living was limited to teaching, sewing, working in a factory, or becoming a nurse after a slow and tedious apprenticeship. It was thought by many that working in a man's office was neither desirable nor quite respectable, thus to enter a field so new and supposedly fraught with danger took some courage and determination." By the turn of the century, office work was acceptable for women to the extent that Girls High School and other schools offered business classes to prepare students for the working world. Atlanta, home to Southern branches of banks, insurance companies, and other businesses, provided many opportunities for office work. Companies were eager to hire women and cited their diligence and willingness to work for lower wages as reasons to hire them. From the employee's perspective, clerical work was respectable, and many women viewed it as a step up from comparable-paying factory jobs and less personally restrictive than teaching school. Offices provided opportunities for women and men to work side by side. *Southern Shorthand and Business University, Junior Shorthand Department; unattributed; Atlanta, c. 1907.*

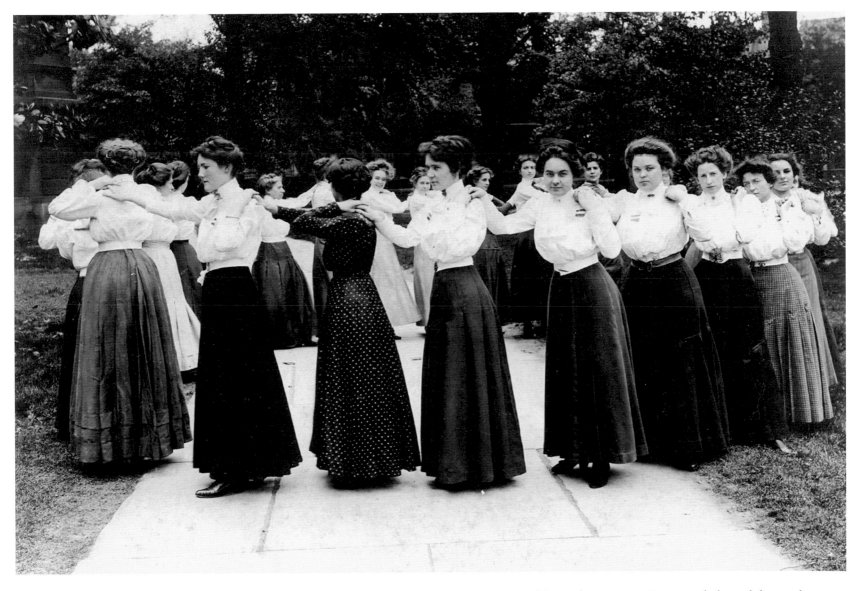

By 1900, an unofficial uniform emerged for working women. Pairing a dark wool skirt with a crisp, long-sleeved white shirtwaist, or blouse, yielded a look that was both practical and professional. These future teachers at the Atlanta Kindergarten Normal School adopted the style, as did scores of other teachers, office workers, and professionals. In 1909, two-thirds of American women in college were preparing to teach, a profession deemed appropriate for women. *Students at the Atlanta Kindergarten Normal School; unattributed; Atlanta, c. 1913.*

The Reconstruction-era vigilante organization, the Ku Klux Klan, was revitalized in the Atlanta area in the mid-1910s. Klan members hoped to "save" the South by spreading a message of white supremacy and anti-Semitism and by targeting African Americans, Jews, immigrants, Roman Catholics, labor organizers, and others suspected of defying societal norms. Women were admitted into the Klan in 1921, one year after they got the right to vote. A newspaper proclaimed the group's rationale: "Well, may the Colored citizen now prepare for serious trouble. 'The female of the species is more deadly than the male.'" Letterhead for the Betsy Ross Klan No. 1 Women's Department lists its address as 204 1/2 Moreland Avenue in southeast Atlanta. Klan robes were intended to ensure anonymity, but membership was often disclosed. Demand for the robes and printed materials kept dozens of employees busy at the robe and printing plants in Buckhead. *Cotton Ku Klux Klan uniform; unassociated; c. 1921. (Atlanta History Center collection; Jonathan Hollada, photographer.)*

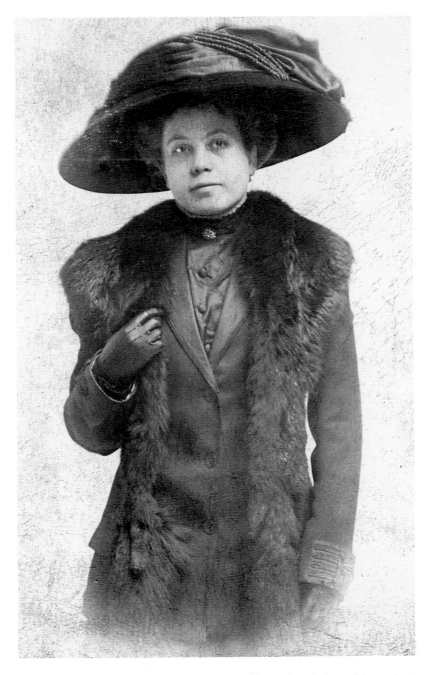

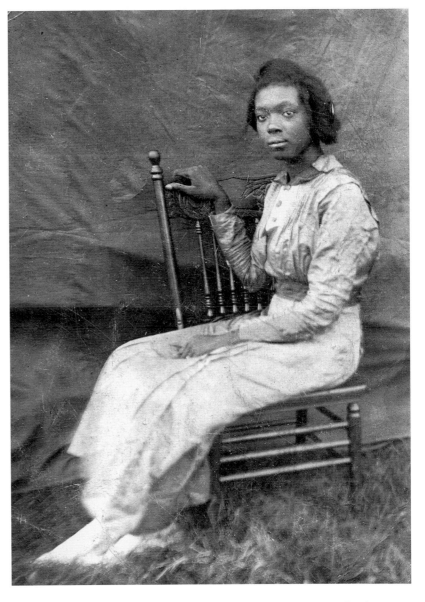

The Atlanta city directories list two African-American women by the name of Fannie Adams; one was a teacher and the other a cook. Due to their second-class status, African-American women were restricted to separate fountains, back seats on public transportation, and black-only establishments. *Alberta "Fannie" Adams; unattributed; c. 1910.*

The well-to-do women of Auburn Avenue dressed as fashionably as their white counterparts. In the early 20th century, the epitome of fashion for street wear required a well-tailored suit and refined accessories such as furs and eye-catching hats. *Unidentified subject; unattributed; c. 1908.*

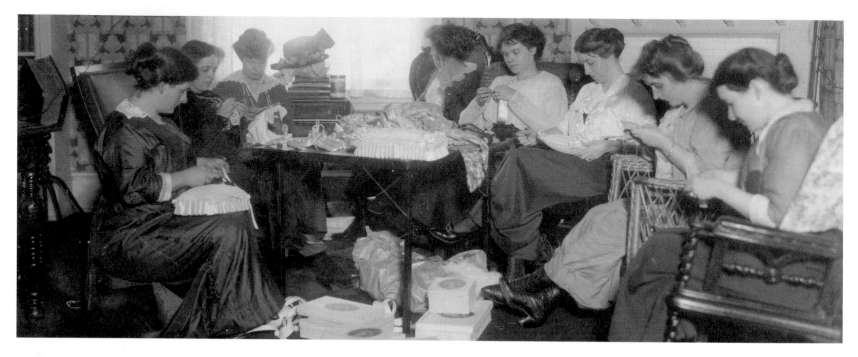

Despite the urgent call by some Atlantans for progress, including the right for women to vote, many women advocated equally for tradition. The Junior Order of Old Fashioned Women sewed at the home of Florence Jackson Bryan for their 1913 bazaar. *Pictured from left to right: Florence Jackson Bryan (Mrs. Shepard Bryan), Myrtice Scott West (Mrs. H.F. West), Louise Black MacDougald (Mrs. John F. MacDougald), Susan Calhoun Oglesby (Mrs. Junius G. Oglesby Jr.), Roline Clarke Adair (Mrs. A.D. Adair), Frances Carter Jordan (Mrs. Lee Jordan), Julia Porter Block (Mrs. E. Bates Block), and Evelyn Parsons Jackson (Mrs. Marion M. Jackson); unattributed; Atlanta, 1913.*

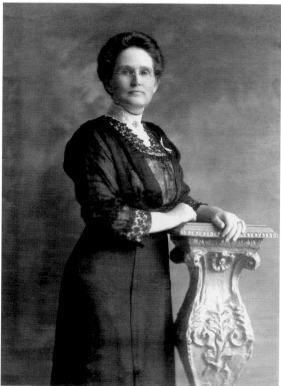

Mary Harris Armour, nicknamed the "Georgia Cyclone," helped establish prohibition, which existed in the state from 1908 until 1935. As in other regions of the United States, temperance reformers in the Southeast were often evangelical Protestants who viewed alcoholic beverages as a societal evil that destroyed families and fostered crime, poverty, and violence. African-American and white women established separate temperance unions in Atlanta in the 1880s. *Mary Harris Armour; unattributed; c. 1908.*

Some early 20th-century women activists believed that a refined appearance and genteel manners would help them achieve radical political goals. Rebecca Latimer Felton (the first woman to serve in the United States Senate) and her younger sister, Mary Latimer McLendon, were leaders in Georgia's woman suffrage and prohibition movements. In 1894, McLendon established the Atlanta chapter of the Georgia Woman Suffrage Association, serving as its president from 1896 to 1899 and again from 1906 until her death in 1921. *Suffrage advocates in civic parade: Mary L. McLendon drives Mrs. Hardin and Mrs. Grossman; unattributed; Atlanta, 1913.*

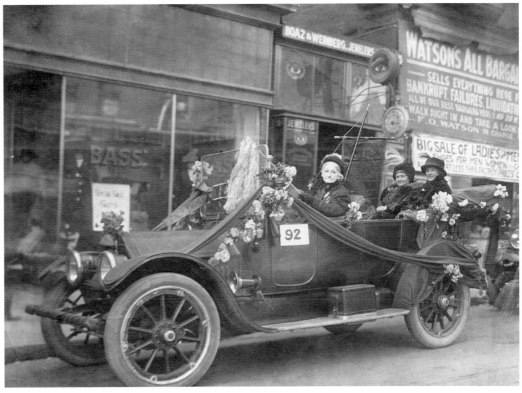

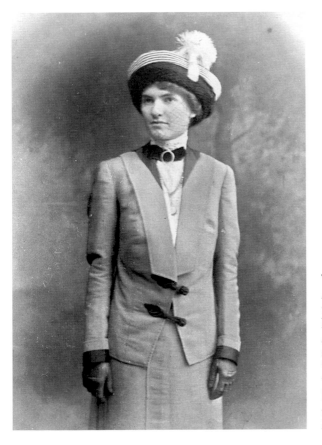

The first unified effort of Georgia's white woman suffrage organizations was a parade held in Atlanta in November 1915. Five hundred participants in cars, on floats, and on foot participated in this event, which was the first suffrage parade in the Southeast. Eleanore Raoul, mounted astride her white horse, led the procession, but not everyone supported the cause. "After it was over," the Atlanta native said, "I went to the stable to put my horse away. Some young men started booing me and said that giving women the right to vote would be the end of chivalry in the South. I replied 'This is chivalry?' They didn't say another word." Eleanore's sister, Mary, recalled that Eleanore "had the talent of dressing to suit her style—and the effect was stunning." The straightforward lines of suffragists' tailored clothing echoed their simple call: "Votes for Women." *Eleanore Raoul; unattributed; c. 1914. (From the Raoul Family Papers, courtesy of the Special Collections and Archives Division, Robert W. Woodruff Library, Emory University.)*

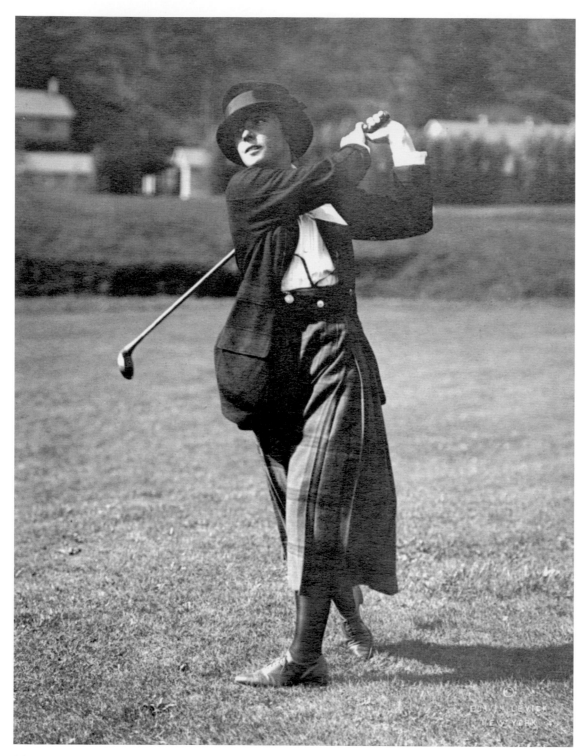

Before Bobby Jones, Alexa Stirling was the first Atlanta golfer to gain national attention, blazing a trail for women golfers and beginning a rich legacy that has spanned more than a century. Stirling won numerous regional and national competitions and was a three-time winner of the U.S. Woman's Amateur title. She won her first national title in 1916 at the Belmont Spring Country Club and remains the youngest champion on record. *Alexa Stirling; Edwin Levick, photographer; Belmont Spring Country Club, Waverly, Massachusetts, 1916.*

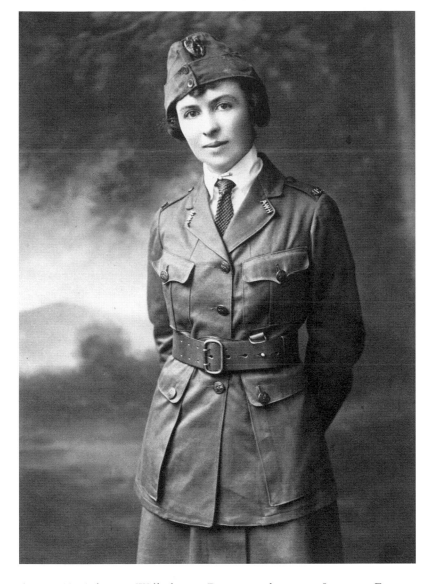

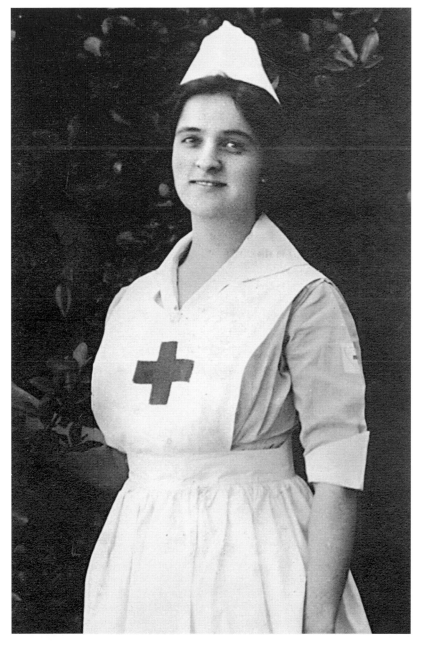

At age 18, Atlantan Wilhelmina Drummond went to Luzancy, France, where she served with the American Women's Hospital for two years during World War I. As a chauffeur for the hospital unit, she serviced her car, changing up to six tires per day; fortunately, she could change one in 20 minutes. When needed, she also served as a nurse and French translator. Her khaki uniform with leather trim was adapted from common military styles of the day. Women's activities during World War I increased support for the passage of the suffrage amendment in 1920. Drummond's uniform is in the collection of the Atlanta History Center. *Wilhelmina Drummond; Otto Sarony Company, photographer; New York, 1918.*

Most women participating in the war effort served as nurses and entertainers. Nell Hodgson Woodruff was one of many Atlanta women who volunteered with the American Red Cross. At home, women were involved in bond drives, hostess centers at local army posts, and nursing units. *Nell Hodgson Woodruff (Mrs. Robert W. Woodruff); unattributed; Atlanta, c. 1914.*

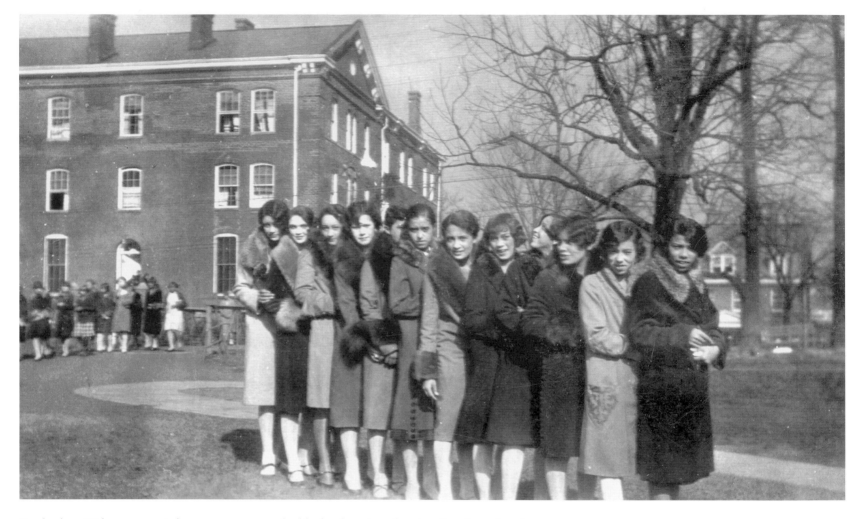

By the late 19th century, Atlanta was a center for black education, drawing female and male students from across the country. In 1929, Atlanta University, Morehouse College, and Spelman College came together as the Atlanta University System; it later became the largest consortium of historically African-American educational institutions in the United States. For college students in the Jazz Age, calf-length, shawl-collared raccoon coats were extremely popular yet too warm for Southern climates. Anxious to fit in with their peers, Atlanta students adopted fur-collared coats instead. The female icons of the 1920s, the so-called flappers, were named for another fashion trend—wearing their galoshes unbuckled. On many college campuses, women expressed their youthful rebellion through bobbed hair and short dresses as well as smoking, drinking, and frank discussions of sex. These well-heeled Atlanta University coeds have embraced popular dress and hair styles but show no outward signs of impropriety. *Ann Rucker (second from left) with friends; unattributed; c. 1926.*

FIVE

FASHIONING
SPIRITED AND RESOURCEFUL WOMEN
1920–1939

Due in part to the city's expanding borders through the annexation of new communities like Edgewood, Kirkwood, and West End, Atlanta's population grew steadily, reaching 300,000 by the close of the 1930s. Continued economic growth paralleled the physical expansion. Early 20th-century civic and business leaders envisioned an Atlanta to rival other American cities in its cultural and recreational offerings. In this era, the "Sweet" Auburn area, centered on Auburn Avenue, flourished as the hub of African-American life, affording blacks new economic, political, and cultural opportunities.

In the 20th century, many women embraced modernity by displaying their sexuality and claiming space in the city. During the 1920s, shorter dresses, bobbed hair, and daring dances gave women a new look and a new attitude—and alarmed those who saw these changes as signs of civilization in decay. Despite the growing number of women seeking employment outside the home, the Great Depression encouraged a legislative and social reaction against any change in women's traditional roles as homemakers and mothers, overshadowing the political and social gains of the previous two decades.

Surprising as it may seem, Atlanta suffragists persuaded the city's Democratic Executive Committee to allow white women to vote in city primaries in 1919. With the passage of the 19th Amendment to the U.S. Constitution, women got the right to vote in August 1920. On Election Day, November 8, 1920, women—both black and white—arrived at polling places throughout Atlanta and demanded to vote. In all but one ward, they were denied on a technicality: they had not registered the requisite six months in advance. The 100 or so votes cast by women in the Sixth Ward (80 percent by African Americans) were excluded. The Georgia legislature did not ratify the 19th Amendment until 1970, although women voted in statewide elections beginning in 1922.

More than 40 percent of Atlanta's women worked for wages in 1920, the third highest percentage in the country. Most were employed as teachers, nurses, domestics, factory workers, and in other familiar roles, but increasing numbers of women entered traditionally male fields, including architecture, journalism, and business, even filling seats on corporate boards. During the economic downturn of the 1930s, going to college became a rare privilege, unthinkable to most families. The rebellious spirit of the "flappers" of the 1920s seemed frivolous to young women confronting economic catastrophe.

The experience of Atlantans during the Depression echoed the national themes of business and bank failure, high unemployment, widespread hunger, and poverty. In 1932, thousands of unemployed black and white workers marched on the courthouse to protest the inadequacy of city relief measures. President Franklin Delano Roosevelt's New Deal efforts allocated significant federal funds for public works projects throughout the United States, $7 million of which was designated for Atlanta.

The economic crisis of the 1930s meant that Americans bought and made less clothing than in previous years. It was common for a woman to remake a man's suit for herself. By taking it apart, cutting it down, and turning the pieces inside out, one could create a tailored suit with a four-gore skirt. Everyday clothes were worn and patched repeatedly until they wore out; scraps were made into quilts. Despite the harsh realities of life, fashion marched forward, influenced by the glamour and opulence of Hollywood, which provided a welcome escape.

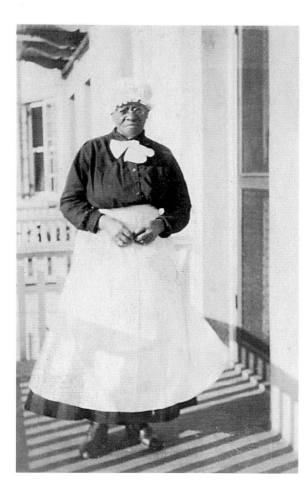

Like many African-American women in the South, Laura Watson, here at age 65, earned a living as a cook for an elite white family. Feeding four generations of the Peters family during her 50 years in their employment suggests that she was either a fine cook, a dependable employee, or, most likely, both. Her dark dress, starched white apron, and necktie lend a neat appearance, while her ruffled cap resembles the turbans worn by previous generations of African-American working women. *Laura Watson; unattributed; Atlanta, November 1923.*

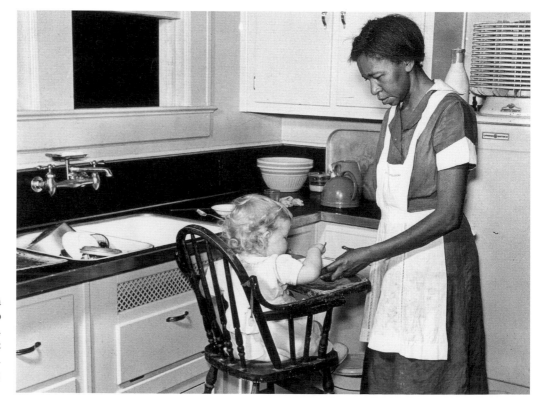

Of the 21,000 African-American women employed in Atlanta in 1930, 90 percent were domestic workers who cooked, cleaned, and cared for their employer's children. When serving at luncheons and other parties, domestic workers often wore uniforms supplied by their employers. *Unidentified child nurse; Marion Post Wolcott, photographer; Atlanta, 1939. (Courtesy of Library of Congress.)*

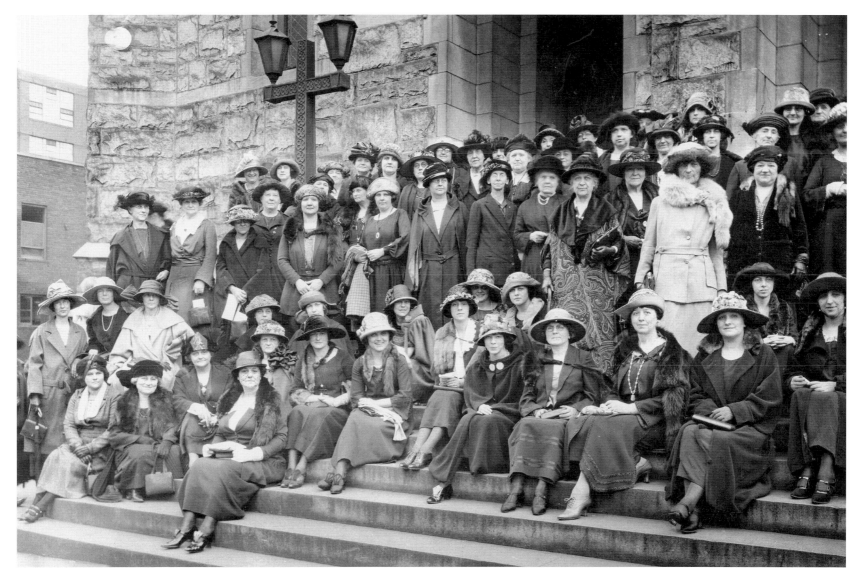

Viewed as the moral compass of society, women—both black and white—continued working for churches, charities, and clubs throughout the city in the 1920s and 1930s. After the 1906 race riot, small efforts were made to promote racial understanding in the city, leading to the creation of the Commission of Interracial Cooperation (CIC) in 1919. An outgrowth of the Women's Committee of CIC was the Atlanta-based Association of Southern Women for the Prevention of Lynching (ASWPL), established by Jessie Daniel Ames in 1930. This organization advocated antiviolence to thousands of white women throughout the South through letter-writing campaigns, conferences, and petition drives. Neither the CIC nor the ASWPL ever questioned the practice of racial separation, nor did the latter include black women in its membership. *Unidentified women at the First Baptist Church; unattributed; Atlanta, c. 1924.*

The need for specialized hair and skin care products for African Americans enabled some black businesswomen, most notably Madame C.J. Walker, to earn a very good living. In Atlanta, Mademoiselle Mabel Driskell marketed her hair and beauty preparations through her Dris-Cura Manufacturing Company and Parlor. The savvy entrepreneur targeted Atlanta University students by advertising in their football program. *Advertisement, The Crimson Hurricane Football Yearbook of Atlanta University; Atlanta, 1923.*

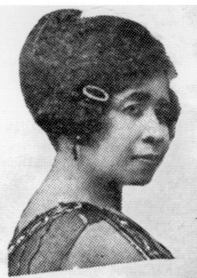

In the 1920s, Atlanta University offered courses for African-American students in high school, normal school, and at the college level. Ann Rucker, the daughter of prominent Atlantans Henry A. Rucker and Annie Eunice Long, graduated from Atlanta University and Hampton Institute and became a librarian at Fisk University. In 1932, the now Ann Rucker Anderson was a librarian at the Auburn Avenue branch of the Carnegie Library, the city's public library for African Americans. *Ann Rucker (center) with friends at Atlanta University; unattributed; Atlanta, c. 1926.*

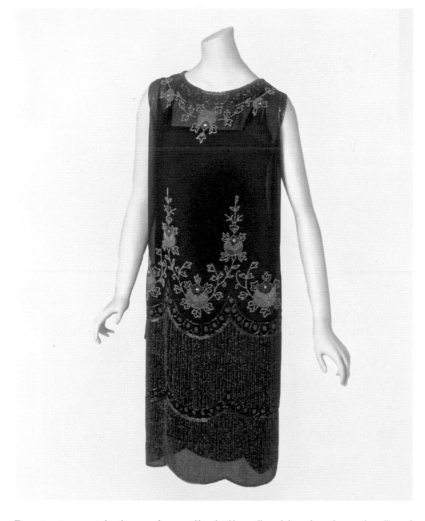

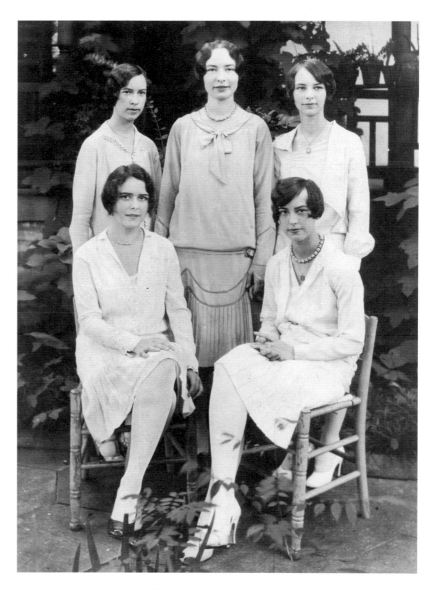

Despite its straight lines, sheer silk chiffon, floral beadwork, and a fluted hem give this dress timeless feminine appeal. In contrast to earlier styles that exaggerated women's natural curves, the boyish "flapper" look of the 1920s minimized them. Young women rejected the restricting corsets of their mothers and grandmothers, instead opting for new brassieres, which became popular for creating the boyish figure. Women eagerly embraced the new style. Critics of this fashion viewed it with disdain and referred to it as "undress" since the boldest women wore only a dress, step-ins (a roomy, one-piece undergarment), stockings, and shoes. In addition, some women rolled their stockings down to an inch or so above the hemline, resulting in a rather coy flash of the knees when they moved. Previously frowned-upon practices, like wearing lipstick, makeup, and smoking in public, became more widely accepted in this era. *Beaded silk dress, likely from Paris; unassociated; c. 1925. (Atlanta History Center collection; Jonathan Hollada, photographer.)*

As the eldest of five sisters, Mary Brown Spalding likely piqued her siblings' interest in fashion, socializing, and boys. In some families, older girls helped raise the younger children to relieve their overworked mothers. Often playing together in their youth, some sisters remained close friends throughout their lives. Mary Temperance Connally Spalding, the girls' mother, was actively involved in the Atlanta Council of the PTA. Proud of their brood, the Spaldings paired this image with one from the girls' childhood for a family Christmas card. In it, the girls were photographed in the family garden, lined up in birth order like neatly spaced stair steps. *Mary Brown, Constance, Frances, Sally, and Elizabeth Spalding; unattributed; Atlanta, 1928.*

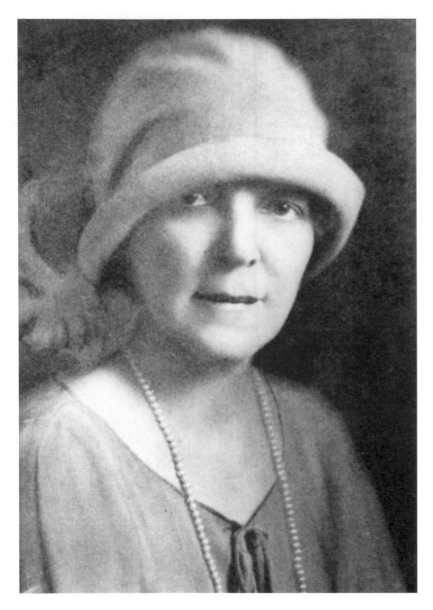

Frances Newman was a local literary figure with a passion for clothing and the color violet. In 1928, writing a friend from Paris, she commented, "I am getting a velvet and a fuchsia evening frock from Nicole Groult." A few weeks later she detailed her purchases: "I am bringing home nine frocks, six hats, five coats, two pairs of shoes . . . two negligees, two pairs of mules, etcetera. If ever, this is the time for the grand amour." *Frances Newman; unattributed; 1929.*

The youngest daughter of a prominent Atlanta family, Frances Newman wrote two modernist novels, *The Hard-Boiled Virgin* (1926) and *Dead Lovers are Faithful Lovers* (1928), about the struggles of Southern women in a male-dominated society. Her novels received mixed reviews for their satire of Southern culture, particularly the restricted roles of women in courtship and marriage. Atlantans were shocked by her portrayal of Southerners; in Boston, her books were banned for their allusions to sexuality. *The Hard-Boiled Virgin* became an immediate best-seller. *Book jacket of* Dead Lovers are Faithful Lovers; *Frances Newman, author; 1928.*

A high-spirited and intellectual youth, Margaret Mitchell started her career as a journalist in 1922 under the name Peggy Mitchell, writing articles, interviews, sketches, and book reviews for the *Atlanta Journal*. She wrote *Gone with the Wind* from 1926 to 1929 while convalescing in her Peachtree Street apartment. Published in 1936, the novel became an overnight best-seller and earned Mitchell the Pulitzer Prize. *Margaret Mitchell (Mrs. John Marsh); unattributed; c. 1920.*

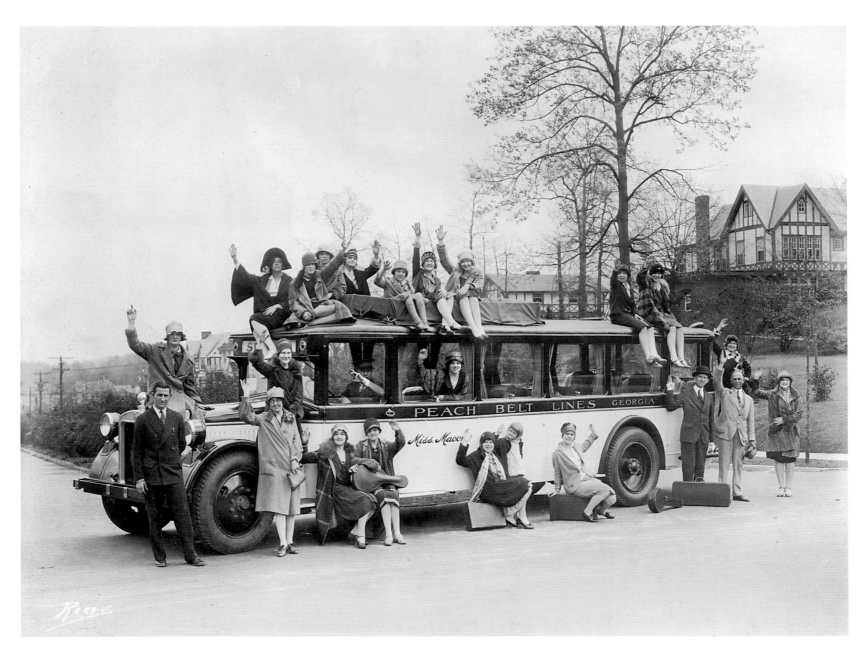

Women who nurtured their musical talent were often admired, provided their selections and playing styles were not too risqué. The fun-loving coeds from both Washington Seminary and the Griffith School of Music in Atlanta took their annual trip to Oxford, where they gave a concert featuring selections of the mandolin and glee club. *Unidentified music students from the Griffith School of Music and Washington Seminary in Oxford, Georgia; Reeves Studio, photographer; Atlanta, c. 1928.*

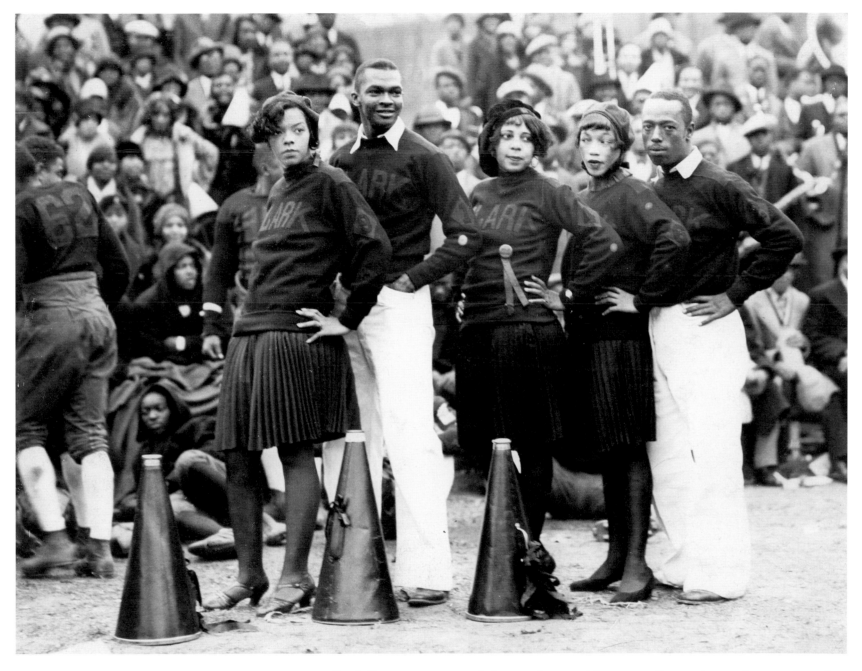

Football games were a central element of campus life, giving college students a chance to show their school spirit. Though the celebrations could be rowdy, the games offered an outlet for students' energy and a sanctioned opportunity to socialize with members of the opposite sex. *Clark College cheerleaders; Reese Green, photographer; Atlanta, c. 1925.*

Candace Bryant designed and knitted the ivory silk and wool dress she wore for her wedding on November 16, 1935. Traditionally, the bride's family assisted in assembling her trousseau of clothing, accessories, and linens in preparation for marriage. For her trousseau, the 1926 graduate of Brenau College in Gainesville, Georgia, made lingerie, including bra and pants sets. Her mother made pairs of garters. Bryant's wedding gown is in the collection of the Atlanta History Center. *Candace Bryant Smith; unattributed; Atlanta, 1935.*

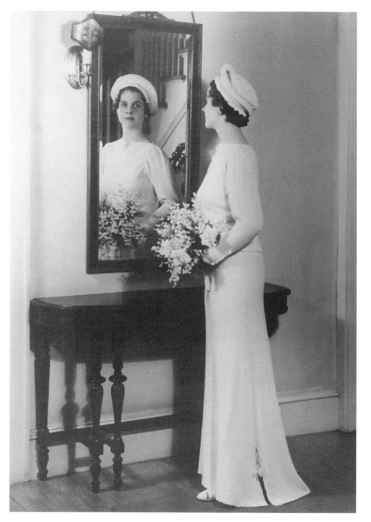

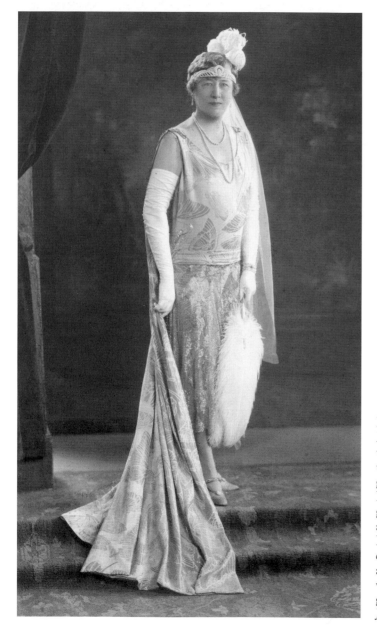

In May 1928, Sarah Frances Grant Slaton sailed from New York to London on the *Ile de France* for her presentation to the Court of St. James. Many Americans believed one of the highest social honors attainable in the early 20th century was official presentation to European royalty. Slaton received the invitation after she and her husband, the former governor of Georgia, met the king and queen while attending a garden party at Buckingham Palace in 1926. Appropriate dress for ladies at the Court of St. James included a trained gown, feather fan, and three ostrich plumes worn in the hair, symbolizing the coat of arms of the Prince of Wales, whose official London residence is the Palace of St. James. Protocol governed details of court dress, including skirt length, neckline depth, and other details, although individuals expressed personal taste through their selections of fabric and accessories. The simple lines of this regal trained gown emphasize the sumptuous brocade, which features metallic gold threads against a peach silk ground. Slaton's presentation gown is in the collection of the Atlanta History Center. *Sarah Frances Grant Slaton (Mrs. John M. Slaton); Lafayette Limited, photographer; London, June 12, 1928.*

With its somber fabrics and lack of adornment, mourning clothing projected an individual's grief while honoring the dead. During the Victorian era, mourning observances became a part of daily life. Etiquette manuals advised a widow to wear plain black for two years following her husband's death, leaving off her mourning cap and crape in the latter months. An additional six months wearing "half mourning" were considered in good taste. People usually observed these customs only to the extent their resources allowed. Given the typical large size of families, women could conceivably spend a large part of their lives in mourning attire. It should come as no surprise, then, that mourning dress could be quite fashionable and also translated into significant business for its purveyors.

When two men murdered Willard Smith, a drugstore clerk, in 1928, young Mary Belle Smith became a widow. The trials of the accused were dramatic: one was sentenced to the electric chair and the other left two hung juries before he pleaded guilty in a third trial. Escorted by her mother, the lovely young widow was often the center of attention. Her appearance in a black veil at one of Richard Gallogly's three trials was particularly striking, since by the late 1920s mourning was less strictly observed. *Mary Belle Smith (Mrs. Willard Smith); Kenneth Rogers, photographer; Atlanta, 1929.*

During the Victorian era, Atlanta's black- and white-owned businesses were generally located side-by-side. With the enactment of Jim Crow legislation, however, black-owned and -operated businesses became centralized along Auburn Avenue and limited their services to black patrons. During the 1920s, "Sweet" Auburn became a vibrant center for African Americans, offering goods and services to people from all walks of life. In this decade, the neighborhood grew dramatically and the number of black-owned entrepreneurs and professionals nearly doubled. Big Bethel A.M.E., like other churches in the city, was an important gathering place for women in the community. *Auburn Avenue; unattributed; Atlanta, c. 1940.*

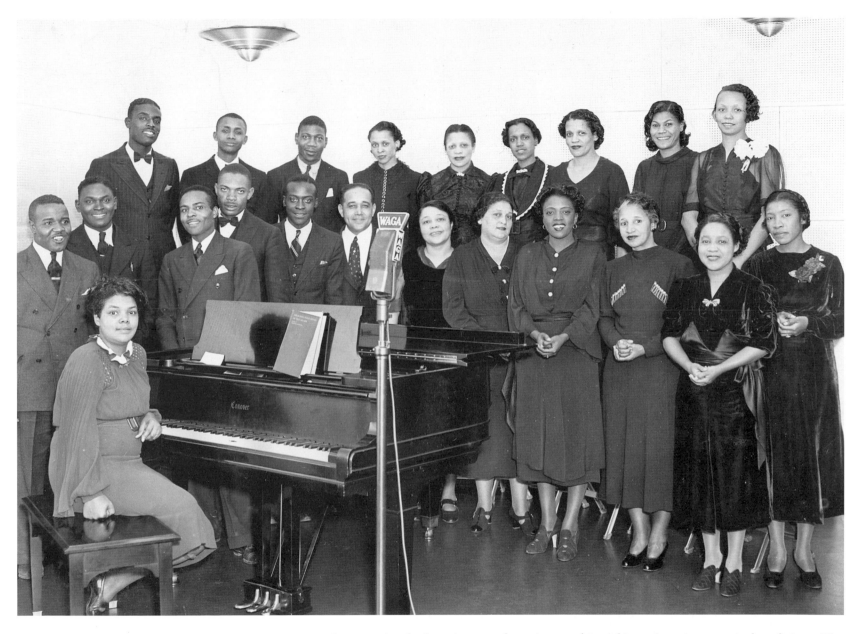

Jazz, a uniquely American art form, is rooted in African-American musical traditions. The popularity of jazz in American cities afforded black musicians opportunities to perform for large audiences and be heard on the radio. Listeners also enjoyed traditional hymns, gospel music, and popular tunes of the day. In Atlanta, Walter Aiken formed the Aiken Singers, who appeared on WAGA radio. Composed of graduates from more than a dozen colleges throughout the country, this ensemble was the first regularly featured African-American radio choir from the region. *The Aiken Singers; unattributed; Atlanta, c. 1938.*

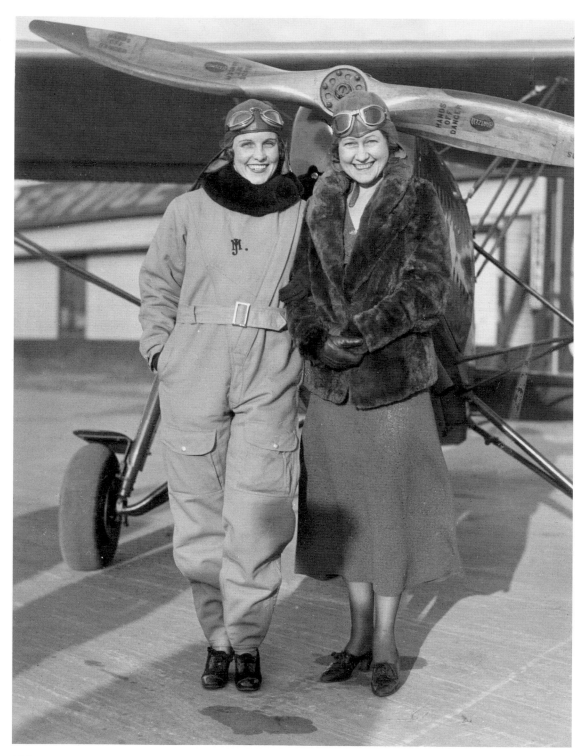

Four Atlanta flyers—Madaline Dickerson Johnson, Charlotte Frye, Erin Darden, and Ruth Mohr—established a chapter of the 99 Club, a national organization for women pilots. In 1934, they welcomed all 621 other members to visit their new clubhouse at Candler Field. The enthusiastic local 99ers flew to picnics and participated in popular contests, including the All-American Air Races. Often referred to as aviatrixes, the early women flyers fascinated the public and often became local or national celebrities. Newspapers regularly reported on female pilots, and the stories invariably described flying clothes, including denim coveralls, riding breeches and putties, and whipcord jodhpurs. The women enjoyed the freedom of flying and apparently the attention it garnered. When Johnson's daughter, little Madaline, was two months old, one newspaper reported, "Mrs. Johnson laughingly remarked that she would begin to teach her daughter to fly 'just as soon as she is big enough to sit in front of the controls.'" Johnson's flight ensemble is in the collection of the Atlanta History Center. *Madaline Dickerson Johnson (left) and Ruth Mohr; unattributed; Atlanta, c. 1934.*

By the 1930s, commercial airlines had begun to make air travel available to businessmen and other travelers. The industry also created new jobs for young women; early stewardesses were required to be certified nurses. Eastern Air Transport, later Eastern Air Lines, began daily Condor service between Atlanta and New York in December 1930. Buelah Unruh was one of Eastern's first air hostesses and appeared in a Coca-Cola advertisement promoting the airline's in-flight service. "Atlantans," recalled one Eastern stewardess, "liked their Cokes first thing in the morning." *Buelah Unruh; advertisement photograph, unattributed; Atlanta, c. 1935.*

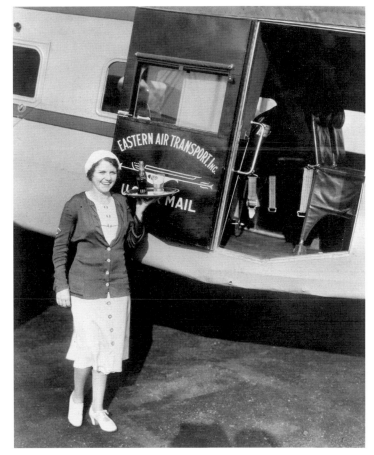

As shop clerks, many young women earned wages that enabled them to purchase small luxuries like stylish accessories, beauty products, movie tickets, and novels. Atlanta was home to several well-known department stores, including Rich's, Davison's, and Regenstein's. Shopping was an important social event for many women, who would never dream of heading to the store without a hat and gloves. Retailers catered to their clientele, even promoting "business girls' specials," which held merchandise until the lunch hour. *Unidentified salesgirl; Marion Post Wolcott, photographer; Atlanta, c. 1939. (Courtesy of Library of Congress.)*

105

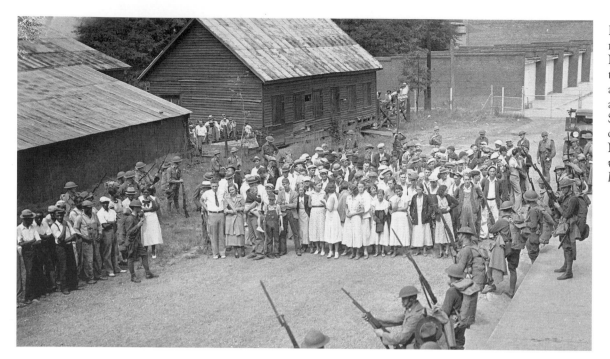

In 1934, textile workers from Atlanta joined a nationwide strike to protest violations of the National Industrial Recovery Act. Although the New Deal legislation recognized unions and gave workers the right to organize, hostile anti-union sentiments persisted in most Southern mills. During the 1934 strike, many of the strikers were detained by the Georgia National Guard at Fort McPherson. *Textile workers' strike; Kenneth Rogers, photographer; Fort McPherson, Georgia, 1934.*

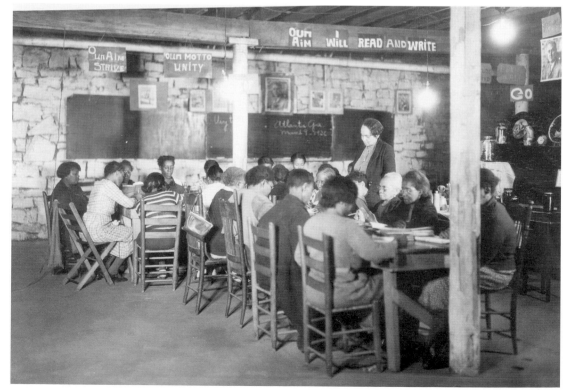

The $7 million in federal funds allocated to Atlanta through the Works Progress Administration (WPA) employed thousands of men who erected schools, built a new sewer system, and improved roads. The Women's Work Division taught literacy classes, ran nurseries, and directed service projects, most of which were racially segregated. In 1934, President Roosevelt placed a professional social worker, Gay Shepperson, in charge of Georgia's relief programs. *Literacy education class; unattributed; Atlanta, c. 1935.*

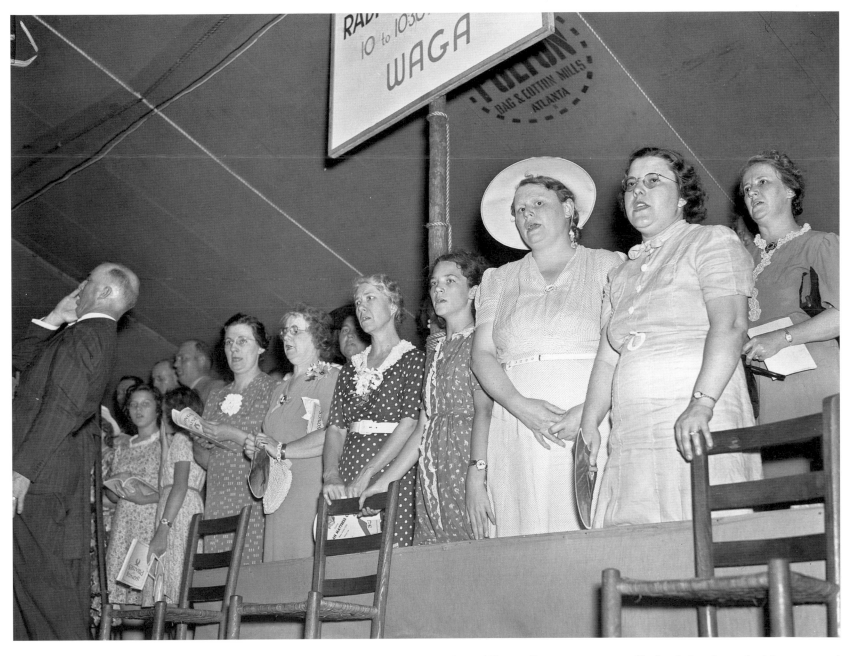

In the South, tent revivals could be small meetings organized by local churches or highly anticipated community events that lasted for several weeks and featured nationally known evangelists. At these spiritual gatherings, some churchgoers were freed from the constraints of Sunday morning worship. The revivals offered much-needed emotional refuge during difficult times. *Unidentified women with Rev. J.M. Hendley in Inman Park; Bill Wilson, photographer; Atlanta, 1939.*

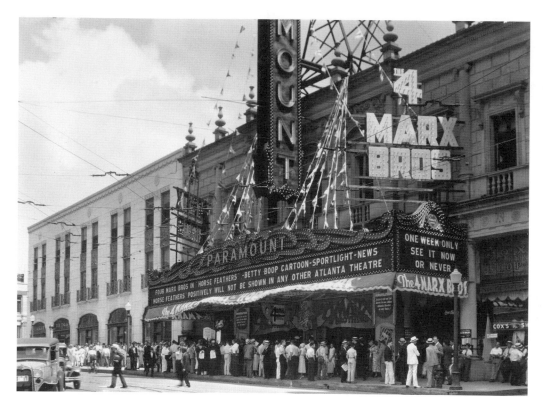

Despite the hardships wrought by the Depression, movie houses thrived in the 1930s. Offering an escape from the adversities of daily life, the luxury and glamour of Hollywood films appealed to every segment of the population. Performances by Shirley Temple, Clark Gable, Will Rogers, and the Marx Brothers, among others, left a lasting impression on a generation of moviegoers. Actors Clarence Muse, Bill Robinson, Hattie McDaniel, and Atlantan Daniel Haynes were particularly popular with African-American audiences. *Paramount Theater on Peachtree Street; William Dunn, photographer; Atlanta, 1933.*

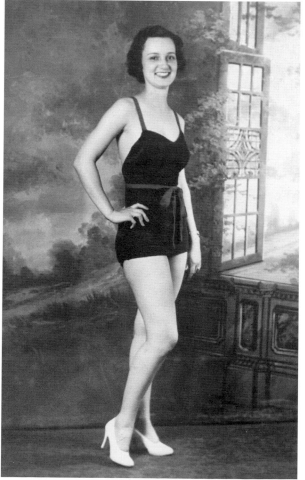

Only a decade after coy young women dared to roll their stockings down to expose their knees, beauty contestants appeared in close-fitting, low-cut bathing suits on public stages across the United States. Unlike the boyish figure of the 1920s, the new physical ideal was slim and athletic, yet decidedly feminine. Taking cues from Hollywood, evening gowns of the 1930s often featured body-skimming, bias-cut dresses with floor-sweeping hems that set off a woman's curves. *Loyce York, Miss Atlanta; H & W Studio, photographer; Atlanta, 1936.*

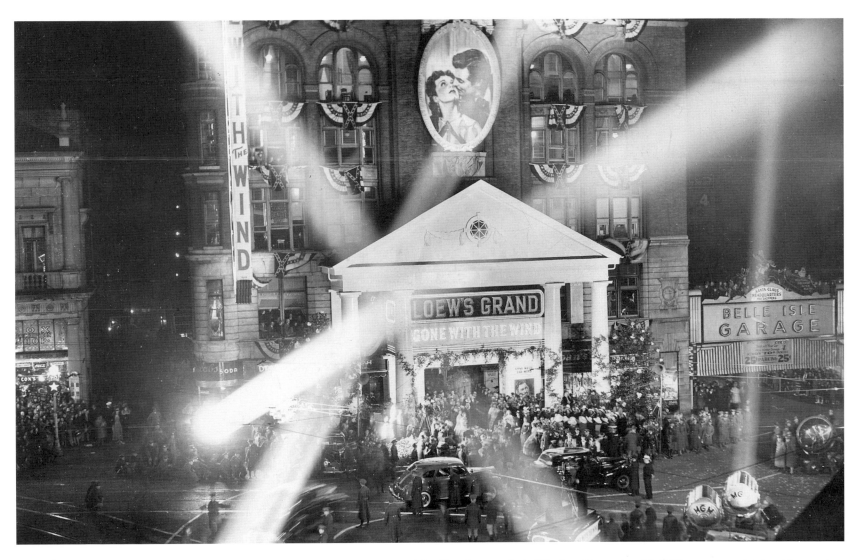

The premiere of the film *Gone with the Wind* on December 15, 1939, was one of Atlanta's grandest occasions. The week's numerous celebrations included a historic-costume ball reportedly attended by 5,000 people and a parade to Loew's Grand Theater. Film stars Vivien Leigh, Clark Gable, and Olivia de Haviland joined author Margaret Mitchell and the film's producer, David Selznick, for the first screening of the Technicolor production. In a radio interview with *Atlanta Journal Magazine* editor Medora Field Perkerson, the novelist offered some insight into her heroine's scandalous behavior, and that of some of Mitchell's contemporaries as well. "The sorrow and hardships and poverty of the Civil War changed Scarlett O'Hara from a normal southern girl to a hardened adventuress—just as the wild period following the [first] World War made modern girls cut loose from their mothers' apron strings and do shocking things." The film adaptation of the Pulitzer Prize–winning novel made Mitchell's lead character O'Hara an icon of the strong-willed Southern woman. Gone with the Wind *premiere; unattributed; Atlanta, December 15, 1939.*

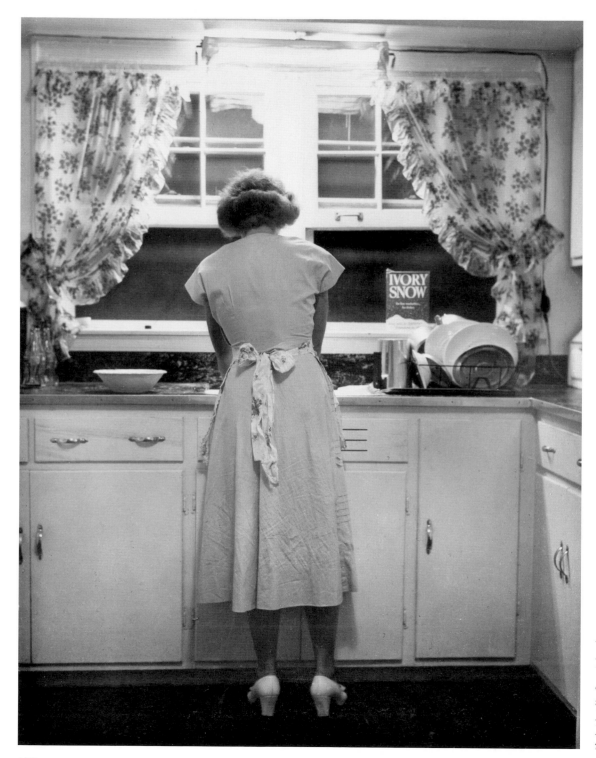

The image of the "happy homemaker" became highly idealized in the years following World War II. A woman was expected to nurture her children, support her husband, play hostess to family and friends, and help manage the household budget. After welcoming her children home from school with freshly baked cookies and milk, she greeted her hardworking husband at the door wearing a neat dress, high heels, and fresh lipstick, and they all sat down to a lovingly prepared meal. Though many women felt fulfilled in this role, modern housewives often experienced isolation in their new suburban lives. For some, housekeeping became a never-ending cycle of cooking, vacuuming, mopping, and scrubbing, leaving little time for herself. *Housewife on Alton Road, NW; Courtland F. Luce Jr., photographer and Dixie Camera Club member; Atlanta, September 1949.*

LABORING
PATRIOTS AND HOUSEWIVES
1940–1959

With the harsh decade of the 1930s behind them and slow but steady economic improvement, Atlantans had reason for hope. World War II propelled the city into a new era of growth and prosperity. Over the course of the 1940s, Atlanta's population grew from about 300,000, one-third of whom were African American, to an official population of more than 330,000. Although city leaders envisioned Atlanta as one of the country's largest and most influential cities, it remained primarily a regional center for commerce and transportation. In the years immediately following World War II, race relations and politics in Atlanta were marked by several pivotal events, including the 1946 black voter registration drive and the creation of the Atlanta Negro Voters League in 1949. The 1951 Plan of Improvement restructured government responsibilities of the City of Atlanta and Fulton County and led to the annexation of densely populated areas to the north and south. As a result, Atlanta's land base tripled to 118 square miles, adding 100,000 new residents to its population, which exceeded 428,000 the following year.

When the United States entered World War II in 1941, 6.5 million women were ushered into the workforce to fill jobs traditionally reserved for men.

Public policy encouraged women to support the war effort by working, and many found employment in factories, in offices, and on military bases. These new roles altered society's views on women and domesticity, but as soldiers returned from the war, most women were forced out of their jobs. In the 1950s, women continued to experience new opportunities in work, education, and community activism, but under the constraints of the domestic ideal. Although greater numbers of young women attended college, many were said to be there only to earn an "M.R.S." degree.

Whether taking factory work or volunteering for military service, many "Rosie the Riveters," office clerks, and other workers entered the job market for the first time. Nationally, over 250,000 women served in the U.S. military during World War II. Each branch of service had a women's corps with its own officers and training centers. Most women were assigned to clerical and administrative jobs that freed men to fight on the front lines. Many others worked in highly skilled maintenance and technical jobs, including piloting aircraft, servicing engines, and decoding messages. Like their male counterparts, both black and white women joined the armed services. Women would serve their

country again when the Korean War erupted in June 1950. The experience women gained during military service often led to successful careers after the war.

Despite the uncertainty of wartime life, women continued their daily routines of cooking, cleaning, and child rearing, often without their husbands. These tasks were made more difficult by food, gasoline, and clothing rationing, which limited each citizen to one pair of leather shoes per year. Civilians made important contributions during World War II by cultivating backyard victory gardens. People were urged to grow food because, as the secretary of agriculture put it, "Food will win the war and write the peace."

After World War II, the emerging Cold War and "feminine mystique" often discouraged women's political and economic aspirations for equality. New, full-skirted fashions emphasized women's natural curves and sometimes embellished them with padding at the shoulders and hips. These postwar styles, with their detailed construction, ornamentation, and yards of fabric, symbolized hope for the future. At the same time, the introduction of the television into millions of homes and the "ideal" family depicted on popular TV shows, like

Leave it to Beaver and *Father Knows Best*, permeated the American psyche. Many middle-class women strived to be model homemakers and were often viewed with suspicion if they worked outside the home. Nevertheless, the number of women in the workforce continued to rise in the 1950s. Surprisingly, new women workers were increasingly likely to be middle-aged and middle-class. In the 1950s, the average age at which women married was 20, the youngest in 60 years. The country's strong economy fostered a baby boom—the birthrate soared between 1946 and 1964. The traditional family ideal was also reinforced by the growth of suburbs, which appealed to young couples and families by offering affordable homes, new modern conveniences, and easier commutes on new interstate highways.

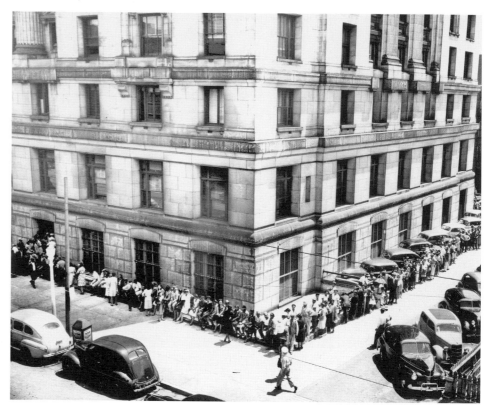

The U.S. Supreme Court set the stage for African Americans to advocate for social change in the South when it outlawed the all-white primary in 1944. Two years later, numerous African-American organizations came together as the All-Citizens Registration Committee and organized a massive drive to register black voters. According to Clarence Bacote, "This effort lasted for fifty-one days. We were able to increase the registration of blacks in Fulton County from about 7,000 to 24,750. And that's when we were going to be recognized" (Kuhn, Joye, and West, 337). The registration line wound around the courthouse. *Voter registration line; unattributed; Atlanta, 1946.*

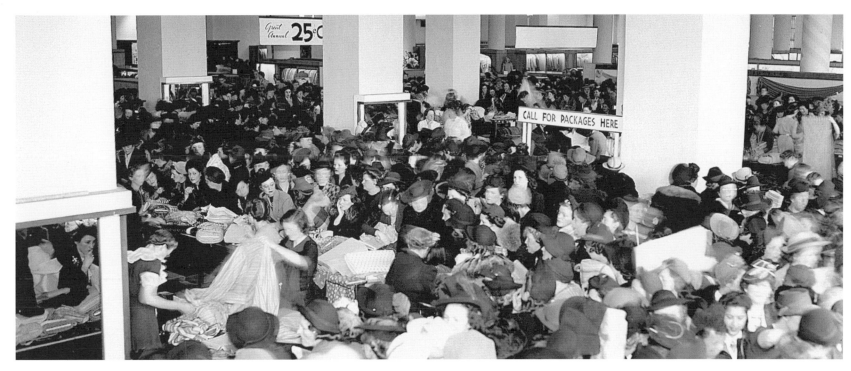

Sales in the fabric department of Rich's downtown store appealed to budget-conscious women as much as discounted ready-to-wear garments and accessories. Noting that women were sewing fewer new garments as a result of rationing and patriotic efforts, some companies offered sewing patterns to help women update existing garments and remain stylish at minimal expense. *Rich's department store; Lane Brothers, photographer; Atlanta, c. 1942. (Courtesy of the Special Collections Department, Georgia State University Library.)*

This serviceable wool dress in Rich's signature dark green was the work uniform for female elevator operators. Like much of the support staff, most elevator operators were African American. Many employers recognized the significant effect of uniforms on employee morale. *Transportation Magazine* recommended: "Get enough size variety in operator's uniforms so that each girl can have a proper fit. This point can't be stressed too much in keeping women happy." *Wool uniform by Pat Lesser; unassociated; c. 1945. (Atlanta History Center collection; Jonathan Hollada, photographer.)*

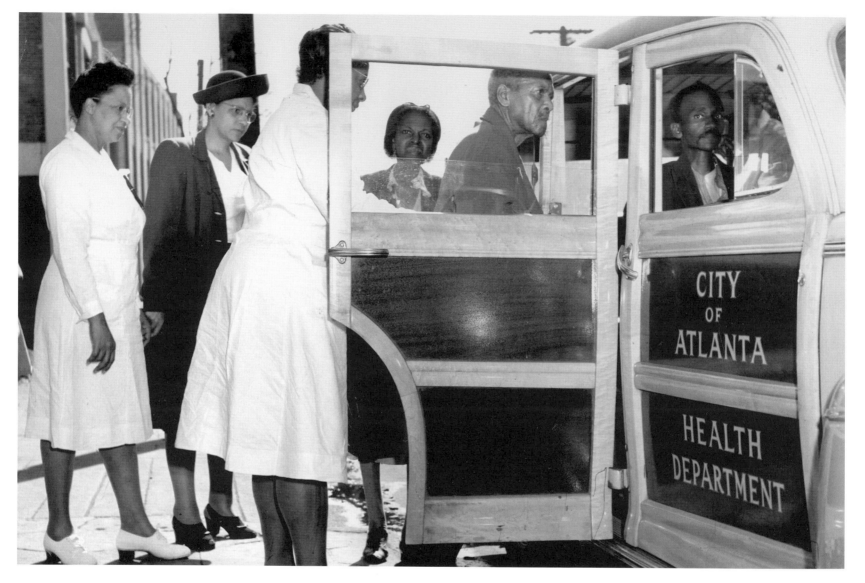

First established in 1907, the Atlanta Anti-Tuberculosis and Visiting Nurse Association offered treatment for tuberculosis to those unable to obtain hospital care. Supported by private donations as well as city and county funding, the organization served both white and black patients. Lucy Cherry headed the Negro Program for the association in the 1940s. Like its white counterpart, the program emphasized health education and early detection, provided clinic and home care for the indigent, and was staffed by paid professionals and volunteers. The work of this and other anti-tuberculosis organizations helped to lower dramatically the national death rate from the disease by the 1970s. *Lucy Cherry, director of the Negro Program for the association (second from left), with public health nurses; Lane Brothers, photographer; Atlanta, 1940. (Courtesy of the Special Collections Department, Georgia State University Library.)*

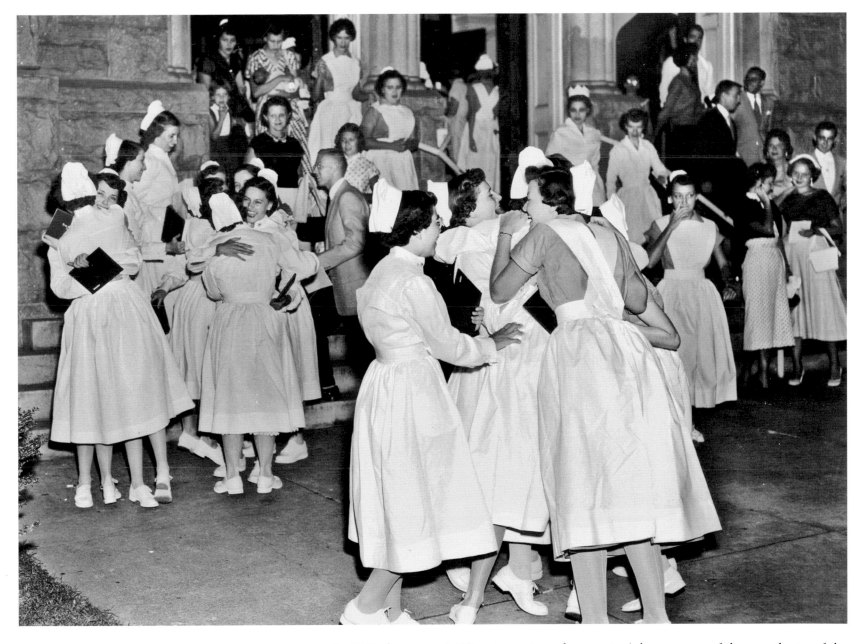

In 1955, there were 2,439 active registered nurses in Atlanta, many of them graduates of the Beaumont School of Vocational Nursing, Emory School of Nursing, Grady Memorial Hospital School of Nursing, and other local schools. Although African-American midwives were accepted in both black and white communities, black nurses had a difficult time maintaining employment in their chosen field. In 1947, the Urban League reported only 111 black registered nurses in the city. *Grady Memorial Hospital School of Nursing graduates; unattributed; Atlanta, c. 1955.*

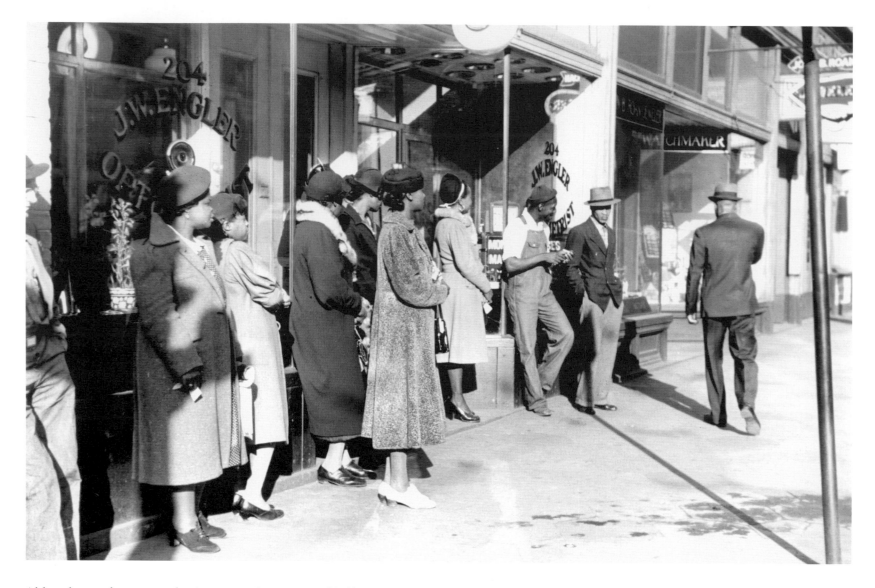

Although most domestic workers' commutes by streetcar added hours to their workdays, a few black enclaves existed in otherwise white neighborhoods. Alice Adams recalled her daily routine: "I would leave home early in the morning, [be] on the job at seven, leave this job at seven, then get home around eight. You'd leave home in the dark, get back at dark. You never knew what home looked like. . . . I'll tell you what it was—long hours and little pay" (Kuhn, Joye, and West, 113). It was common for a domestic to work six or seven days a week and to earn only 50¢ a day. *Streetcar stop; Marion Post Wolcott, photographer; Atlanta, c. 1940. (Courtesy of Library of Congress.)*

The first floor of James and Solange Hawkins' West Peachtree Street home was used for his chiropractic office. Many white families of moderate means could afford to hire help, since domestic workers received low wages. Middle-class women freed from various housekeeping duties often chose to volunteer in the community or pursue their own careers. *Dr. James A. Hawkins and Solange Alberta Loiselet Hawkins; unattributed; Atlanta, Easter 1949.*

Working for the Hawkins family meant that Mae Joyce was away from her own family on Easter Sunday. Many domestics, including cooks, were responsible for childcare. Dorothy Bolden recollected, "You gave as much love to their children as you would give to yours, almost. You respected the child and you protected the child in that home while you was working. That child was top priority in that home and you had to give that child comfort, cause their momma and daddy was gone all the time" (Kuhn, Joye, and West, 116). *Pictured from left to right: Solange Hawkins, Mae Joyce, and Andrea Hawkins; unattributed; Atlanta, Easter 1949.*

Most women in the armed forces wanted to appear polished and feminine. Many WAVES (Women Accepted for Volunteer Emergency Service) found their uniforms flattering and functional in any weather. The hat came with a neck-protecting havelock, while the handbag had a detachable strap, interior pockets, and pen holder. The first WAVES supplied their own footwear, which was not always as serviceable. "We march EVERYWHERE," wrote Lt. Elizabeth Setze of her military training. "You should see us marching five blocks to our meals! So far my feet, with my 1 1/2-inch heeled shoes are all right, but most of the others are sporting blisters." *Graduates and cadets of the Naval Training School for WAVES; U.S. Navy, photographer; Milledgeville, Georgia, 1943.*

This image of May Lewis Alston serving Lt. Elizabeth Setze at the Terminal Station USO suggests the various ways American women supported the war effort. Setze, an Atlanta native, was assigned to Smith College in Northampton, Massachusetts, where she trained the first class of women naval officer candidates in 1942. By the end of World War II, more than 83,000 women had volunteered for service with the U.S. Navy in the WAVES. Among military personnel, the WAVES were particularly proud to wear the smart-looking uniforms designed by American fashion designer Mainbocher, which featured a distinctive rounded collar overlapping a pointed lapel. Setze served in the naval reserves until her retirement in 1963. *May Lewis Alston (Mrs. Philip H. Alston) and Lt. Elizabeth Setze; unattributed; Atlanta, 1942.*

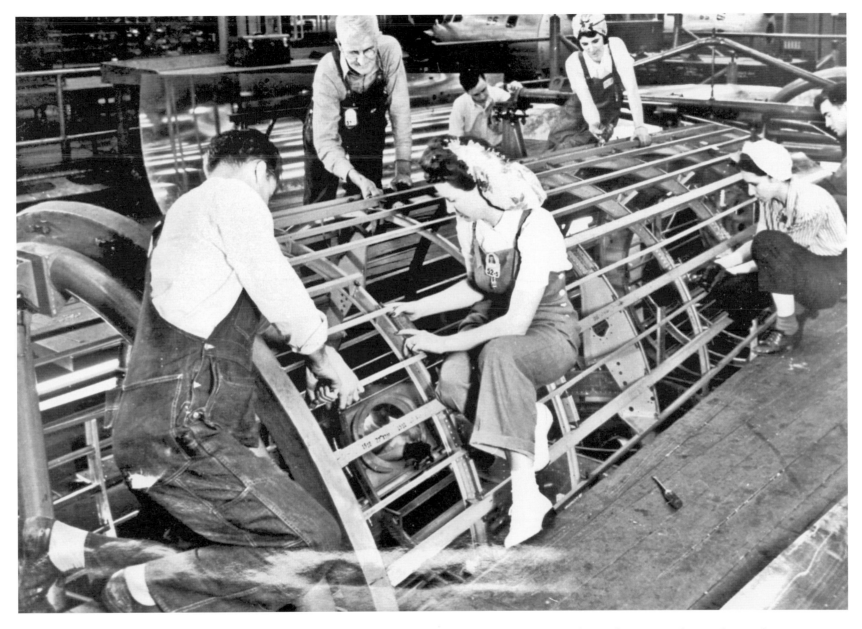

In the years before "Rosie the Riveter" adopted casual trousers as her uniform, a few women were wearing them for work and play. Striving to retain their femininity, some female factory workers wore head coverings, lipstick, and heeled oxfords with their utilitarian pants. Bell Aircraft in Marietta, which manufactured B-29s, was the Atlanta area's biggest wartime industry. At its height in 1945, the plant employed 28,000 people. Ten percent of its employees were African American; women comprised more than one-third of the workforce. *Bell Aircraft employees; unattributed; Marietta, Georgia, c. 1943.*

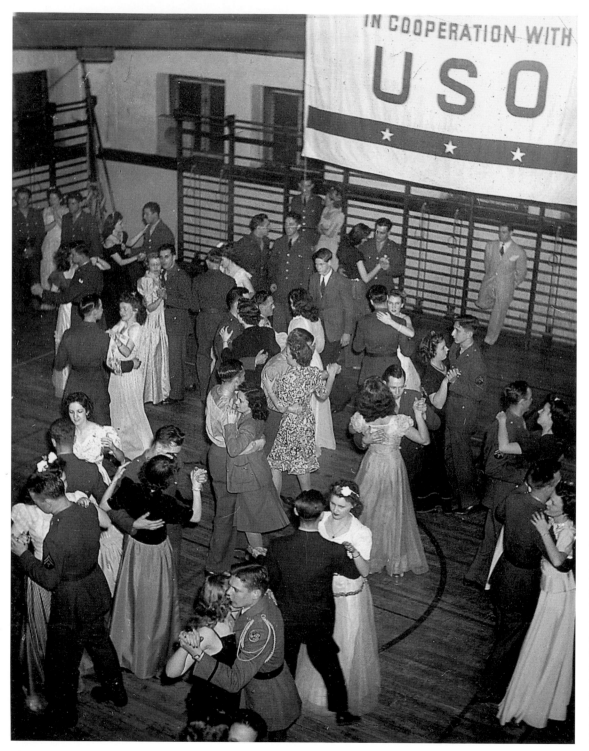

United Service Organizations (USOs) were particularly active in Atlanta since more than one million troops stationed on nearby military bases visited the city during the war. To boost morale, local women played key roles in organizing dances and other distractions, such as sightseeing, attending church services, and even sharing a home-cooked meal. Coeds from Atlanta's traditionally black colleges volunteered at the USO center on Hunter Street to sponsor dances, dinners, athletic contests, and other entertainments. Like all branches of the military, USO activities were segregated. *USO dance; unattributed; Atlanta, c. 1943.*

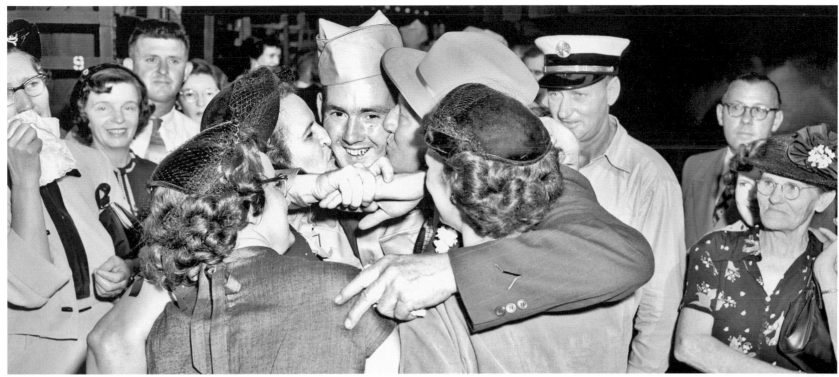

One soldier's safe homecoming brought joy and relief to his family, who inundated him with hugs and kisses at Atlanta's Union Station. The Korean War, like the Vietnam War, continues for the families of those who are still missing and presumed dead. *Unidentified prisoner of war returning home; Bill Wilson, photographer; Union Station, Atlanta, September 1953.*

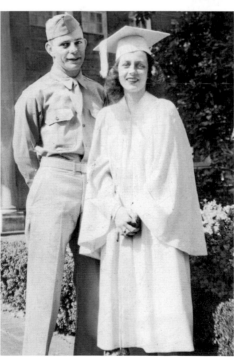

Pictured here with his sister Helen, Atlantan Ernest Beaudry was killed in combat near Aachen, Germany, just six months after joining the army at the age of 21. Although the war brought economic prosperity and jobs to many Atlantans, its residents lived in constant fear that a loved one would die or be seriously injured in military service. *Ernest and Helen Beaudry; unattributed; Atlanta, 1943.*

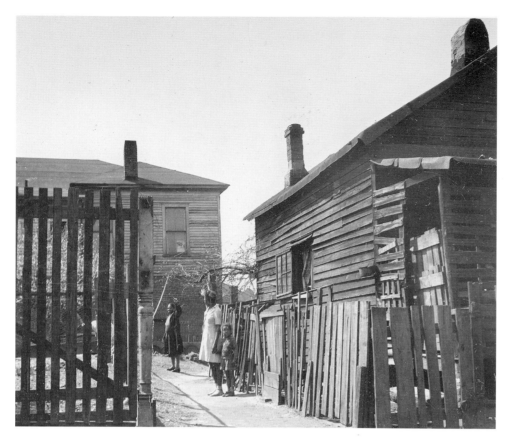

As part of the New Deal, Atlanta was chosen as the site for the first public housing in the United States—Techwood Homes for whites and University Homes for blacks. Despite national and local efforts, overcrowded and dilapidated housing remained a widespread problem in Atlanta after World War II. Housing options for African Americans were extremely limited because of discriminatory lending practices, restrictive deeds and covenants, zoning regulations, and violence. *Unidentified subjects at urban residences; Julian Maddox, photographer; Atlanta, 1948.*

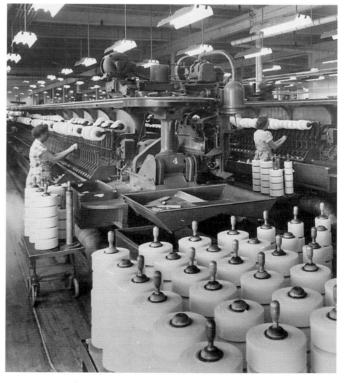

Like elsewhere in the Southeast, Atlanta's Fulton Bag and Cotton Mill and Exposition Cotton Mill created villages by providing company stores and affordable housing adjacent to their mills. Entire families worked in a mill, often spending most of their lives in the village. As was common in the industry, Nanny Washburn was hired at the Exposition mill at age eight and worked with her sister, who later joined the United Textile Workers of America. *Geneva York (left) and Gertie Peppers; Gabriel Benzur, photographer; Atlanta, c. 1950.*

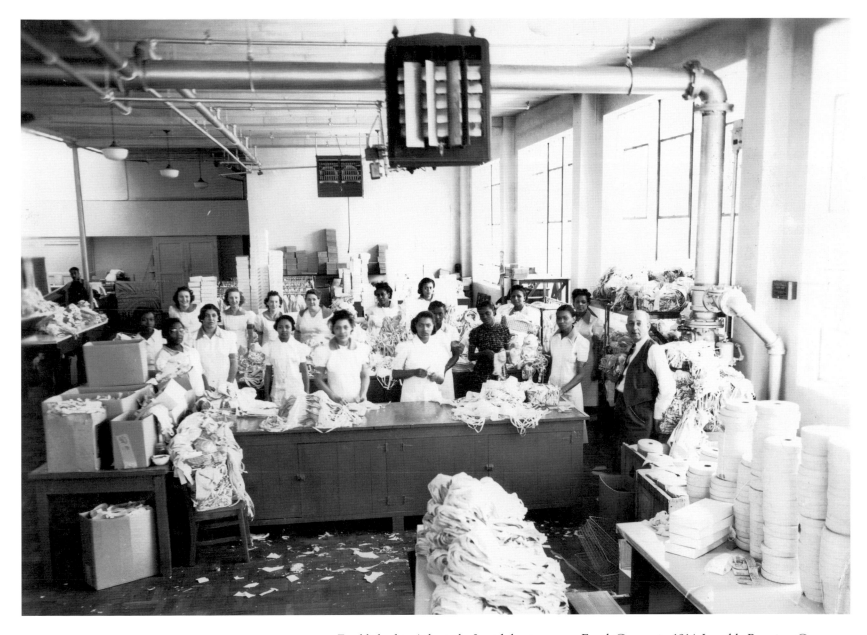

Established in Atlanta by Jewish businessman Frank Garson in 1914, Lovable Brassiere Company became "the world's leading producer of popular priced bra fashions." Beginning in the 1930s, Lovable fully integrated its factories and lunchrooms. The company was progressive for its wages as well; workers received $9 per week, $4 above the regional average. Lovable's marketing was aimed at both white and black consumers, though all of the advertising featured white models. *Lovable Brassiere employees; unattributed; Atlanta, c. 1940. (Courtesy of the Ida Pearle and Joseph Cuba Archives of the William Breman Jewish Heritage Museum.)*

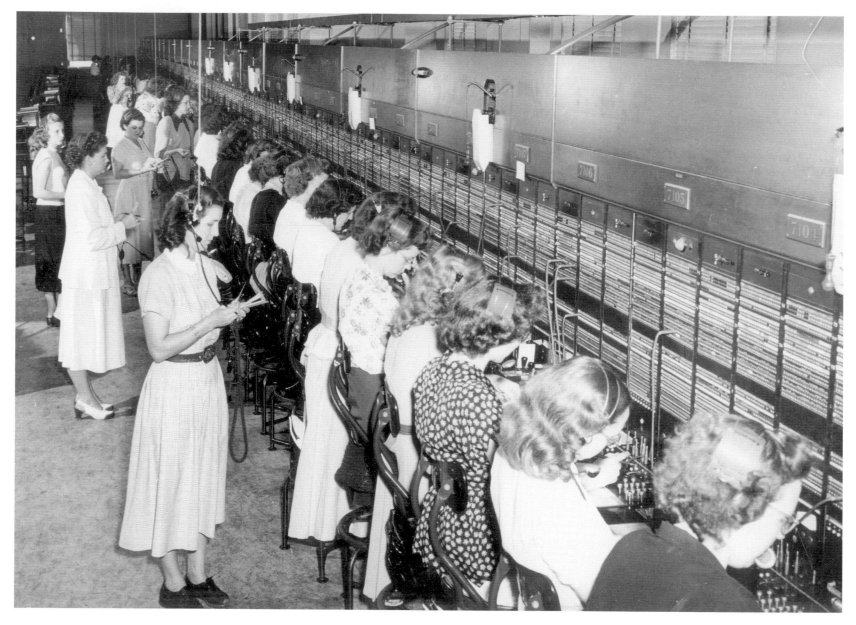

Women served as telephone operators from the early days of the industry when switchboard operators connected each caller to the desired number. Although operators usually sat during their shifts, the job could be fast-paced and required close attention to detail. Many operators enjoyed the social aspect of the job, whether assisting customers or visiting with co-workers. These conventionally feminine jobs became more attractive after the war with the renewed emphasis on traditional women's roles. *Southern Bell telephone operators; Julian Maddox, photographer; Atlanta, c. 1947.*

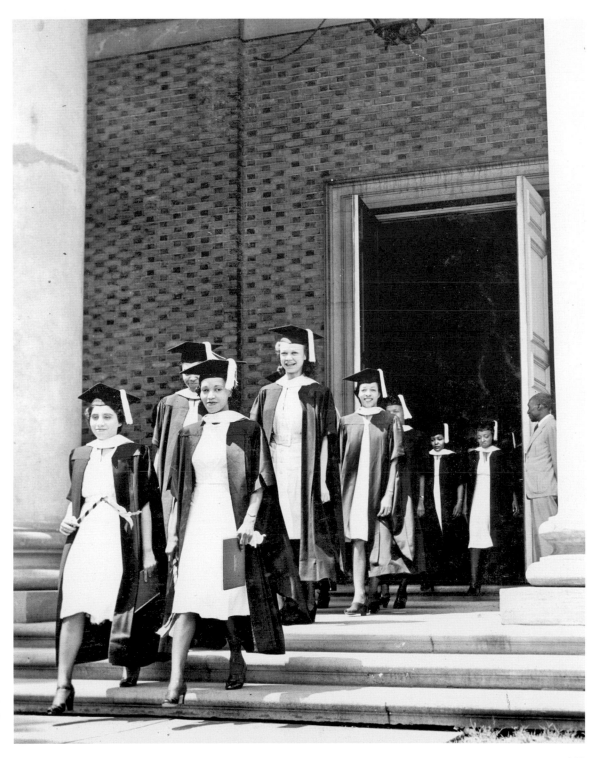

In 1940, graduating from college was a major step in overcoming class barriers. Beginning in 1944, the GI Bill enabled several million veterans to enroll in college—an opportunity many men could not have realized otherwise. That same year, the United Negro College Fund (UNCF) was established to coordinate the fund-raising efforts of the country's all-black, private institutions of higher learning. The primary goal of UNCF was to raise scholarship funds so more African-American men and women could attend college. *Atlanta University graduates; unattributed; Atlanta, June 1942.*

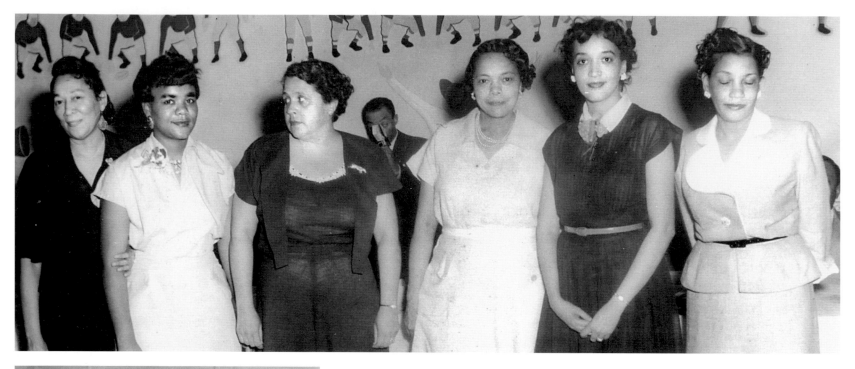

These women pose after a Hungry Club Forum meeting at the Butler Street YMCA, which has long been one of the most important meeting places for Atlanta's African Americans. The club, whose motto is "Food for taste and food for thought for those who hunger for knowledge and information," has met weekly at the Y since 1945. Each meeting features a speaker prominent in politics, government, business, education, or a related field. In the club's early days, white guests were rare; later, everyone, especially politicians, eagerly sought invitations. *Unidentified Hungry Club Forum attendees; unattributed; Atlanta, 1951.*

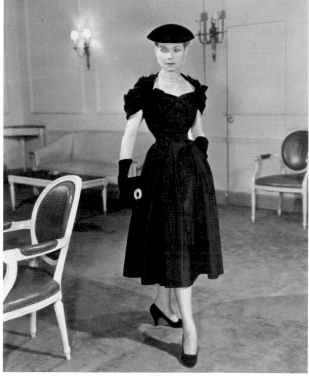

The era of nipped waists and full skirts ushered in by Christian Dior's "New Look" in 1947 signified a return to more traditional women's roles, one reminiscent of bygone days in which women presumably recognized that their place was in the home. Several years later, in a nod to Atlanta's growing prominence, Dior designed the city's namesake black taffeta cocktail dress. *Model wearing Dior's "Atlanta" dress;* Journal-Constitution Magazine; *Atlanta, 1951.*

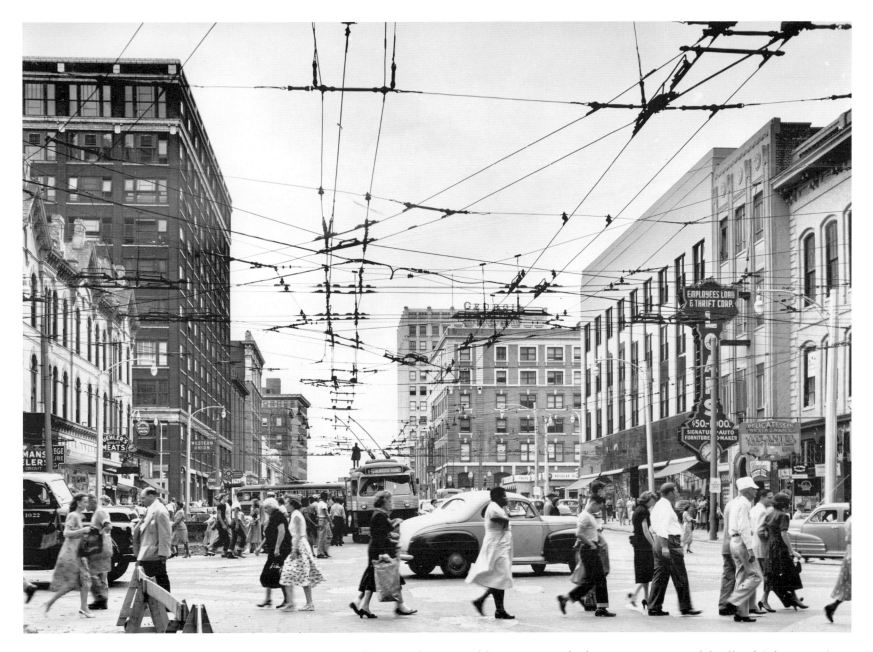

In addition to shopping, athletic events, and other amusements, city life offered Atlanta residents a variety of cultural activities, including regular performances by the Metropolitan Opera, the Atlanta Civic Ballet, and the Atlanta Symphony Orchestra. *Downtown Atlanta; Gabriel Benzur, photographer; Atlanta, 1951.*

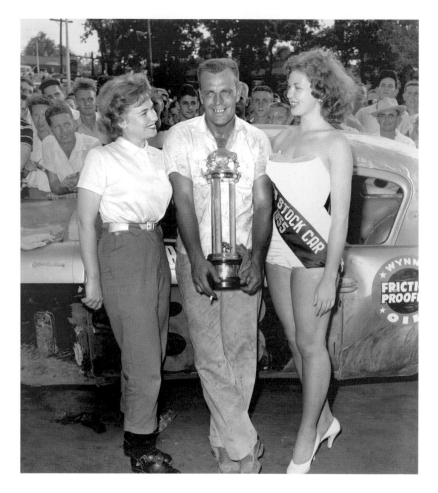

With its exhibits of art, livestock, machinery, rides, games, performances, and other amusements, many couples considered the Southeastern Fair a great place to go on a date. *Unidentified visitors at the Southeastern Fair; Bill Wilson, photographer; Lakewood Park, Atlanta, 1959.*

Atlanta sports fans flocked to stock car races at the Lakewood Race Track, where attractive young women flanked driver Paul Smith as he accepted his first-place trophy. As the photographer Bill Wilson observed, "They always had a beauty queen or something who always snuggled up and kissed the winner of the race." American culture in the 1950s glorified the curvaceous feminine form presented in movies, magazines, and beauty pageants. Given the era's focus on traditional women's roles, it is not surprising that the gauge for beauty was the hourglass figure—whether clothed in pants and motorcycle boots or a bathing suit and heels. *Pictured from left to right: unidentified fan, Paul Smith, and Miss Stock Car 1955; Bill Wilson, photographer; Atlanta, 1955.*

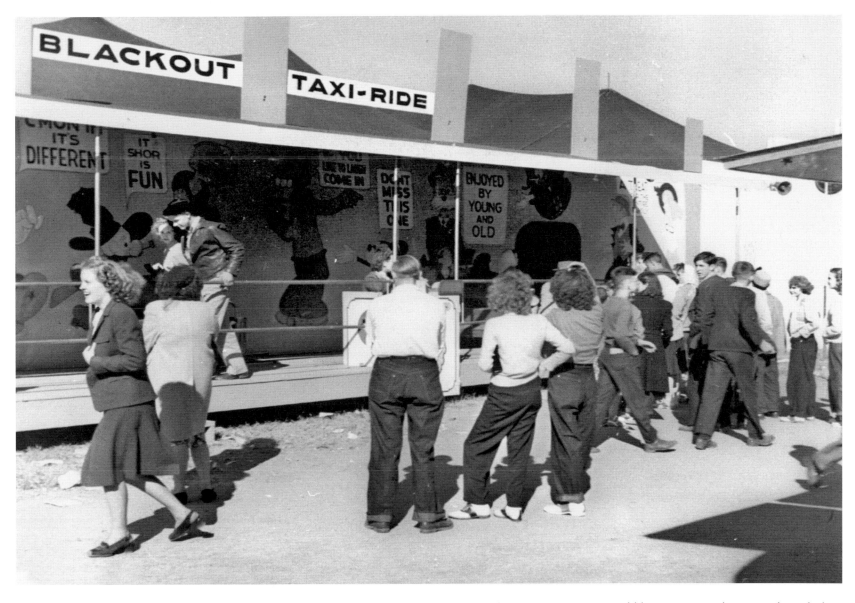

In the 1950s, teenagers across the country incorporated blue jeans into their casual wardrobes. Wholesome girls often wore their dungarees with sweater sets and saddle shoes, while clean-cut boys opted for button-down shirts and oxfords. Many youths tuned their radios to rock 'n' roll stations to hear the latest hits by Elvis Presley, Little Richard, Fats Domino, Brenda Lee, and a host of other acts. *Unidentified fairgoers; Courtland F. Luce Jr., photographer and member of the Atlanta and Dixie Camera Clubs; Atlanta, c. 1959.*

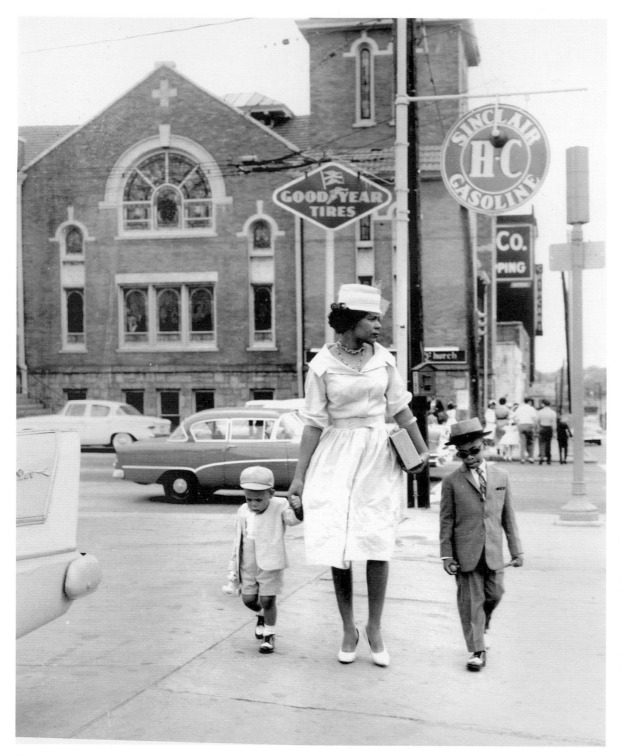

The fashionable Helen Jackson, wife of prominent musician Graham Jackson, strolled along a city street with her two young sons. A favorite musician of President Franklin Delano Roosevelt, Graham Jackson built a replica of the President's Little White House in Warm Springs, Georgia. Jackson's Little White House is located on White House Drive in southwest Atlanta. Elite African Americans called Atlanta their home long before the former slave Alonzo F. Herndon became the city's first black millionaire by offering life insurance to African Americans. *Helen Balton Jackson (Mrs. Graham Jackson) with sons Gerald (left) and Graham Jr.; unattributed; c. 1960.*

REVAMPING
ADVOCATES AND DETERMINED WOMEN
1960–1979

In 1960, the population of the city of Atlanta was over 487,000, while the metropolitan area contained more than 1.3 million people. The decade that followed saw new areas of the city opened for black residential development, particularly in the southwest. Shifting neighborhood boundaries hastened white Atlantans' flight to the suburbs, and by 1970, the city of Atlanta had a majority African-American population for the first time in its history. During the 1970s, the population boomed, and by 1980, over 2.2 million people called the Atlanta metro area home.

The 1960s witnessed a burst of social activism and the questioning of traditional authority on several fronts. African Americans began to exert their growing political power and break down the color line in politics, education, and housing. Many joined the civil rights movement to combat racism, segregation, and inequality. In 1963, some 250,000 blacks and whites gathered in Washington, D.C., to lobby for civil rights, at that time the single largest protest demonstration in American history. There, renowned Atlantan Martin Luther King Jr. delivered his famous "I Have a Dream" speech.

As women participated in the civil rights movement, they developed skills necessary to lobby on behalf of women's equality as well. Supporters of equal rights for women generally fell into two camps. The more traditional group, who sought legal and constitutional victories, was generally older, married, white, and middle-class. They formed the National Organization for Women (NOW) in 1966, adopting the National Association for the Advancement of Colored People (NAACP) as one of their models. The younger activists were more radical and tended to be women who were active in civil rights organizations such as the Student Non-Violent Coordinating Committee (SNCC). Instead of large formal organizations, these activists generally formed smaller "consciousness-raising" groups. These two branches of the women's movement frequently clashed over goals and tactics, but together their efforts transformed attitudes and beliefs about women and gender.

In this era, when more and more women went to college in preparation for careers, girls helped integrate public schools. In 1961, seven years after *Brown v. Board of Education* determined that racial segregation in public schools was unconstitutional, Atlanta began the court-ordered desegregation of its public schools. Selected students, chosen from a pool of 133 applicants, peacefully integrated four Atlanta high schools—Northside, Henry Grady, Brown, and Murphy. Some students were profoundly affected by the experience of integration and went on to become leaders in both the civil rights and women's rights movements.

Social and political tensions worsened when the United States began sending troops to Vietnam in 1964. Thousands of men and women served in the military, and as the years wore on, the draft and the war itself became the focus of a new protest movement. Some citizens expressed their opposition to the war through sit-ins and demonstrations, which occasionally turned violent. Despite the uncertainty associated with this era, most women's daily lives continued to revolve around the traditional activities of home and family life. Many families required the second income of a wife and mother, yet women of all races were often relegated to unskilled, low-paying jobs.

A major shift in women's clothing occurred in the 1960s, when street chic began influencing high style. The emphasis on youth went hand-in-hand with revolutions in American culture. Conservative, moderate, and radical fashions reflected political values. Afro-wearing blacks demonstrated pride

in their own cultural heritage; some long-haired whites (dismissed as "peaceniks" and "hippies") rejected traditional values; feminists dispensed with their bras. These styles eventually trickled into mainstream fashion, often without their political connotations. The civil rights movement, women's liberation, and the sexual revolution helped redefine what women could do, what they could wear, and what occupational and recreational opportunities and resources were available to them.

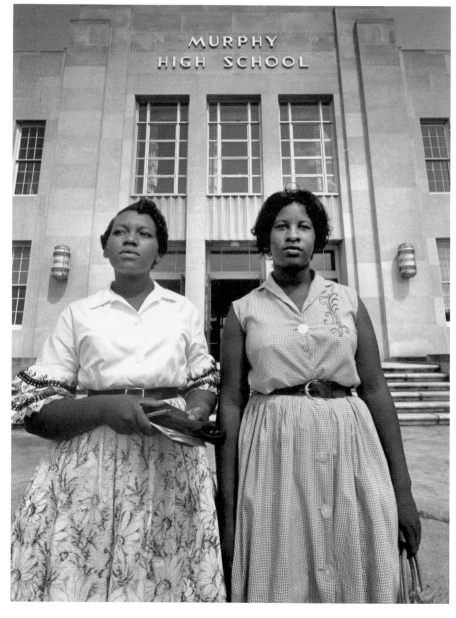

These two girls were among the nine African-American students who peacefully integrated four Atlanta high schools on September 1, 1961. An NAACP suit filed against the city school system in 1958 provided the catalyst for this change. After *Brown v. Board of Education*, school desegregation became a central focus in the struggle for racial equality. Integration in Atlanta schools was peaceful, unlike in many other Southern cities. *Students integrating Murphy High School; Bill Wilson, photographer; Atlanta, 1961.*

This image of a southwest Atlanta ballet studio shows how girls often pursued traditional extracurricular activities like dance classes, etiquette training, and music lessons, despite the turbulence of the 1960s. These activities helped girls build self-confidence and allowed them to foster friendships and social graces. *Ballet studio; Boyd Lewis, photographer; Atlanta, c. 1965.*

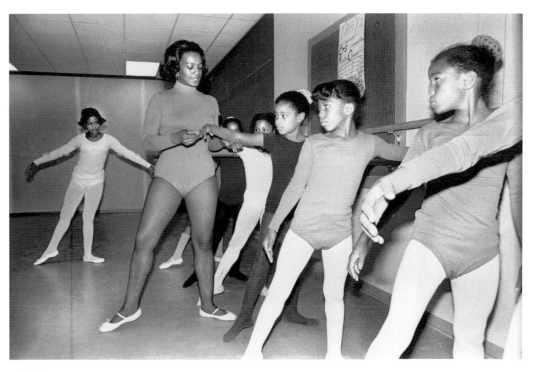

The successes of the women's rights movement opened new doors for women in education and in the workplace. In 1975, more than 3.5 million American women were enrolled in college—about the same number as men. *Clark College graduates; Boyd Lewis, photographer; Atlanta, 1975.*

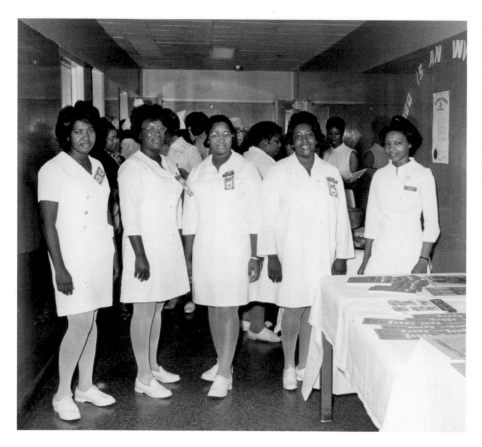

Uniforms, though generally a conservative form of dress, do not escape the influence of fashion. These Grady Memorial Hospital nurses adopted necklines, sleeve lengths, and hemlines to suit their individual tastes. Because polyester did not need ironing, did not wear out, and held its color after repeated washings, it was very popular in the 1960s and 1970s for everyday clothing as well as sophisticated evening styles. In this era, few professional women wore pants to work, but those who did, including some Delta Air Lines flight attendants, usually wore them over a girdle and pantyhose. *Pictured from left to right: Johnnie Allen, Mary Glenn, Barbara Smith, Mattie Burrell, and Mildred Monroe; unattributed; Atlanta, c. 1975.*

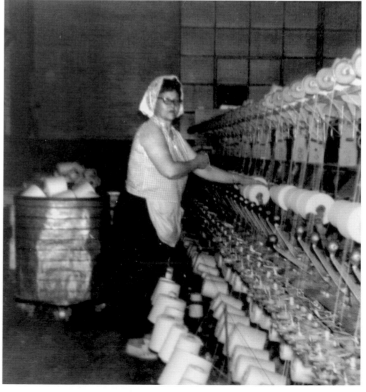

On the factory floor, Doris Jordan wore comfortable clothes, a headscarf, and cat-eye glasses—the iconic accessory of the 1960s. Like other women, Jordan and her co-workers at Whittier Mills may have been frustrated by low wages, sexual discrimination, and limited opportunities for promotion. Although NOW supporters were generally middle-class, their efforts for equality and freedom of choice improved the lives of all American women. *Doris Jordan; unattributed; Atlanta, 1969.*

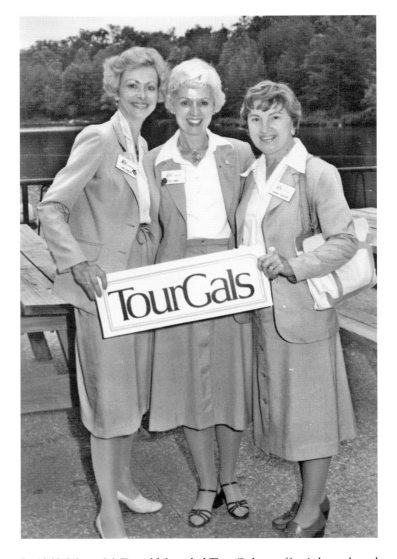

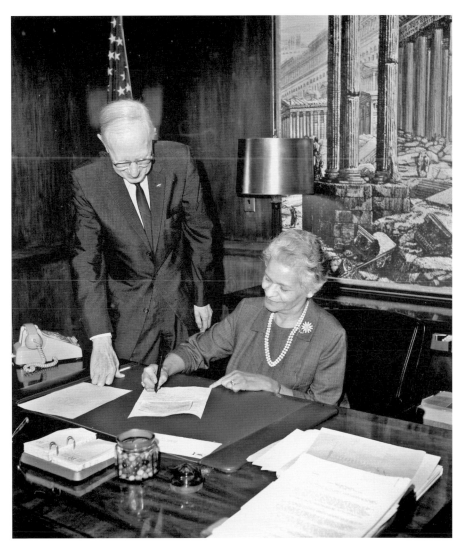

In 1968, Marge McDonald founded TourGals to offer Atlanta-based tour packages for women who accompanied their husbands to the city on business trips. TourGals was an instant success and soon offered convention services and seasonal outings. TourGals' memorable name and Georgia peach–hued uniforms helped to promote the company at a time when women were relative newcomers to business. Tour companies across the country emulated the business now known as Atlanta Arrangements by TourGals. *Pictured from left to right: Linda Bowling, Pat Lanier, and Barbara Peddicord at Lake Lanier; unattributed; Georgia, 1974. (Courtesy of Marge McDonald.)*

Grace Towns Hamilton is shown at her desk when she qualified for the Georgia Democratic primary in 1968. Previously, the Atlanta native worked for 18 years as the executive director of the Atlanta Urban League, which sought to improve educational, health, housing, and recreational opportunities for African Americans. In a special election in 1965, Hamilton became the first African-American woman elected to the Georgia General Assembly. During her tenure, she was the architect of the 1973 Atlanta City Charter, which established a representative number of African Americans in city government through district voting. After 18 years in the state legislature, Hamilton spent 2 years as an advisor to the U.S. Civil Rights Commission. In 1971, she was named Atlanta's Woman of the Year for professional service, the first African American to receive the honor. *Grace Towns Hamilton; unattributed; Atlanta, 1968.*

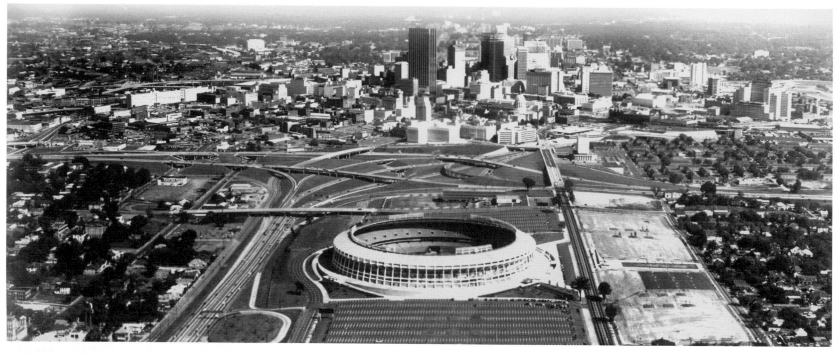

To spur Atlanta's growth as a city, Mayor Ivan Allen Jr. proposed the development of a rapid mass transit system for the city and surrounding communities, helped establish the city as a regional center for ground and air transportation, and oversaw the creation of a new civic center. The mayor also tirelessly pursued his goal of bringing major league sports to the city. Fulton County Stadium, shown in the foreground, became the home of professional baseball and football teams—the Atlanta Braves and the Atlanta Falcons. *Atlanta; Bell and Stanton, Inc., photographer; Atlanta, c. 1965.*

Like her husband, Louise Allen has been a vital force in Atlanta for decades. During World War II, she served as president of the Junior League of Atlanta, raising funds for community service programs through the first Fashionata, a charitable fashion show staged by Rich's department store. An advocate for education and historic preservation, the city of Atlanta honored her for civic service by naming her Woman of the Year in 1969. Upon receiving the award, Allen remarked to the new mayor, Sam Massell, "Sam, Atlanta is a wonderful city—please take care of it!" Allen's evening gown is in the collection of the Atlanta History Center. *Louise Richardson Allen (Mrs. Ivan Allen Jr.); Van Buren Colley, photographer; Atlanta, 1969.*

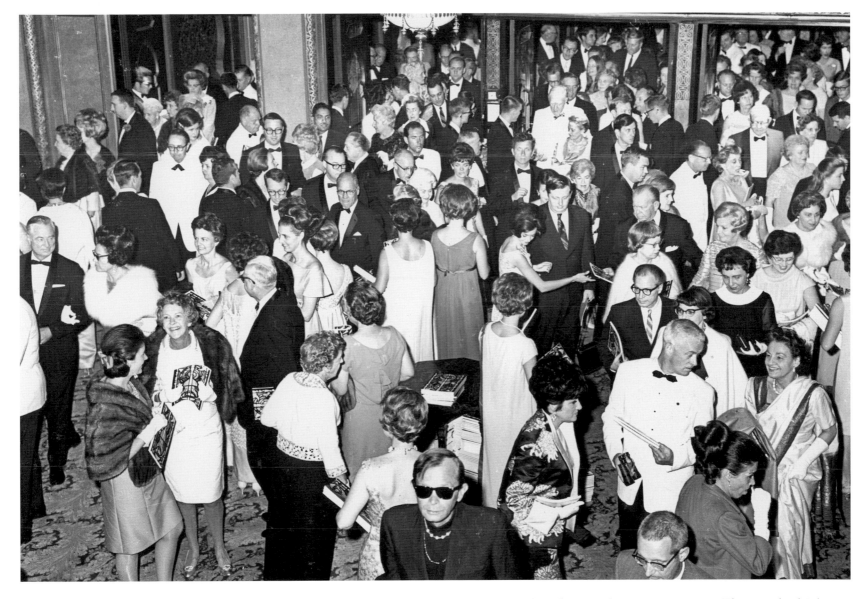

Arts and culture are often considered a reflection of a city's prominence. The growth of Atlanta's arts and cultural institutions was, in part, a response to a tragic event—the crash of a plane carrying more than 100 members of the Atlanta Art Association at Orly airport in France. In the wake of this tragedy, $13 million were raised to build a new arts center in their memory. Completed in 1968, the Atlanta Memorial Arts Building initially housed the High Museum, the Atlanta Symphony Orchestra, the Alliance Theatre, the Atlanta College of Art, and the Atlanta Children's Theatre. Opera was another important cultural offering; throughout the 1960s, the Metropolitan Opera performed regularly at the Fox Theatre. *Fox Theatre lobby on opera night; Joe McTyre, photographer; Atlanta, 1969.*

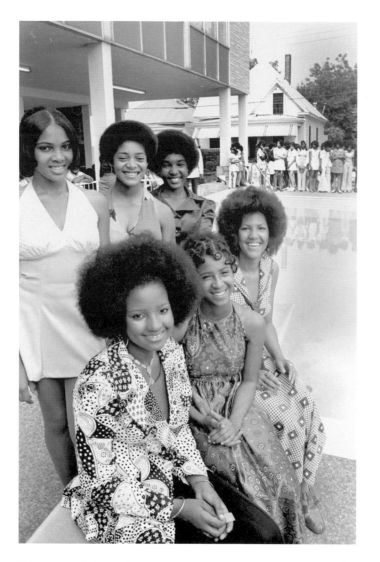

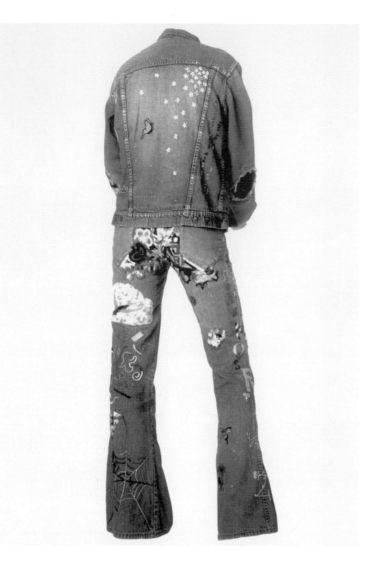

Like many African-American women, some contestants in the 1972 Miss Black Teen pageant rejected the prevailing white ideal of beauty, celebrated their racial heritage, and grew Afros. In the late 1960s and early 1970s, vibrant colors, flowing shapes, and bold prints reflected ethnic influences on fashion. By this time, miniskirts were an accepted style; women's hemlines could be anywhere from 4 to 12 inches above the knee. *Miss Black Teen pageant contestants; Boyd Lewis, photographer; Atlanta, 1972.*

In the 1960s, getting dressed could be a political act. Many people personalized manufactured clothing, including jeans, with patches, tie-dye treatments, or even embroidery, as on this outfit. From their 19th-century origins as work pants for laboring men, blue jeans came to symbolize a youthful counterculture in the 1960s and 1970s and became a staple of college students' wardrobes. Today, jeans are ubiquitous. The first embroidery designs on these bell-bottom hip-huggers covered badly worn areas, but the maker's children liked them so much that they soon came up with new designs. The jacket was bought and decorated to match the jeans. *Denim outfit, jacket by Sears, Roebuck & Co., stitched and worn by Ann T. Crissey; Tucker, Georgia, c. 1974. (Atlanta History Center collection; Jonathan Hollada, photographer.)*

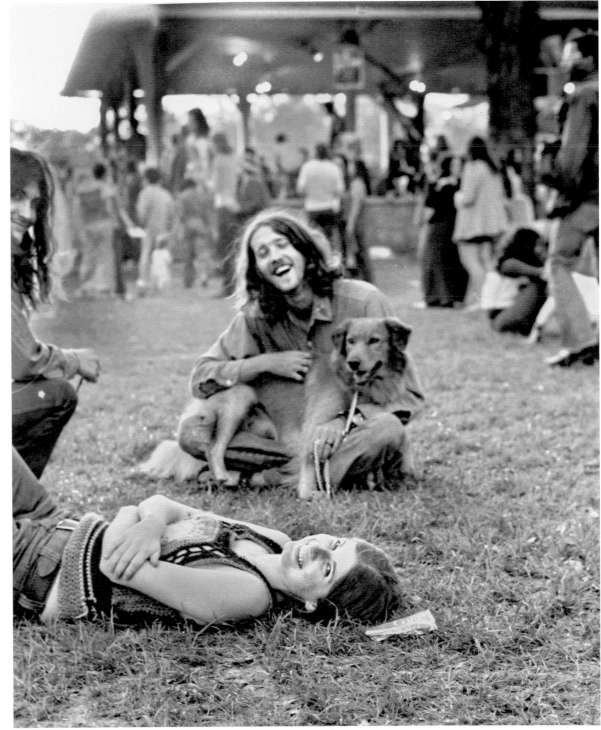

Known for wearing long hair and unconventional clothing, experimenting with drugs, and having unsanctioned sex, so-called hippies were inseparable from the psychedelic and folk music scenes. Atlanta women embraced these subcultures in varying degrees, if at all. Although some women participated in "free love," most simply wanted to control their own reproduction. The approval of birth control pills by the Food and Drug Administration in 1960 gave women from all walks of life access to reproductive choice. *Unidentified subjects; Boyd Lewis, photographer; Atlanta, 1972.*

In this image, a somber Atlanta family views a Martin Luther King memorial march from their front porch. Reverend King, perhaps the best-known symbol of the civil rights movement, was shot and killed in Memphis, Tennessee, on April 4, 1968. In 1983, Congress passed legislation to make the third Monday in January a holiday in his honor. The annual observance provides opportunities for locals and others to express their support for King's teachings and leadership, which transformed the nation. *Unidentified family; Boyd Lewis, photographer; Atlanta, January 15, 1974.*

As her husband gained prominence and media attention, Coretta Scott King was thrust into the spotlight. After his assassination, many Americans turned to her as a symbol of strength and as the steward of his legacy. In 1972, she joined 8,000 African Americans in Gary, Indiana, for the National Black Political Convention. The meeting's agenda stated that participants "must accept major responsibility for creating both the atmosphere and the program for fundamental, far-ranging change in America." In her effort to unify black leadership, King joined Betty Shabazz, the widow of Malcolm X, at the event. King commented, "I think that the overall significance of coming together said to us that we can, together, do a lot more than we can being separated and divided" (Hampton and Fayer, 580). *Coretta Scott King (left) with an unidentified woman; Boyd Lewis, photographer; Atlanta, c. 1974.*

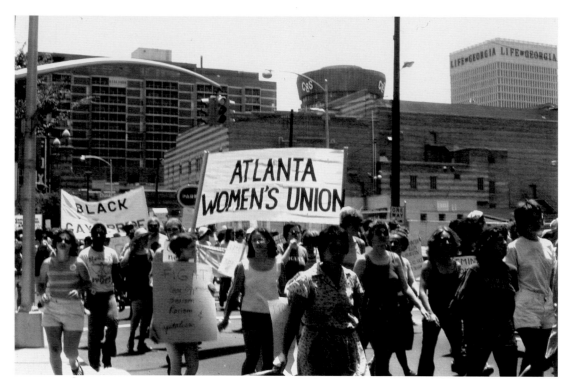

The 1969 Stonewall Riots in New York City's Greenwich Village marked the beginning of a new era in the gay and lesbian struggle against discrimination. Local activists responded to Stonewall by organizing public demonstrations for gay and lesbian rights in a rally known as Gay Pride. In 1972, the Atlanta Feminist Alliance was formed; two years later Atlanta's first independent feminist bookstore, Charis Books, opened. The first national march on Washington, D.C., for gay and lesbian rights was held in 1979 with about 150,000 marchers participating. *Gay Pride parade; unattributed; Atlanta, 1977.*

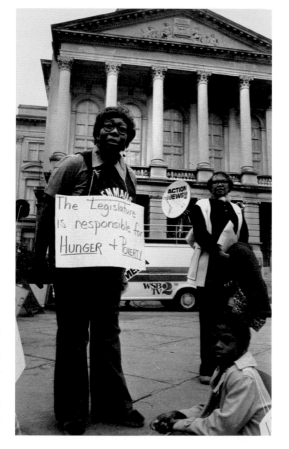

While some Americans demonstrated for civil rights and women's rights and against the Vietnam War, others focused on economic inequality. Ethel Mae Matthews, founder of the Atlanta Welfare Rights Organization, demonstrated outside the state capitol in 1976, calling on the legislature to take responsibility for alleviating poverty. Matthews described the city's marginalized residents: "It's an excellent place for some black people. But not for all black people, it's not an excellent place to live. Because if it was an excellent place to live, they would get people some jobs—all those people who sleep on the street, who eat out of the garbage can" (Hampton and Fayer, 623). *Ethel Matthews at the state capitol; Boyd Lewis, photographer; Atlanta, 1976.*

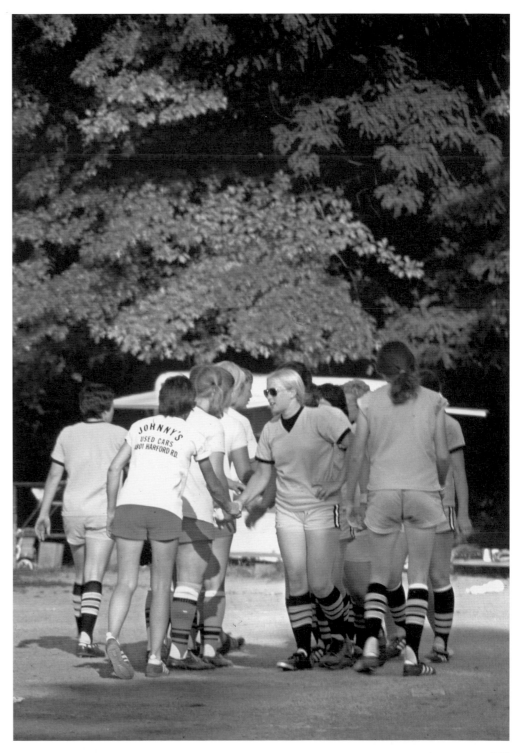

Members of two softball teams congratulate one another after a game at an Equal Rights Amendment (ERA) picnic. In 1972, the U.S. Congress passed the amendment for equal rights regardless of sex, which was forwarded to the states for ratification. The Georgia Legislature voted down the amendment repeatedly. Thirty-five states passed it—three fewer than the number required for ratification.

Women's rights activists won an important victory in 1973, when the Supreme Court ruled in Roe v. Wade that states did not have the authority to pass laws prohibiting abortion. Another high point in the battle for women's rights was the passage of Title IX of the Higher Education Act, which banned sex discrimination in schools and set the stage for gender equity in college athletic programs. *Unidentified softball players; unattributed; Atlanta, 1975.*

RESOURCES AND SUGGESTED READINGS

Ambrose, Andy. *Atlanta: An Illustrated History*. Athens, GA: Hill Street, 2003.

Banta, Martha. *Imaging American Women: Idea and Ideals in Cultural History*. New York: Columbia University, 1987.

Bernhard, Virginia. *Hidden Histories of Women in the New South*. Columbia: University of Missouri, 1994.

Bernhard, Virginia, Betty Brandon, Elizabeth Fox-Genovese, and Theda Perdue, eds. *Southern Women: Histories and Identities*. Columbia: University of Missouri, 1992.

Blackwelder, Julia Kirk. "Women in the Work Force: Atlanta, New Orleans, and San Antonio, 1930 to 1940." *Journal of Urban History* 1978 4(3): 331–358.

———. "Quiet Suffering: Atlanta Women in the 1930's." *Georgia Historical Quarterly* 1977 61(2): 112–124.

Blass, Kimberly S. and Michael Rose. *Atlanta Scenes: Photojournalism in the Atlanta History Center Collection*. Charleston, SC: Arcadia, 1998.

Brown, Carrie. *Rosie's Mom: Forgotten Women Workers of the First World War*. Boston: Northeastern University, 2002.

Bynum, Victoria E. *Unruly Women: The Politics of Social and Sexual Control in the Old South*. Chapel Hill: University of North Carolina, 1992.

Carroll, Maureen Anne. "Office Girls/ Business Women: Work, Gender, and Civicism in Atlanta, Georgia, 1919–1940." Ph.D. diss., Emory University, 1995.

Chauncey, George, Martin Bauml Duberman, and Martha Vicinus, eds. *Hidden From History: Reclaiming the Gay and Lesbian Past*. New York: New American Library, 1989.

Crane, Diana. *Fashion and Its Social Agendas: Class, Gender, and Identity in Clothing*. Chicago: University of Chicago, 2000.

Crater, Paul. *World War II in Atlanta*. Charleston, SC: Arcadia, 2003.

Crawford, Vicki L. et al., eds. *Women in the Civil Rights Movement: Trailblazers and Torchbearers, 1941–1965*. Bloomington: Indiana University, 1993.

Evans, Sara M. *Born for Liberty: A History of Women in America*. New York: The Free Press, 1989.

Foster, Helen Bradley. *New Raiments of Self: African American Clothing in the Antebellum South*. Oxford: Berg Publishing Limited, 1997.

Friedan, Betty. *The Feminine Mystique*. New York: Norton, 1963.

Garrett, Franklin M. *Atlanta and Environs: A Chronicle of Its People and Events*. 2 vols. Athens: University of Georgia, 1954.

———. *Yesterday's Atlanta*. Miami: E.A. Seemann, 1977.

Hall, Jacquelyn Dowd. *Revolt Against Chivalry: Jessie Daniel Ames and the Women's Campaign Against Lynching*. Rev. ed. New York: Columbia University, 1993.

———. "O. Delight Smith's Progressive Era: Labor, Feminism and Reform in the Urban South," in *Visible Women: New Essays on American Activism*. Ava Baron ed. Ithaca, New York: Cornell University, 1991.

———. "Private Eyes, Public Women: Images of Class and Sex in the Urban South," Atlanta, Georgia, 1913–1915." *Atlanta History* 1993 36(4): 24–39.

Hampton, Henry and Steve Fayer. *Voices of Freedom: An Oral History of the Civil Rights Movement From the 1950s Through the 1980s*. New York: Bantam Books, 1990.

Hardin, Elizabeth Pendleton. *The Private War of Lizzie Hardin: A Kentucky Confederate Girl's Diary of the Civil War in Kentucky, Virginia, Tennessee, Alabama, and Georgia*. Frankfort: Kentucky Historical Society, 1963.

Hawks, Joanne V. and Sheila L. Skemp, eds. *Sex, Race, and the Role of Women in the South*. Jackson: University Press of Mississippi, 1983.

Hickey, Georgina. "Visibility, Politics, and Urban Development: Working-Class Women in Early Twentieth Century Atlanta." Ph.D. diss., University of Michigan, 1995.

———. " 'Meet Me at the Arcade': Women, Business, and Consumerism in Downtown Atlanta, 1917-1964." *Atlanta History* 1996–1997 40(3–4): 5–15.

———. "Waging War on 'Loose Living Hotels' and 'Cheap Soda Water Joints': The Criminalization of Working-Class Women in Atlanta's Public Space." *Georgia Historical Quarterly* 82 (winter 1998): 775–800.

———. *Hope and Danger in the New South City: Working-Class Women and Urban Development in Atlanta, 1890–1940*. Athens: University of Georgia, 2003.

Hornsby, Alton Jr. *Chronology of African American History: From 1492 to the Present*. Detroit: Gale Research, 1997.

Hunt, Patricia K. and Lucy R. Sibley. "African American Women's Dress in Georgia, 1890–1914: A Photographic Examination." *Clothing and Textiles Research Journal* 1994 12(2): 20–26.

Hunter, Tera. *To 'Joy My Freedom: Southern Black Women's Lives and Labors After the Civil War*. Cambridge: Harvard University, 1997.

Judson, Sarah, Mercer. "Building the New South City: African American and White Clubwomen in Atlanta, 1895–1930." M.A. thesis, New York University, 1997.

Kuhn, Clifford M., Harlon E. Joye, and E. Bernard West. *Living Atlanta: An Oral History of the City 1914-1948*. Athens: University of Georgia, 1990.

Maclachlan, Gretchen E. "Atlanta's Industrial Women, 1879–1920." *Atlanta History* 1993 36(4): 16–23.

Maclachlan, Gretchen Ehrmann. "Women's Work: Atlanta's Industrialization and Urbanization, 1879–1929." Ph.D. diss., Emory University, 1992.

Meyerowitz, Joanne, ed. *Not June Cleaver: Women and Gender in Postwar America, 1945–1960*. Philadelphia: Temple University, 1994.

Minnix, Kathleen. *Laughter in the Amen Corner: The Life of Evangelist Sam Jones*. Athens: University of Georgia, 1993.

Nasstrom, Kathryn L. "Women, the Civil Rights Movement, and the Politics of Historical Memory in Atlanta, 1946–1973." M.A. thesis, University of North Carolina at Chapel Hill, 1993.

Norton, Mary Beth, ed. *Major Problems in American Women's History: Documents and Essays*. Lexington, MA: D.C. Heath, 1989.

Parker, Rozsika. *The Subversive Stitch: Embroidery and the Making of the Feminine*. New York: Routledge, 1989.

Peiss, Kathy. *Hope in a Jar: The Making of America's Beauty Culture*. New York: Metropolitan Books, 1998.

Rooks, Noliwe. *Hair Raising: Beauty, Culture and African American Women*. New Brunswick, NJ: Rutgers University, 1996.

Rose, Michael. *Atlanta: A Portrait of the Civil War*. Charleston, SC: Arcadia, 1999.

———. *Atlanta Then and Now*. San Diego, CA: Thunder Bay, 2001.

Roth, Darlene R. and Louise E. Shaw. *Atlanta Women: From Myth to Modern Times—A Century of History*. Atlanta: Atlanta Historical Society, 1980.

Roth, Darlene R. *Matronage: Patterns in Women's Organization, Atlanta, Georgia, 1890–1940*. New York: Carlson, 1994.

Roth, Darlene and Andy Ambrose. *Metropolitan Frontiers: A Short History of Atlanta*. Atlanta: Longstreet, 1996.

Scott, Anne Firor. *The Southern Lady: From Pedestal to Politics, 1830–1930*. Charlottesville: University of Virginia, 1995.

———, ed. *Unheard Voices: the First Historians of Southern Women*. Charlottesville: University of Virginia, 1993.

Severa, Joan. *Dressed for the Photographer: Ordinary Americans and Fashion, 1840–1900*. Kent, OH: Kent State University, 1995.

Skinner, Arthur N. and James L. Skinner. *The Death of a Confederate: Selections from the Letters of the Archibald Smith Family of Roswell, Georgia, 1864–1956*. Athens: University of Georgia, 1996.

Smith-Rosenberg, Carroll. *Disorderly Conduct: Visions of Gender in Victorian America*. New York: Oxford University, 1985.

Spritzer, Lorraine Nelson. *Grace Towns Hamilton and the Politics of Southern Change*. Athens: University of Georgia, 1997.

Steele, Christy and Anne Todd, eds. *A Confederate Girl: The Diary of Carrie Berry, 1864*. Mankato, Minnesota: Blue Earth Books, 2000.

Wenger, Beth S. "Jewish Women of the Club: The Changing Public Role of Atlanta's Jewish Women (1870–1930)." *American Jewish History* 1987 76(3): 311–333.